QUEEN ELIZABETH II

AMMONITE
PRESS

PRESS
ASSOCIATION
Images

For Lois

First published 2011 by
Ammonite Press
an imprint of AE Publications Ltd,
166 High Street, Lewes, East Sussex, BN7 1XU

This title has been created using material first published in
Queen Elizabeth II (2008)

Text © Ammonite Press, 2008
Images © PA Photos, 2008
Copyright © in the work Ammonite Press, 2008

ISBN 978-1-90770-807-7

British Cataloguing in Publication Data. A catalogue
record of this book is available from the British Library.

Editor: Elizabeth Roberts
Managing Editor: Richard Wiles
Picture research: Press Association Images
Design: Terry Jeavons

Colour reproduction by GMC Reprographics
Printed and bound in China by 1010 Printing International Ltd

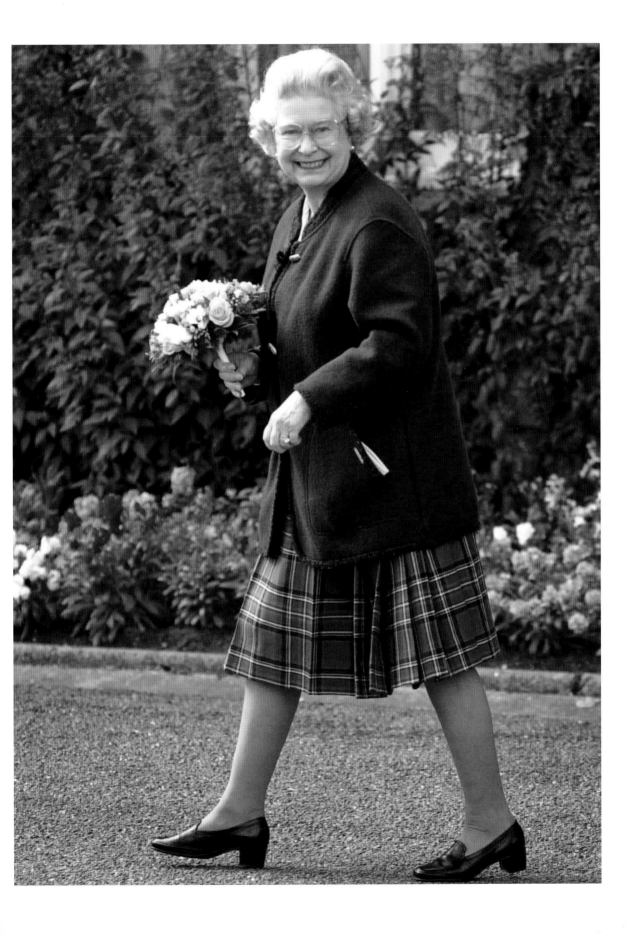

'I declare before you all that my whole life,

whether it be long or short, shall be

devoted to your service, and the service of

our great Imperial family to which we all belong'

Princess Elizabeth in a broadcast to the Empire and Commonwealth
on her 21st birthday, 21 April, 1947

CONTENTS

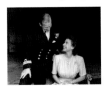
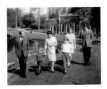
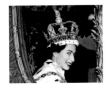
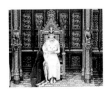
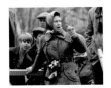
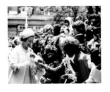
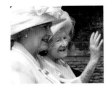
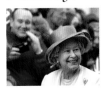
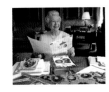
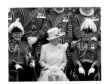
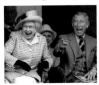

A Photographer's View of the Royal Year

In 1947, when the Press Association covered the wedding of Princess Elizabeth to Prince Philip, the demand for pictures from the regional press on the same day was huge. Road and rail was not fast enough, so the Press Association chartered aircraft from a company at Croydon Airport to drop the photographs, in canvas wallets with streamers, on open spaces around the country from where newspapers could collect their pictures on time.

Now, 64 years later, those newspapers would expect to have a picture of the bride and groom emerging from the Great West Door of Westminster Abbey on their websites before the happy couple had left in the horse-drawn carriage that was to take them back to Buckingham Palace.

Technology has changed so much today that it permits a photographer, albeit one with a rather heavy shutter finger, to take more pictures in an afternoon than his or her predecessor might have done in an entire year – but the reason why photographers cover the Queen's official engagements, and other events, has not altered.

In a world of constant change where the latest tastes in music, fashion and celebrity can flicker into life, burn brightly and fade into oblivion faster than a meteorite, the Queen is held in a unique position by the nation. She leads the nation when she stands at the Cenotaph on Remembrance Sunday; she represents the nation when she travels abroad; and she *is* the nation when she speaks from the throne at the State Opening of Parliament. For us, these events have a cosy familiarity; for her, they are a vitally important part of her life.

Most working weeks, the Queen is based at Buckingham Palace. Like everyone else, she is entitled to a private life, but her advisers have made huge efforts in recent years to open up to the cameras those parts of her working life that hitherto have been behind closed doors.

The media now carries pictures from inside the Palace of investitures – some 20 or so a year – when the Queen honours those who have carried out special public service. And there is usually a photographer in attendance when she receives

visitors from around the globe, such as prime ministers and presidents on official rather than state visits, and incoming ambassadors and high commissioners. And there are pictures of her hosting receptions for sportsmen, entertainers, residents in London of countries she is to visit and journalists. The Royal corgis even put in an appearance when she posed for a group picture with members of the England team that won the Rugby World Cup.

The Queen makes frequent visits to all parts of the UK. They are carefully planned to ensure that she meets a wide cross-section of people. And these days, photographers are less likely to record her meeting the local mayor than to photograph her visiting an organic food store.

My first regional Royal visit was in 1980, when the Queen took the salute at the Lord High Admiral's Divisions at the Britannia Royal Naval College at Dartmouth, where her youngest son, Prince Andrew, was among the midshipmen passing out. As a young photographer on the *Herald Express*, my responsibility was to photograph her alighting from the Royal train at Totnes, before I rushed the film back to the paper's office in Torquay in time for the final editions.

Coverage of regional visits – or themed days when members of the Royal family fan out to learn more about topics such as the maritime community, the entertainment industry, the media, the design industry and the emergency services – as well as many ceremonial or state events in London, is managed under Rota rules.

A Rota includes – if space permits – photographers from local newspapers, national newspapers, wire services and those who specialise in supplying magazines. Identified by a small coloured card swinging from their suit lapel or camera, they are afforded the best access, but in exchange have to share the material they collect with their colleagues.

Those unlucky enough not to have been allocated a Rota pass might choose to work from a Fixed Point, which is an area designated by those organising the visit as being specially for the press, from where they might be able to see the Queen arriving or leaving, or photograph an important part of the visit. At other times, photographers will choose to work at the back of the crowd, perched on small stepladders, hoping that she will head in their direction for a walkabout or that her attention will be drawn to someone near where they are standing.

The Palace press office tries, where possible, to ensure that an early part of the visit contains a visual element. They, like all experienced journalists, are aware that a good picture can turn an event primarily of local interest into one that will be reported widely. They also understand the need for picture-led events to happen at a time convenient to newspaper deadlines.

Other news about the Queen can turn a nice, but unexceptional, picture into one of rather greater importance. I was assigned to photograph a reception where she was presenting the National Awards of the Royal Anniversary Trust – but the news that day that in future she would be paying tax on her personal income meant that pictures from that event were destined for the front pages.

The Queen has a rhythm to her public engagements through the year. Long before she returns to London from Sandringham, where she spends Christmas and the New Year, photographers will be anticipating where she will be going in the spring for one of her two overseas visits of the year. They will also be looking forward to the first of the two incoming state visits.

The Thursday before Easter is the traditional Maundy Service, where the Queen hands out Maundy money to one man and one woman for every year of her life. The day usually produces a range of interesting pictures: the Maundy money being carried in by Yeomen of the Guard; a colourful group picture outside the cathedral where the service is being held; and the Queen and the Duke of Edinburgh holding small posies of flowers that have been presented to them.

Over Easter, the Queen and her court move to Windsor castle, the largest inhabited castle in the world. If a state visit is planned for the time that she is there, both photographers and motorists will be looking forward to a carriage procession through the town's genteel streets rather than the more familiar sight of one along The Mall, in London.

Whether in London or Windsor, state visits follow a broadly similar routine: formal welcomes, inspections of troops and items from the Royal collection, a call on the prime minister, visits by politicians, a trip to Westminster Abbey, banquets and return banquets. They are finely choreographed, and the plans are carefully honed to ensure photographers have good positions to work from. The format of the visit will be very familiar to most photographers, but they also look for that

split second that lifts a picture from a simple record of what happened to a moment that will be remembered.

Exactly that happened to me once when the Queen and the Duke of Edinburgh hosted a dinner at Buckingham Palace for leaders of the G7. Before the meal, a group photograph was planned for the Queen and Duke with the dignitaries. However, the Duke stayed behind to talk to other guests and, rather than the formal picture anticipated, I had a picture of the Queen pointing at an empty seat and asking, 'Who's sitting there?' Now photographers are only ushered in once everyone is sitting down and ready!

A state visit by the Queen is the highest endorsement of the diplomatic relationship between the UK government and that of the host country. The Queen only makes a state visit to see another head of state once. The accompanying photographers will usually see the country at its best. The media arrangements will have been planned and finessed over months. Sometimes I was lucky and travelled in air-conditioned coaches, whisked through the traffic by police motorcyclists; at other times, the best way to cover as many events as possible was to find a local taxi driver willing to find routes around chaotic streets.

The Queen's visits reflect the changing world. I watched her step ashore from the Royal yacht in Cape Town, South Africa, to be greeted by Nelson Mandela, and I was there when she and Russia's President Boris Yeltsin toasted the future in the Kremlin. A generation beforehand, neither event could even have been dreamed of.

Overseas visits are frequently fast moving, but often involve lots of waiting Photographers may not have the local knowledge or language skills to communicate with police officers or diplomats. The days can be long, with early starts to get to the first engagement and late finishes covering state banquets. At the end of the trip, which may have included several countries, tempers can be sorely frayed and home seems to be a long way away.

Royal transport has always held a fascination for photographers. The Royal yacht spoke uniquely of the values of our nation and heritage: it is best described as Buckingham Palace afloat. There were several occasions when I was covering an

overseas tour when the chance to go aboard for a brief pre-dinner photo opportunity provided a welcome break from the hustle and bustle of life ashore. The photo opportunities did not last long: photographers would be briefed before being ushered in, given the opportunity to take pictures for less than 30 seconds, and then ushered out. On one occasion, a local TV cameraman came away with nothing after spending the allotted 30 seconds trying to erect his tripod.

There is a Royal train that is used by the Queen and other members of the Royal family for overnight journeys. But the Queen sometimes uses other trains. I travelled on the train she used to inaugurate the Channel Tunnel. We left Waterloo, passing through the crowded commuter lines of southeast London, but the timetable was kept to the second – I fear that not every office worker that day had as trouble free a journey as I did.

In France, after passing through the tunnel, she and President Mitterand cut a ceremonial ribbon. For the return journey, the Queen's Rolls Royce travelled on Le Shuttle.

But the Palace press office realises that photography as a medium for communication is more than just coverage of events. They commissioned a series of portraits by photographers from the UK and the Commonwealth, which were released as part of her Jubilee celebrations in 2002. The photographers included her son, the Duke of York, rock singer Bryan Adams, Patrick Lichfield, Rankin and the Press Association's Fiona Hanson.

With her well-known love of horses, the Queen stays at Windsor for Ascot week. For photographers, the week starts on the Saturday before, when she takes the salute at the Trooping the Colour ceremony, which marks her official birthday. Here, some photographers choose a position on, or overlooking, Horse Guards Parade, in London, to watch and record the pageantry; others will be on the Queen Victoria Memorial, affectionately known as the 'Wedding Cake', to see the Queen and members of the Royal family travel to and from Horse Guards by carriage. Then they will switch to their longest telephoto lenses to capture the Queen, the Duke and other members of the Royal family as they emerge on the balcony of Buckingham Palace to watch a flypast by the RAF. It's one of the less

formal parts of the day as the crowds watch them point out the planes to one another and crane their necks as the aircraft pass over the Palace roof.

The Garter ceremony on the following Monday is the traditional curtain raiser for Ascot week. The next four days see the Queen and members of the Royal family ride in carriages along the finishing straight at the racecourse before taking their places in the Royal box. Photographers keep a keen eye out for the Queen walking to the Parade Ring to cast her expert eye over the horses. She last won at Ascot in 1999, with her horse Blueprint.

The Press Association has been photographing the Queen and her horses since 1949, when she won at Fontwell with Monaveen, which she owned jointly with the Queen Mother. Those pictures, taken on glass plates, remain in our archive.

Photographers catch up with the Queen and her love of horses at other times of the year: at the Derby, where they have a great view of the Royal box, perfectly positioned over the finishing line, and at the Royal Windsor Horse Show, where there are great opportunities for informal pictures when she mingles with the public as she browses the stalls, or goes out on the course with the other spectators to watch the carriage driving, in which her husband competed until recently.

The Queen also goes to watch the polo at Smith's Lawn in Windsor Great Park, where photographers have to work from across the 160-yard-wide pitch during the chukkas, before going closer for the presentation of the Queen's Cup. Before heading home, they pack an extensive arsenal of equipment into the boots of their cars. Typically, they carry at least two camera bodies, a wide-angle (16–35mm), standard (24–70mm) and telephoto zooms (70–200mm), as well as a range of telephoto lenses stretching up to 600mm for events such as the polo when they are a long way away. Also in their car will be that ubiquitous small stepladder – vital when working at the back of crowds during a walkabout. Those steps are also useful for keeping a space at events such as film premieres, when photographers stake out for many hours, and occasionally days, before an event.

They will require small electronic flashguns for use on day-to-day assignments, but also larger studio lights for set-piece group pictures, such as the Queen and members of England's Rugby World Cup winning team. Modern transmission requires a laptop, commercially available software and access to

a decent mobile telephone signal or a landline. The situation has not always been so easy. A generation ago, photographers would carry the equipment and chemicals necessary to develop their own negatives in a hotel bathroom, or keep a sharp look out for a high-street mini-lab that could do it for them. The negatives would then be scanned on a purpose-built machine that had to be connected via a modem to the telephone in their hotel bedroom; sometimes that was a matter of swapping plugs, at other times it could mean dismantling hotel furniture!

In earlier days, it meant taking a print to the offices of a local newspaper, news agency or telecommunications company that had the appropriate machine and hoping that they could connect to London before taking 20 minutes to transmit one black and white picture. The alternative was to send the film back to London by motorcycle or by train or, if one was very lucky, in the hands of a member of the press office.

Of course, the Queen has been much more than just a knowledgeable spectator in the equestrian world. Occasionally, she is seen out riding at Windsor, and it was there that she was photographed riding with President Reagan. And before 1987, she rode side-saddle for the Trooping the Colour on her horse Burmese.

After Ascot comes the Buckingham Palace Garden Party. For years, photographers took their longest lenses to watch from the roof; now there are pictures available from ground level as the Queen and other members of the Royal family meet some of the 8,000 guests at each event.

The Queen spends her summer holidays at Balmoral, largely out of sight of the media. The Royal household recognises the interest across the nation in the landmarks in her life. Recent ones include the Golden Jubilee of her coronation, her 80th birthday and her 60th wedding anniversary, and there have been some remarkable images from those events: The Mall filled with a crowd from one end to the other as they celebrated her Golden Jubilee; the Queen opening the birthday cards sent to her by wellwishers from around the world.

Autumn sees an incoming state visit, and one overseas – but the Queen will be back in London for the Remembrance Day service at the Cenotaph in November.

One of the big set-piece events of the year is the State Opening of Parliament, when the Queen rides in the State Coach to the House of Lords and reads a speech outlining the government's legislative programme from the throne. It's a ceremony that has changed little over the years. One of the prime spots is in the House of Lords, where the photographer is high up on a platform head-on to the throne, about 50 yards from where the Queen reads her speech.

From there, I could look to shoot close-ups of her reading her speech – waiting carefully for her to look up from the text – as well as aiming at wider shots of the scene, in addition to capturing well-known faces sitting on the Government or Opposition benches. It is important, too, to look out for MPs' spouses in the galleries above.

One year, I dropped a lens cap during the speech – the noise as it bounced across the wooden planks of the temporary stand we were working from sounded like thunder to me. I expected the whole chamber to turn around to see what was going on, but thankfully no one seemed to have heard it.

The Royal photographers' year finishes on Christmas Day at Sandringham, where the Queen and other members of her family attend morning service at the church on the Norfolk estate.

On a day when news is traditionally rather thin, photographers can be confident of a good 'show' in the next day's papers. The Queen travels to church by car, but others walk, and there's plenty of good picture chances. And when the service finishes, there is another opportunity for photographers to record the latest in Royal winter fashion as the family leaves the church and talks to the crowds of wellwishers waiting outside.

There's a break during the service that gives those photographers who have spent the year on Royal duty a chance to join their colleagues for a mince pie and a cup of tea – or something stronger – in the car park, and to reminisce over the good Royal pictures they have taken over the last 12 months – and those that got away.

MARTIN KEENE
Group Picture Editor
with the Press Association

1

Growing up

Princess Elizabeth (*centre*) with her
parents and sister, Margaret, on the day her father,
formerly the Duke of York, was crowned
King George VI. 12 May, 1937

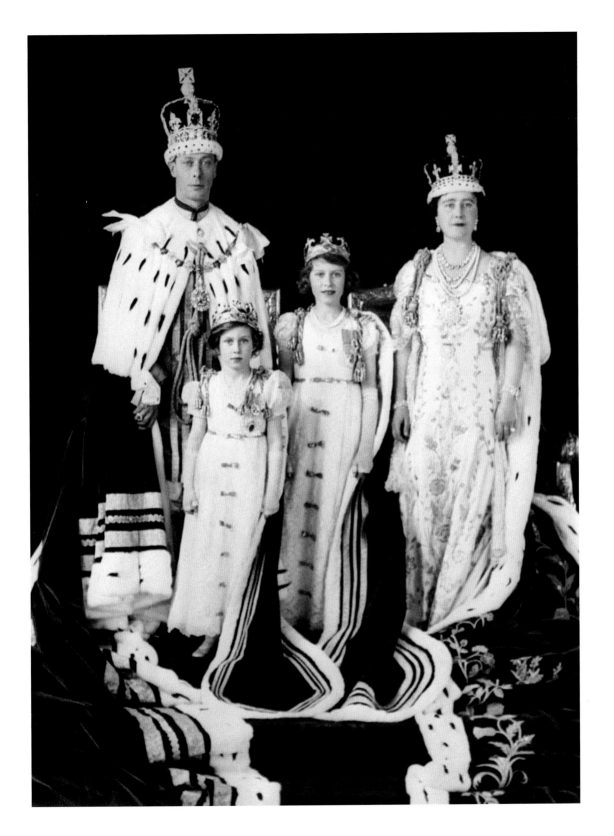

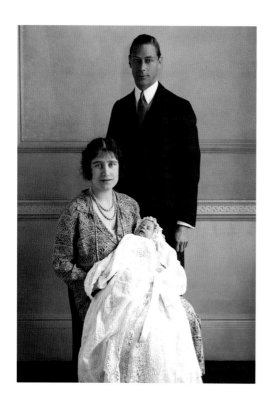

The Duke and Duchess of York
with Elizabeth as a tiny baby. She was
born on 21 April, 1926. ♔

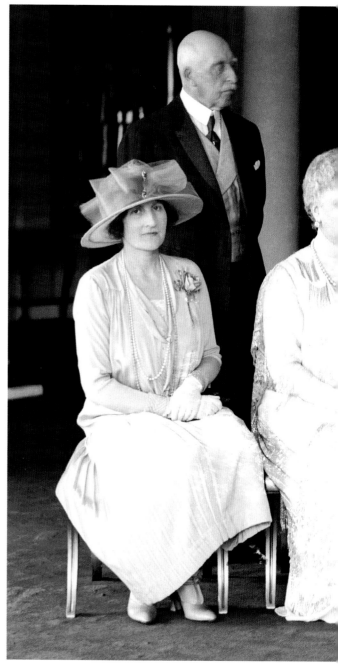

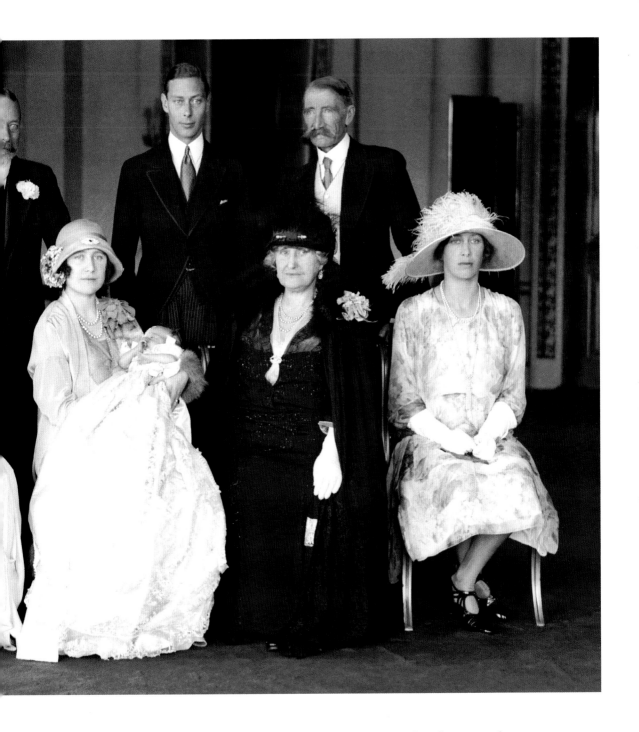

Elizabeth's christening. *Back row, left to right*: The Duke of Connaught,
King George V (Elizabeth's grandfather), the Duke of York (Elizabeth's father)
and the Earl of Strathmore. *Front row, left to right*: Lady Elphinstone, Queen Mary
(Elizabeth's grandmother), the Duchess of York (Elizabeth's mother), the
Countess of Strathmore and Princess Mary. 29 April, 1926

The Duke and Duchess of York with their young
daughter and her grandparents, the King and Queen, on
the balcony of Buckingham Palace. 27 June, 1927 ♕

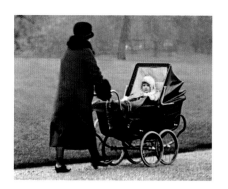 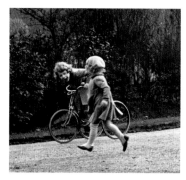

Above left: Elizabeth with her nanny in the park. 1 March, 1929 ♕
Above right: Elizabeth and her sister having fun. 1933 ♕

Elizabeth arrives at the
16th-century church at Balcombe in
Sussex for the wedding of Lady May
Cambridge and Captain Henry Abel
Smith. 1931 ♕

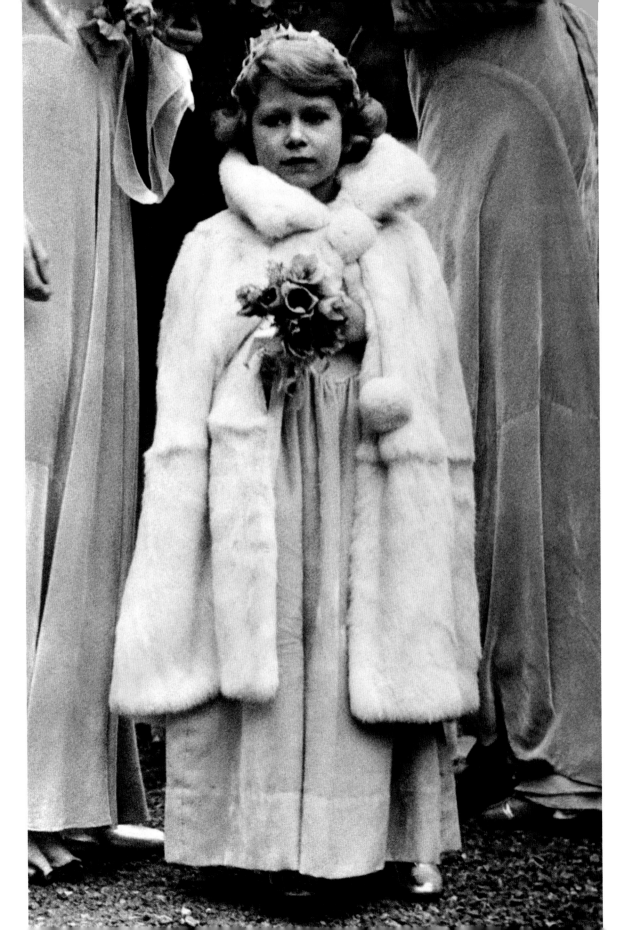

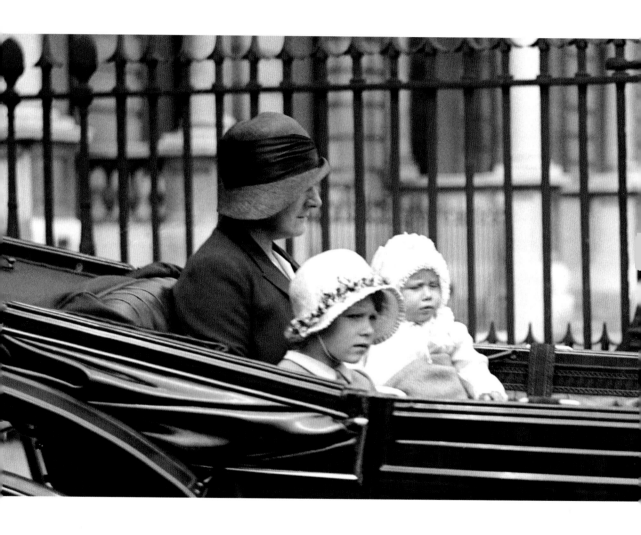

Elizabeth (*centre*) and her sister, Margaret Rose,
leaving Piccadilly, in London, with their nanny
in their horse-drawn carriage. 1931 ♛

Elizabeth with her mother and sister at
a disabled ex-soldiers' sale of work. 1933 ♕

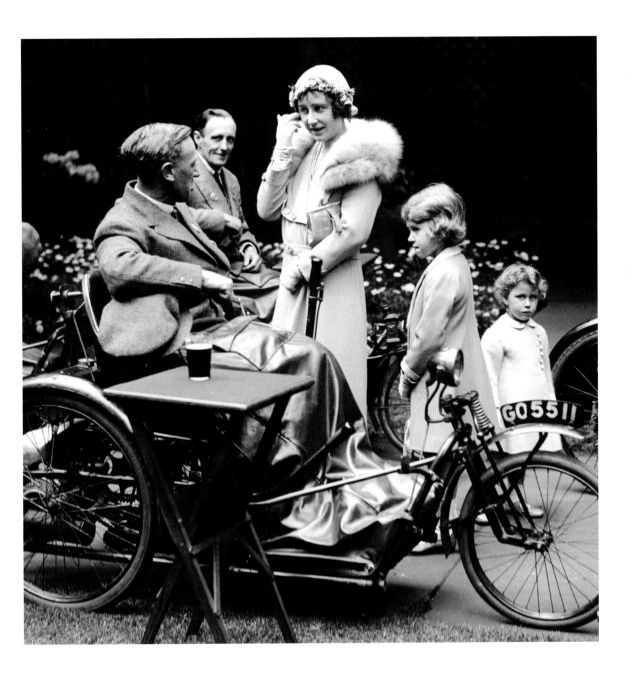

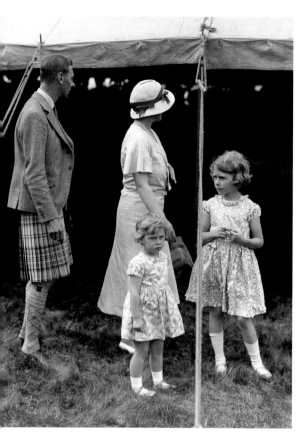

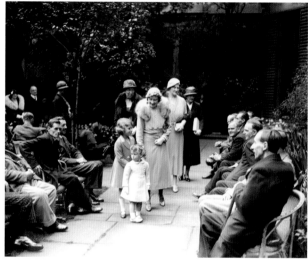

The Duke and Duchess of York with their
two daughters at Abergeldie Castle Fete,
which was selling goods in aid of Crathie
Church. 1933 ♔

The Duchess of York
(*centre*) and her two daughters at
a disabled ex-soldiers' sale of work at
Lowndes Square in London. 1933 ♔

The Duchess of York arrives at
the Royal Tournament in London
accompanied by her daughters. 1935 ♔

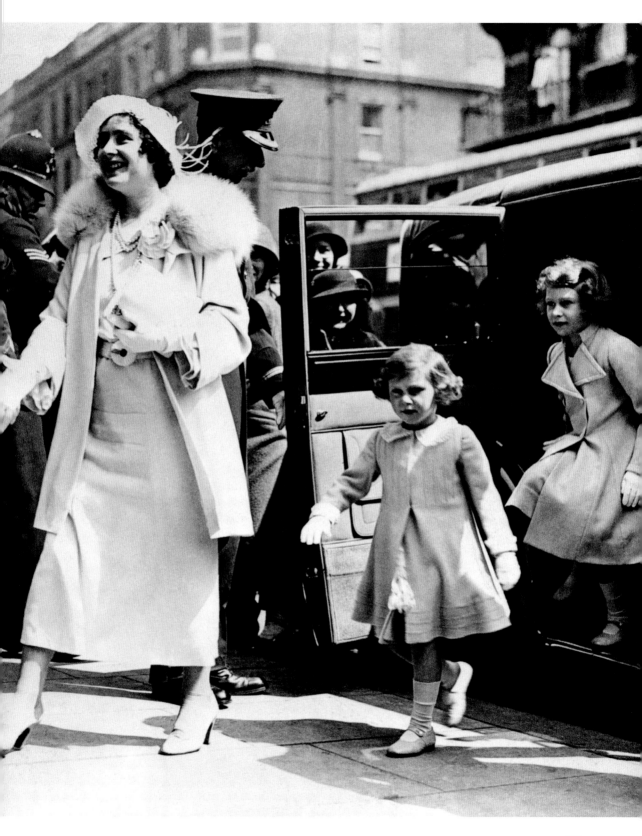

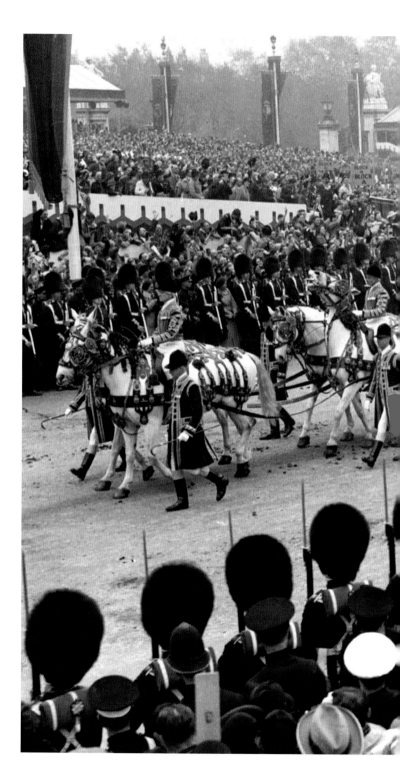

The coronation procession
drives along The Mall on its way
to Westminster Abbey.
12 May, 1937

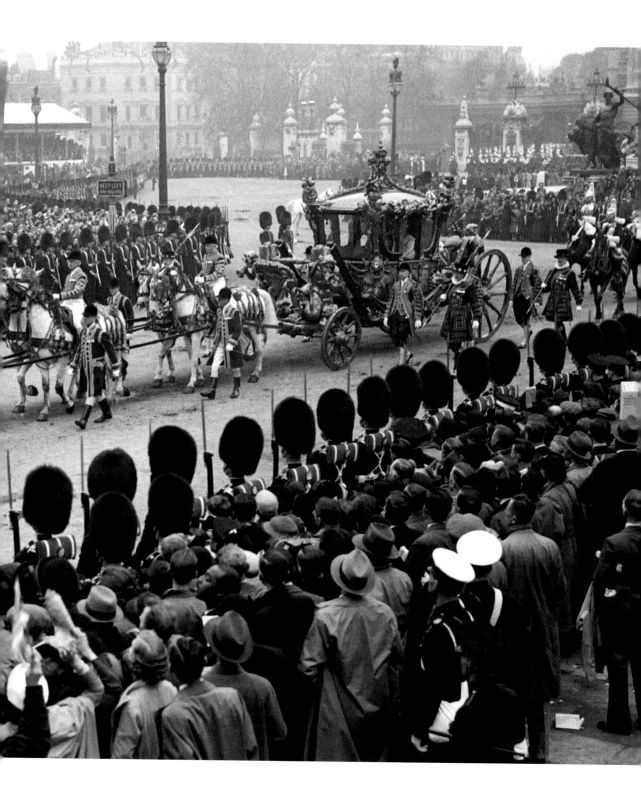

Elizabeth (*centre*) with her
parents, now King George VI and
Queen Elizabeth, and her sister, Margaret,
on the balcony of Buckingham Palace
after the coronation.

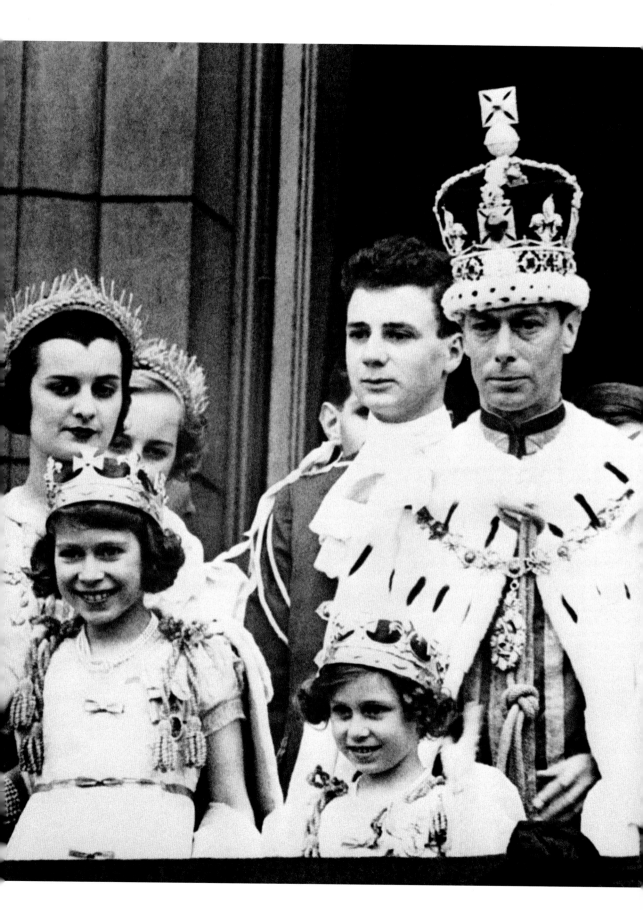

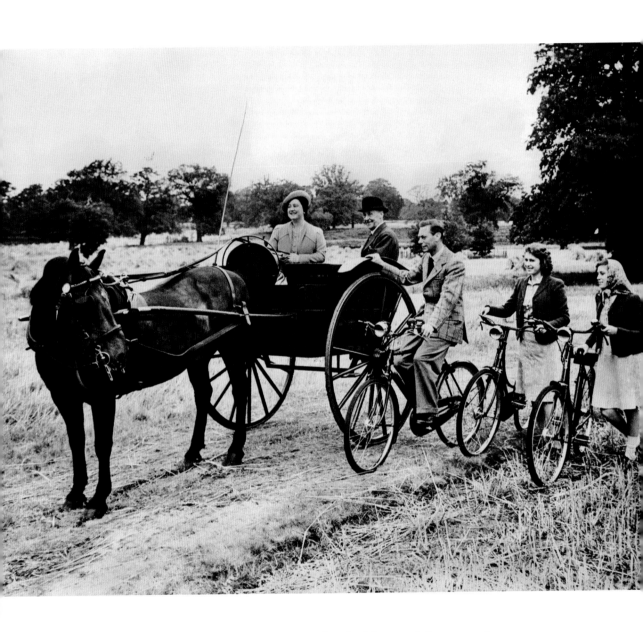

A ride out in the country for the King and Queen and
their daughters during the war. 1940 ♛

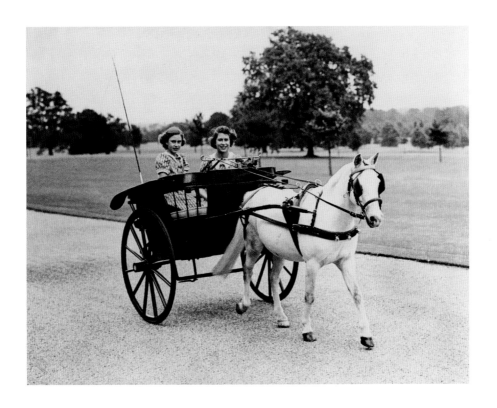

Princesses Elizabeth and Margaret driving
their pony cart in the garden of their wartime
residence (Windsor), where they stayed
during the Second World War. 1941

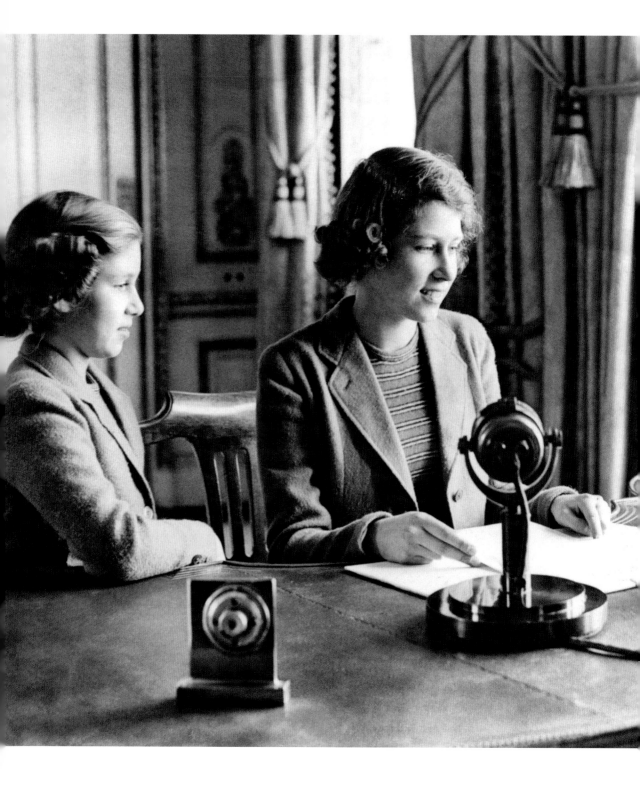

Princess Elizabeth, with her sister beside her, makes
a wartime broadcast from Buckingham Palace for the
BBC's Children's Hour programme. 1940 👑

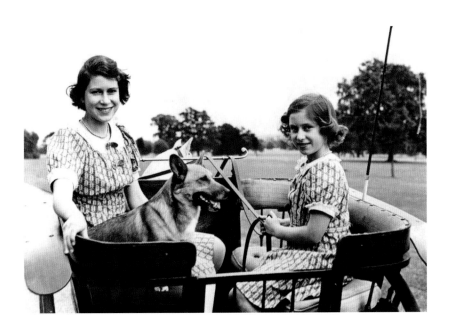

The pony cart was brought into use because of the
shortage of petrol during the war, but it was clearly regarded as fun
by the two young princesses. 1941 ♛

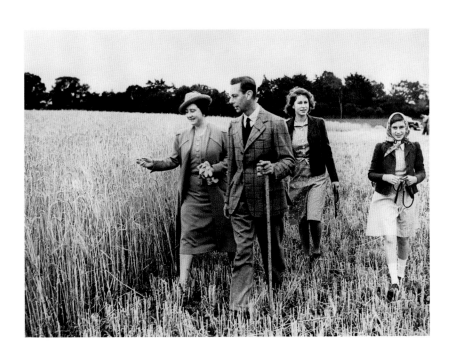

A walk through the fields. 1942 ♛

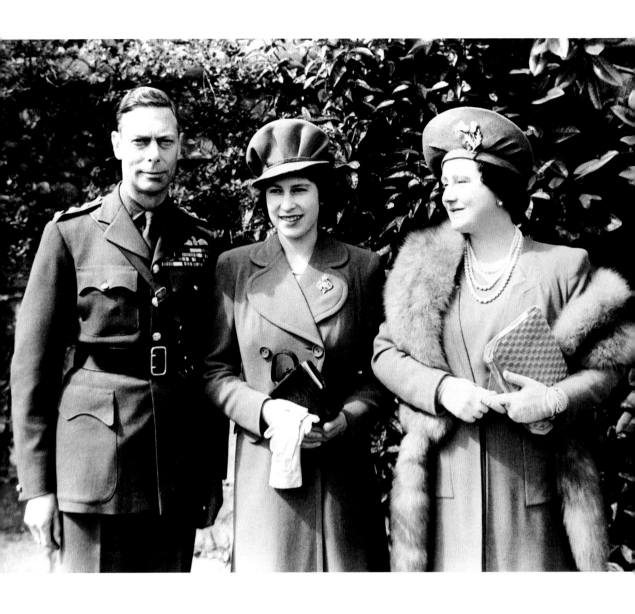

The young Princess
Elizabeth with her
parents on her 18th
birthday.
21 April, 1944 👑

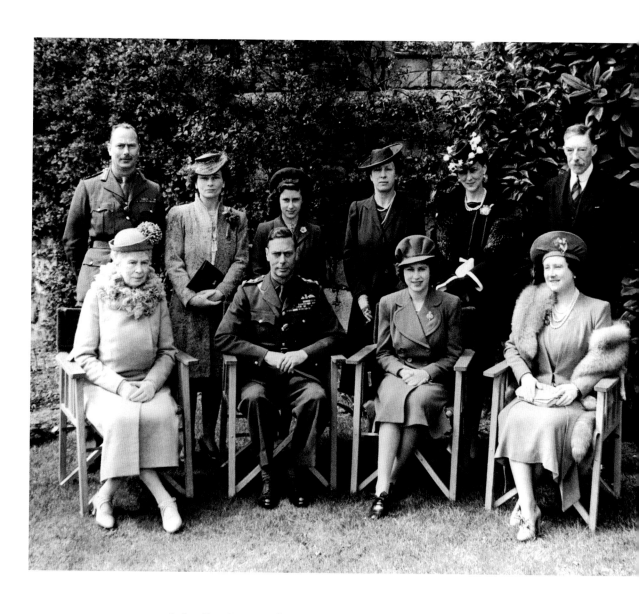

A family picture taken to celebrate Elizabeth's 18th birthday.
Back row, left to right: The Duke of Gloucester, Princess Alice of Gloucester,
Princess Margaret, Princess Mary, Princess Marina and the Earl of
Harewood. *Front row, left to right*: Queen Mary, King George VI,
Princess Elizabeth and Queen Elizabeth. ♛

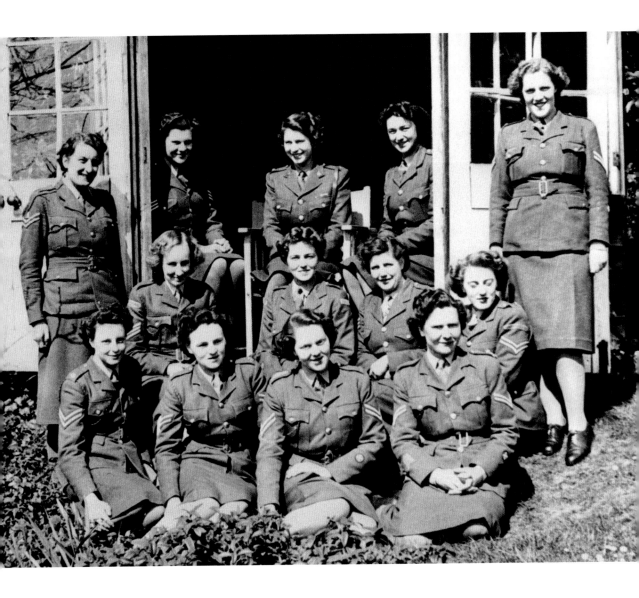

Princess Elizabeth (*top, centre*) with senior and junior

non-commissioned officers on her course at

No 1 MTTC at Camberley, Surrey. 1945 👑

Picture reproduced by permission of the Imperial War Museum

Elizabeth receives vehicle maintenance
instruction on an Austin 10 Light Utility Vehicle while
serving with No 1 MTTC at Camberley, Surrey. ♔

Picture reproduced by permission of the Imperial War Museum

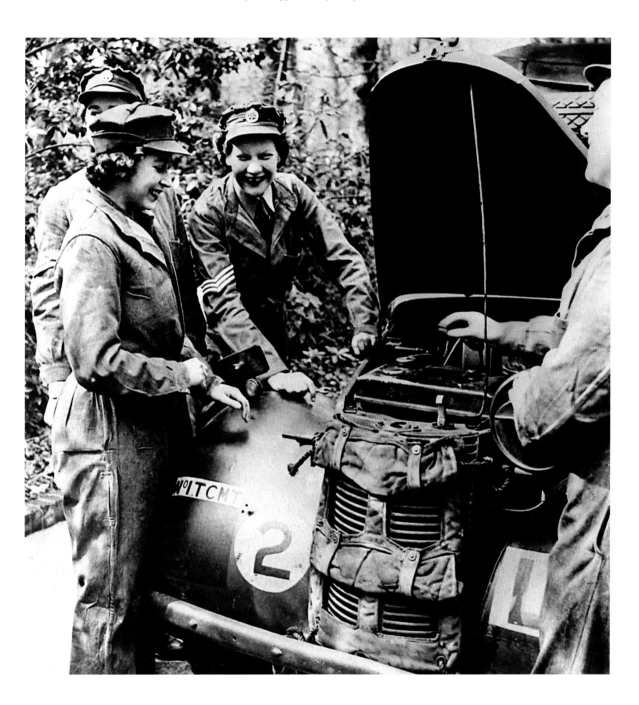

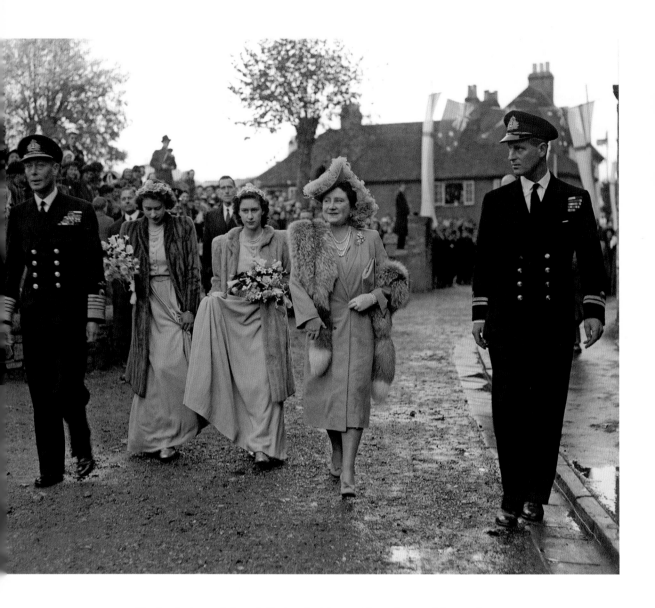

Elizabeth (*second from left*) is a bridesmaid at the wedding of
Patricia Mountbatten to Lord Brabourne. Here she is arriving at
Romsey Abbey accompanied by her sister and parents, and the
man who is to be her husband, Philip Mountbatten (*right*).

26 October, 1946 ♔

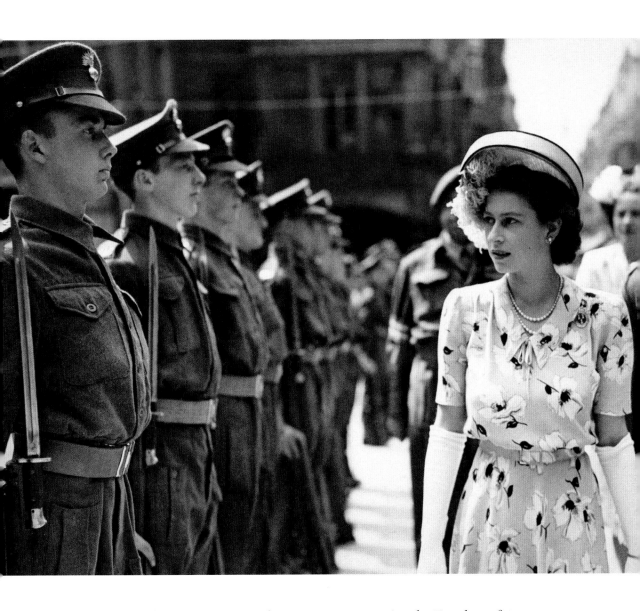

The future Queen attends a ceremony to receive the Freedom of
the City of London at Guildhall – the first significant ceremony
that she undertook unaccompanied. 11 June, 1947

2

Romance

43
ROMANCE

Elizabeth and Philip
pause to exchange a few words at the entrance
of the church at the wedding of Patricia Mountbatten
to Lord Brabourne. 26 October, 1946 ♔

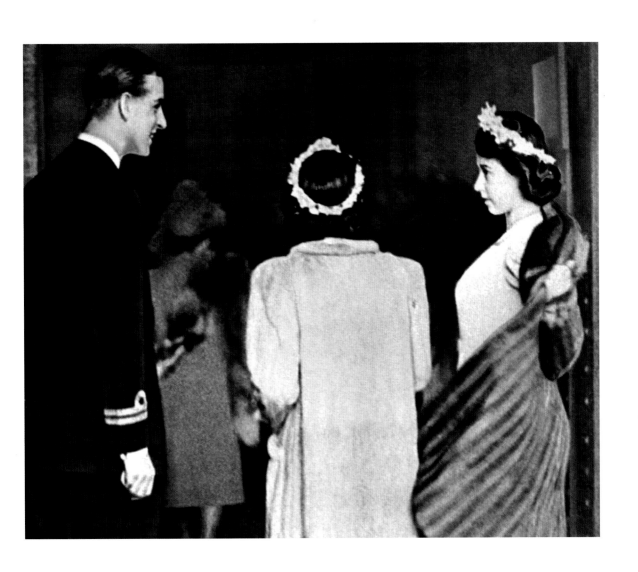

The engagement of Princess Elizabeth
to Philip Mountbatten is announced.
10 July, 1947 ♛

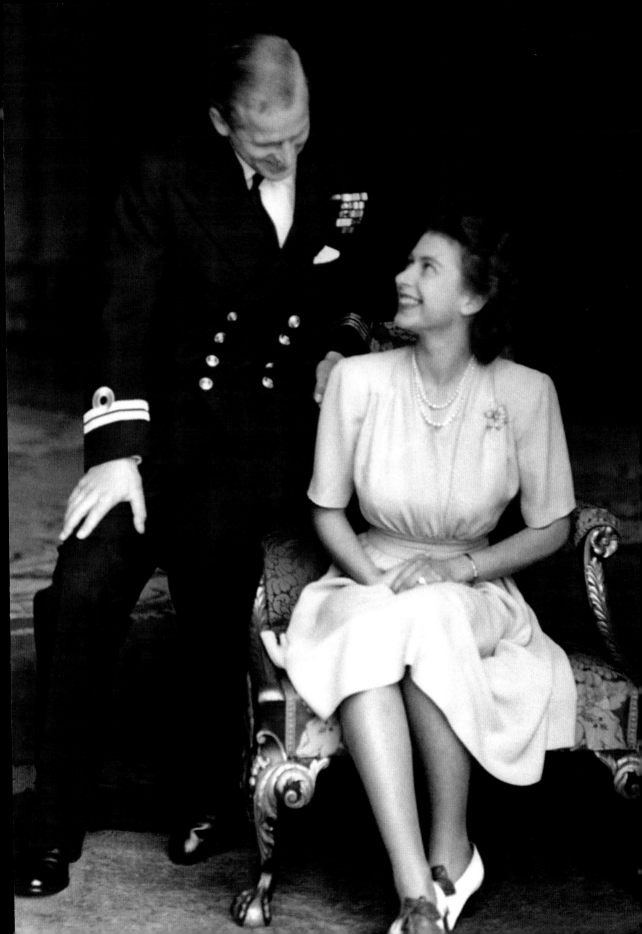

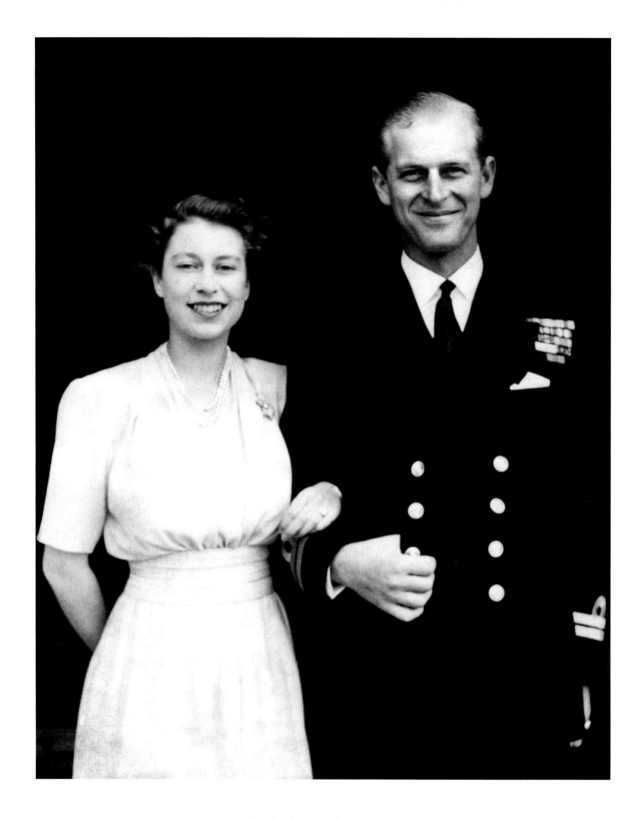

Elizabeth and Philip pose for
the cameras at Buckingham Palace. ♛

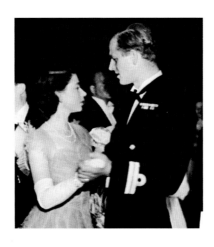

They dance… ♛

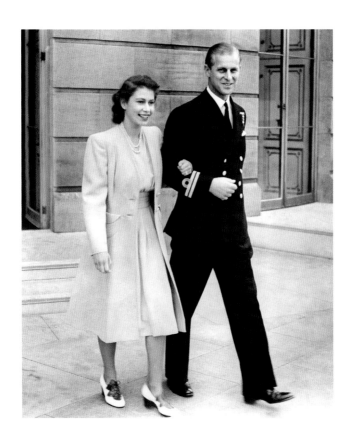

…and take a stroll together at
Buckingham Palace. ♛

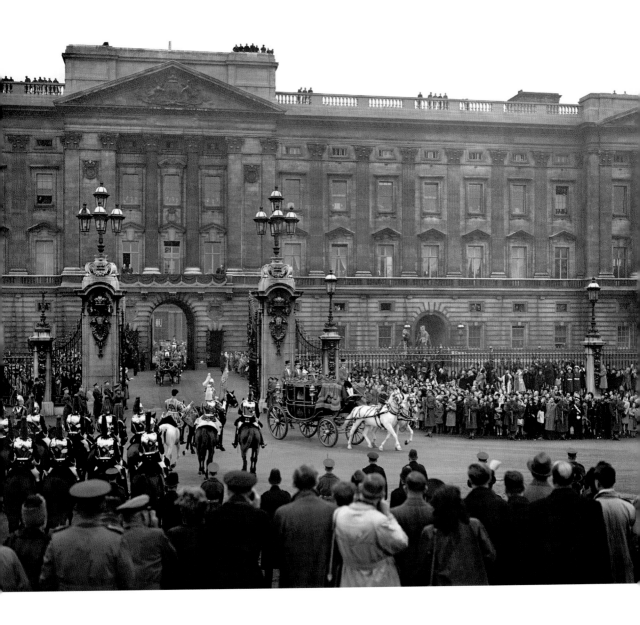

Londoners surge around the gates of
Buckingham Palace for a glimpse of Princess Elizabeth
on her wedding day. 20 November, 1947

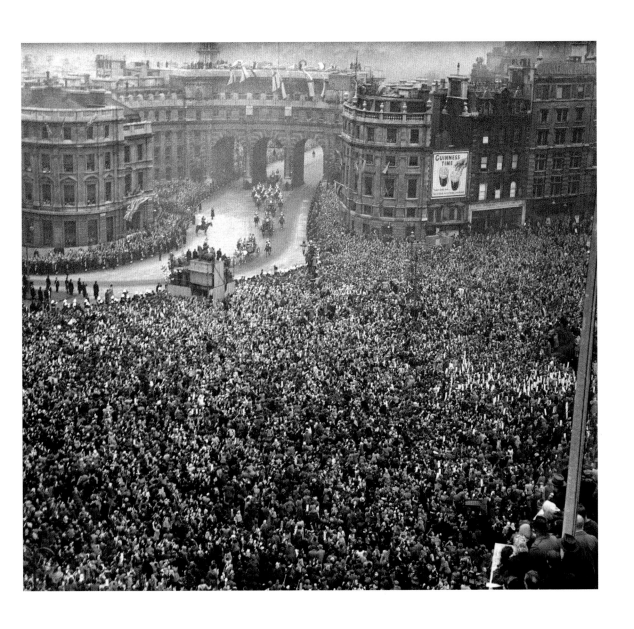

Immense crowds turn out to get a glimpse
of the Royal wedding. People are armed with periscopes in
Trafalgar Square as the procession passes through Admiralty
Arch on the way to Westminster Abbey. 👑

Elizabeth and Philip walk down the aisle with their
two pages and eight bridesmaids after the ceremony at
Westminster Abbey. 👑

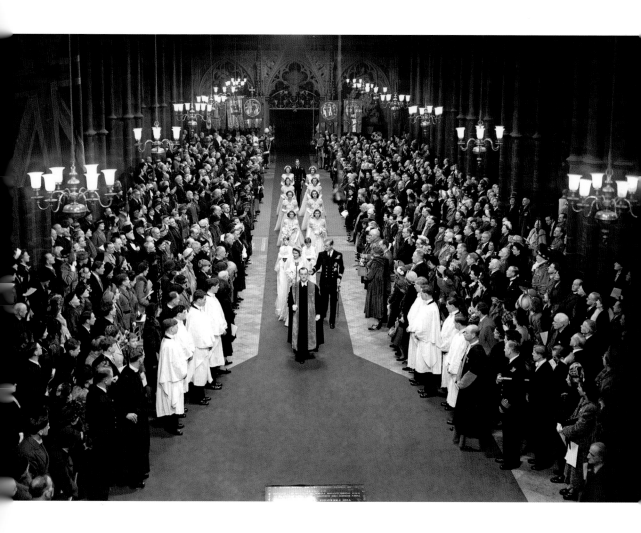

The couple leaving
Westminster Abbey. 👑

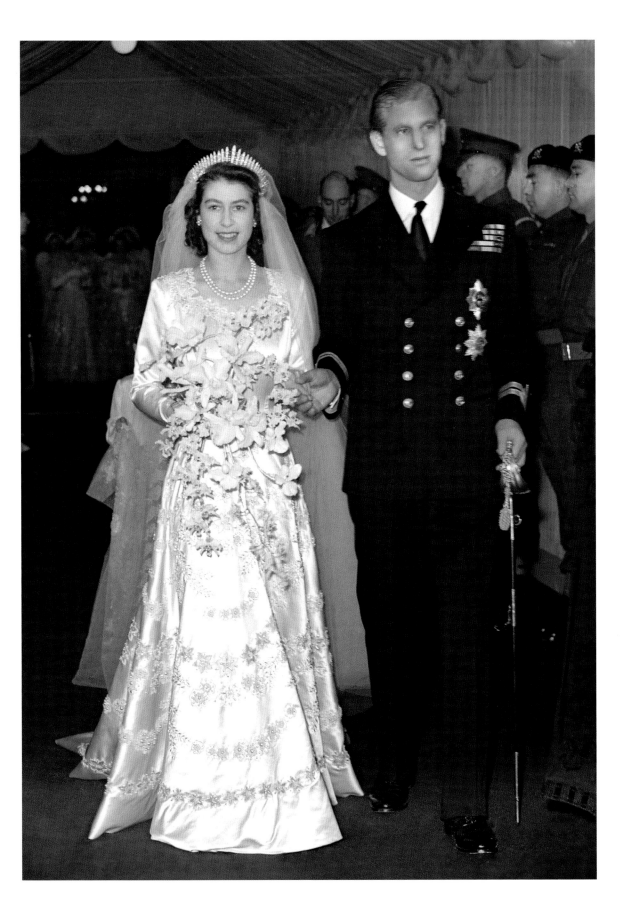

The wedding group in the
Throne Room at Buckingham Palace
after the wedding.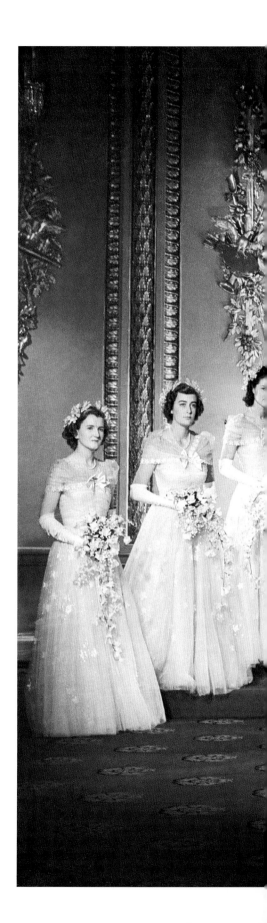

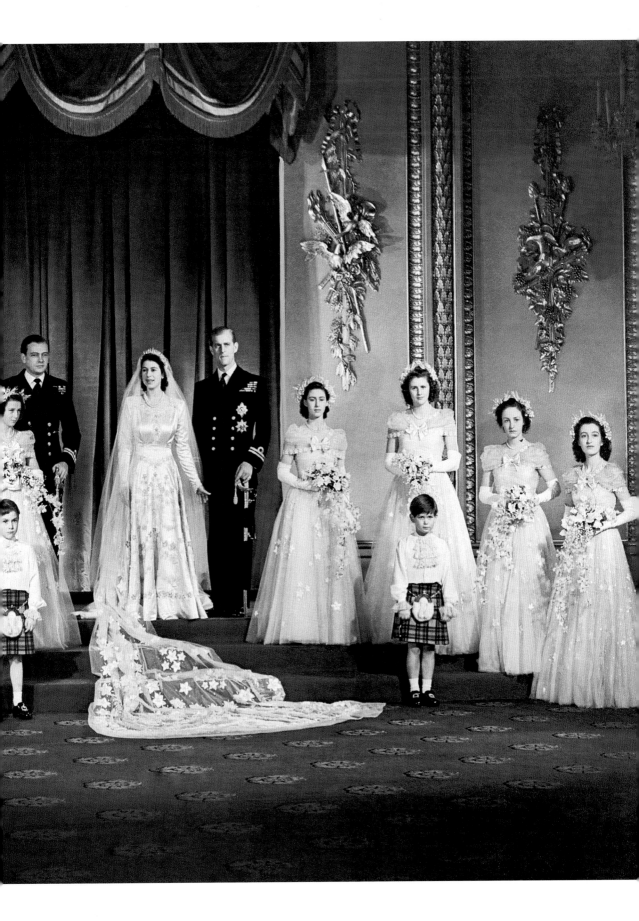

The Royal wedding
party appear on the balcony of
Buckingham Palace.
From left: King George VI,
Princess Margaret, unidentified,
the bride, the groom,
Queen Elizabeth and Queen Mary.

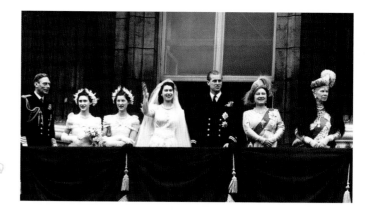

The bride and groom
wave to the crowd.

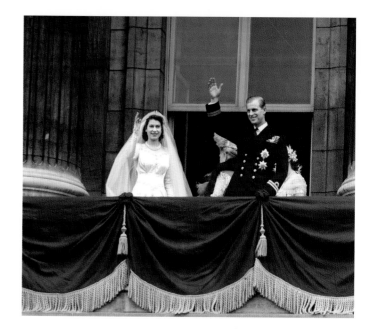

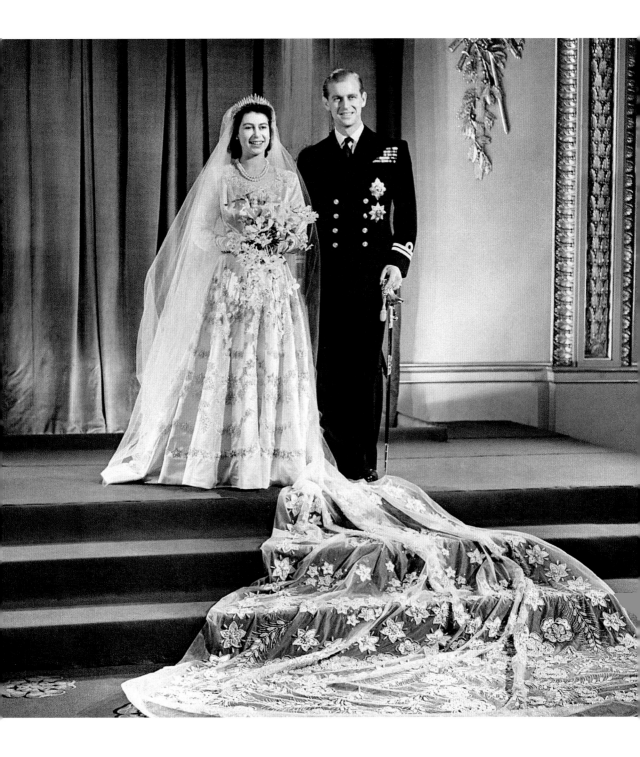

The couple together

in the Throne Room. ♛

Elizabeth and Philip, shortly after their wedding, at Clydebank for the launching of the liner *Caronia*, stop by at the town hall to receive the town's wedding present – an electric sewing machine. ♔

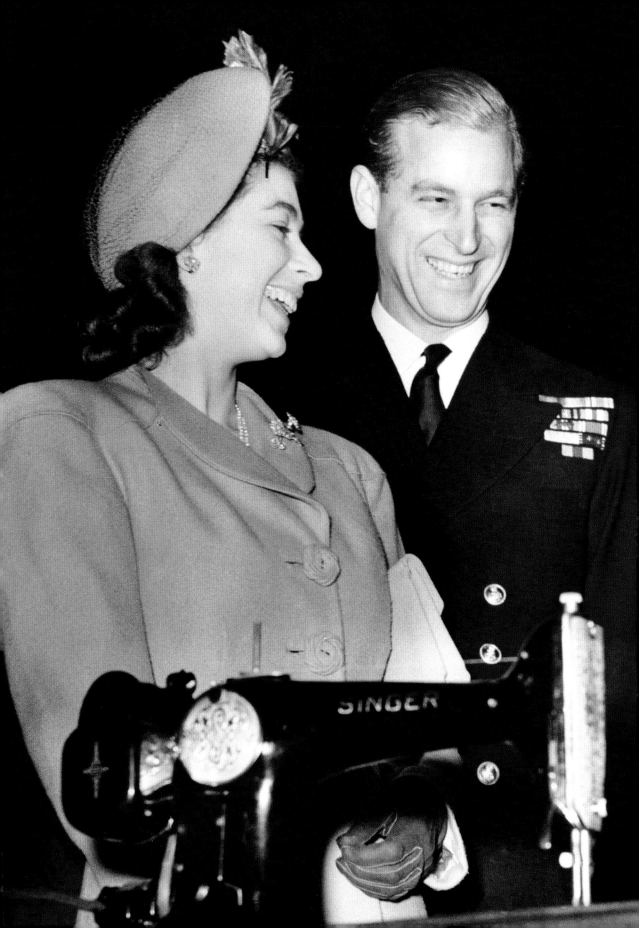

3

A family

Princess Elizabeth holds her son, Charles, after
his christening ceremony in Buckingham Palace.
He was born on 14 November, 1948 and was
named Charles Philip Arthur George.
15 December, 1948 ♛

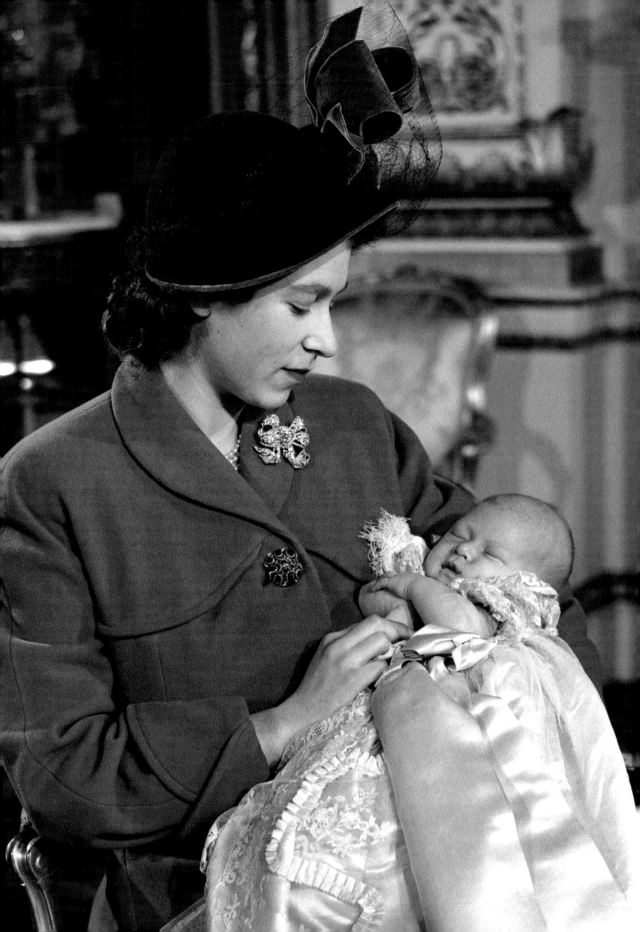

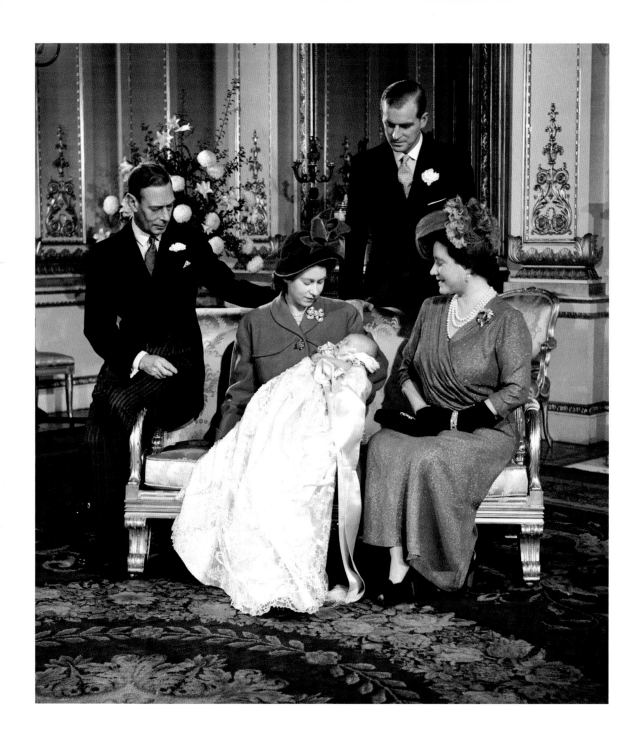

A family group at the christening of Prince
Charles. *From left to right:* King George VI,
Princess Elizabeth with the baby, Prince
Philip and Queen Elizabeth. ♔

Mother and son in the
grounds of Windlesham Moor
in Surrey. 18 July, 1949. 👑

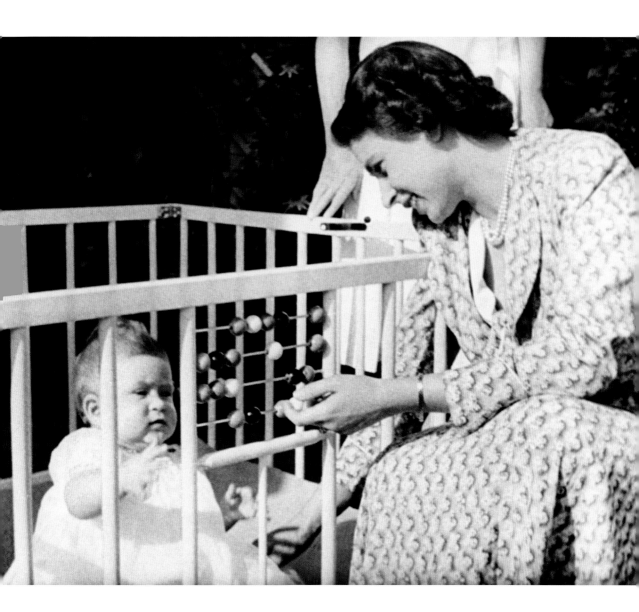

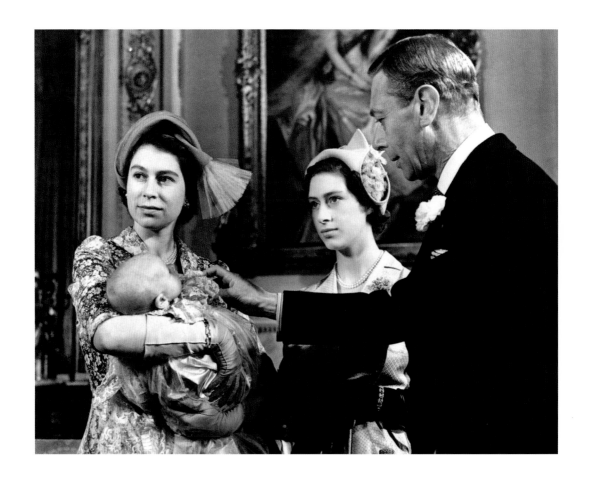

The King plays with his newly christened granddaughter,
Princess Anne Elzabeth Alice Louise, at Buckingham
Palace. Holding the baby is Princess Elizabeth and in the
centre is the baby's aunt, Princess Margaret. The baby is
wearing the Royal robe of Honiton lace handed down from
Queen Victoria's days. 21 October, 1950 ♛

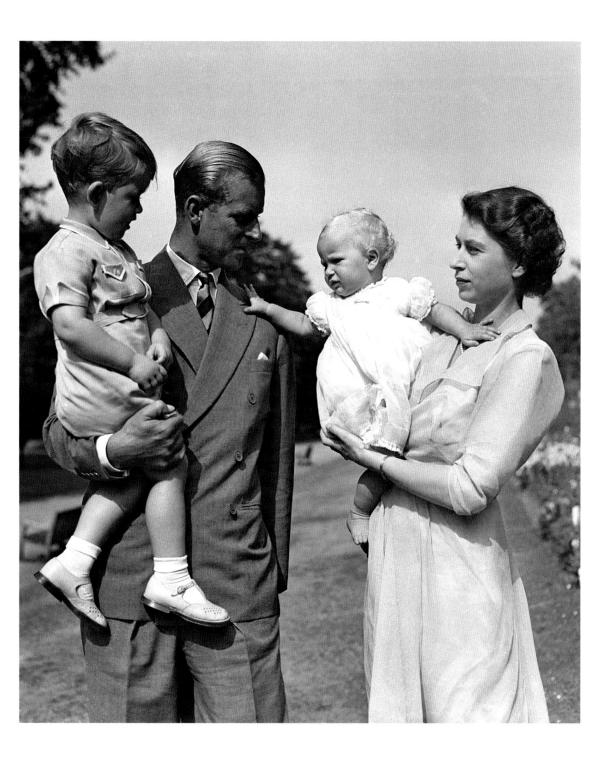

Princess Anne in the arms of Princess Elizabeth
with Prince Philip holding Prince Charles in the grounds
of Clarence House, their London residence.

9 August, 1951

Princess Elizabeth tends to Princess Anne while Lieutenant Colonel Nielson looks on. The family are holidaying in Scotland. 23 August, 1951 ♛

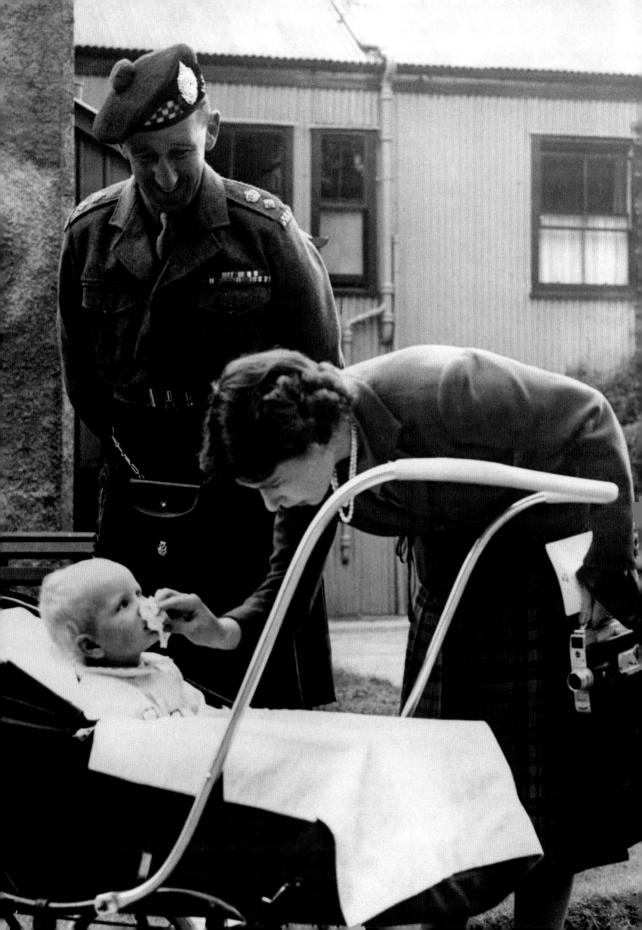

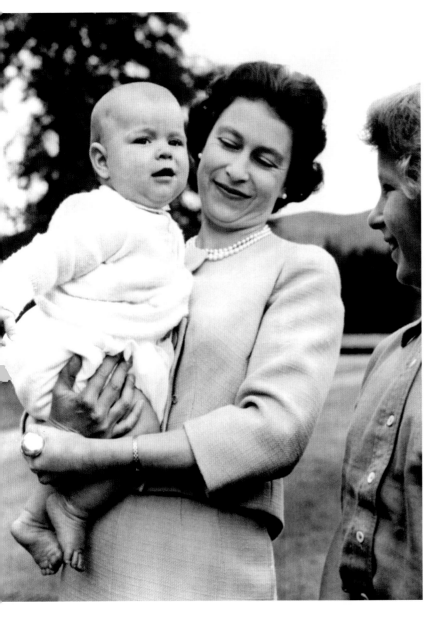

Elizabeth, now
Queen, holds her third
child, Prince Andrew, born
on 19 February, 1960, while
on holiday in Balmoral.
8 September, 1960

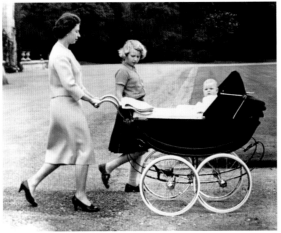

Princess Anne
accompanies her mother
while pushing the baby
Prince Andrew in
his pram.

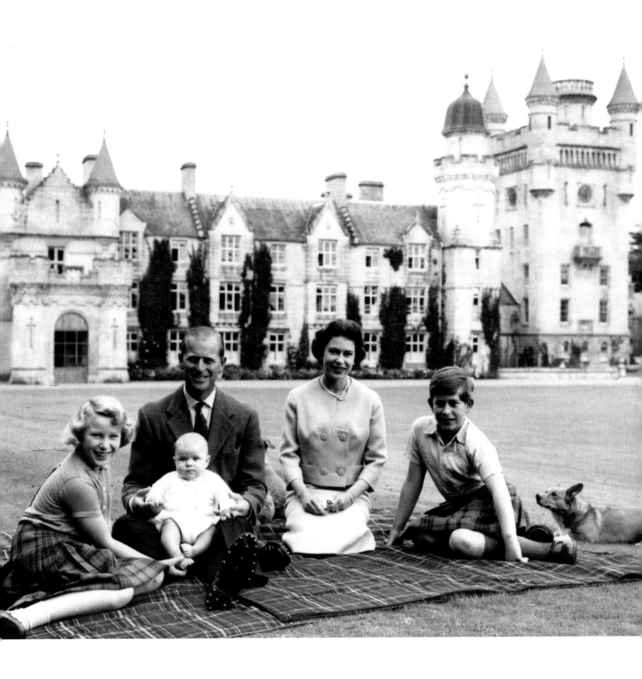

On the lawns at Balmoral: the Queen,
the Duke of Edinburgh and their three
children, Princes Anne, Prince Charles
and baby Andrew. ♛

Prince Edward, the fourth child of the Queen and the
Duke of Edinburgh, born on 10 March, 1964, grips the
finger of his brother, four-year-old Prince Andrew, as the
Queen bends over the baby's crib in the Music Room of
Buckingham Palace. 12 June, 1964

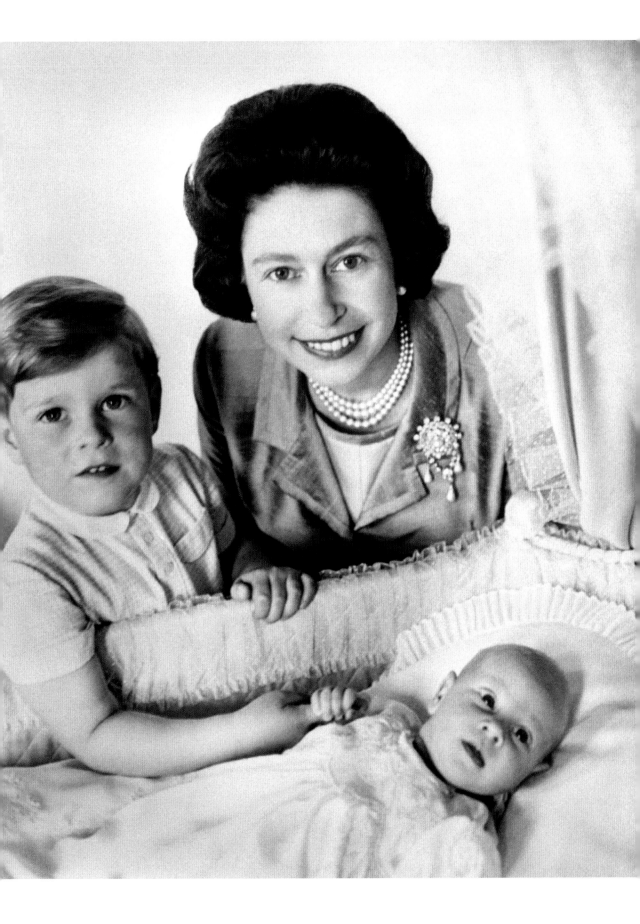

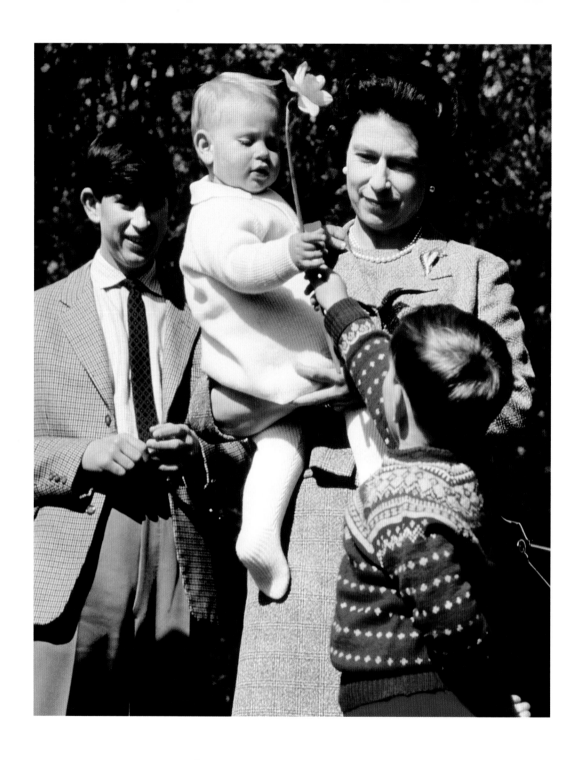

Andrew offers Edward a daffodil while
his elder brother, Charles, looks on. They
are at Windsor for the Queen's 39th
birthday. 21 April, 1965

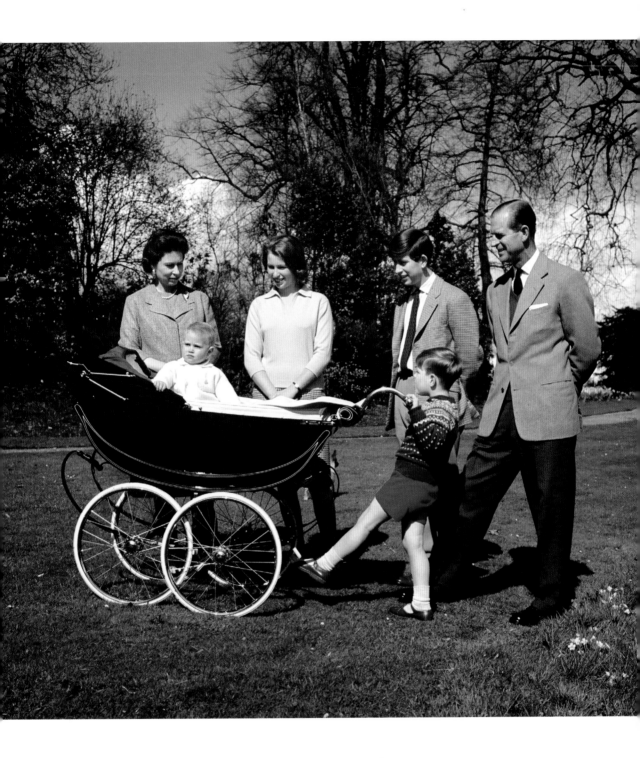

The family all together. ♛

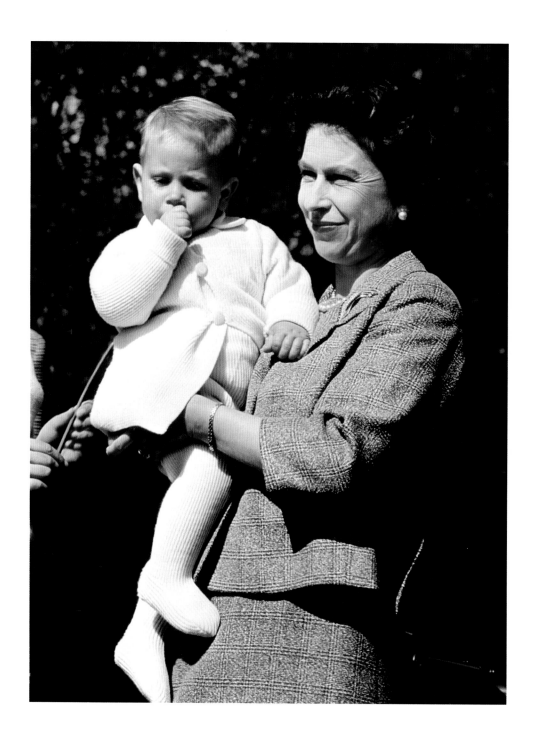

The Queen with
Prince Edward. ♛

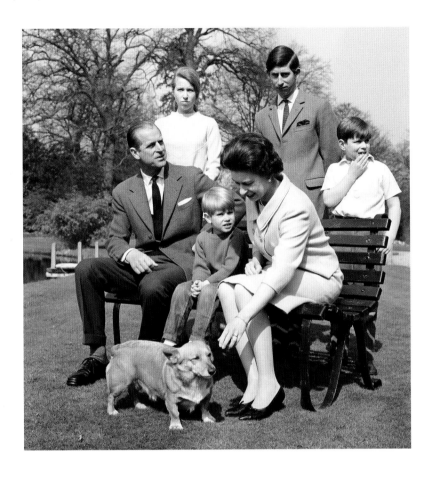

Four-year-old Prince
Edward and the pet corgi
attract the attention of the
Queen as the family poses
for photographs on the
Queen's 42nd birthday at
Windsor Castle.
22 April, 1968 ♛

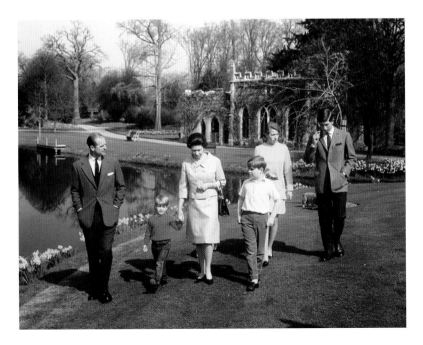

The family strolls in
the grounds. ♛

The Queen explains the details of
Trooping the Colour to Prince Edward at
Buckingham Palace. 1 June, 1972 ♕

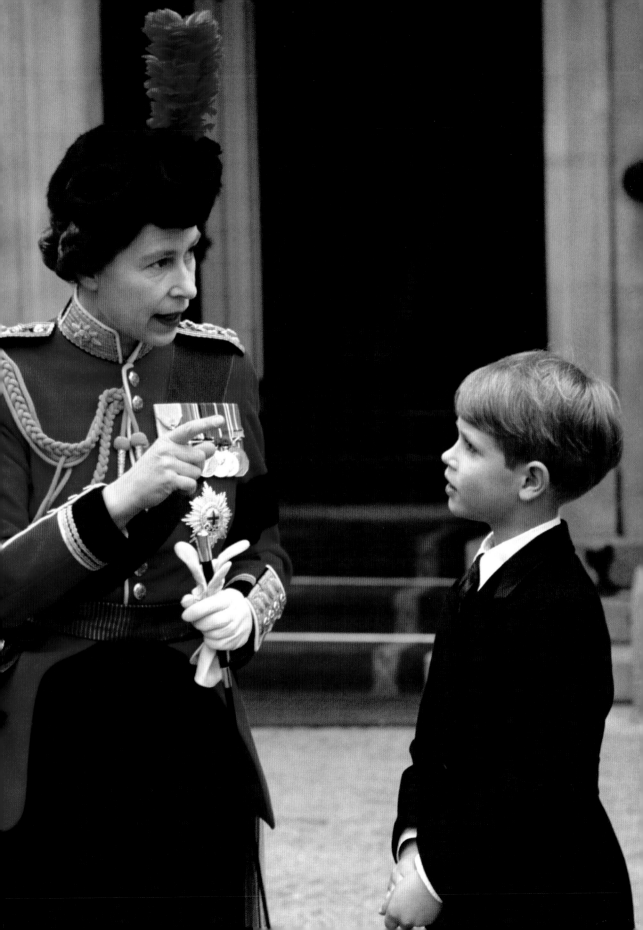

A group photograph of the family at
Balmoral. 1 September, 1979 ♔

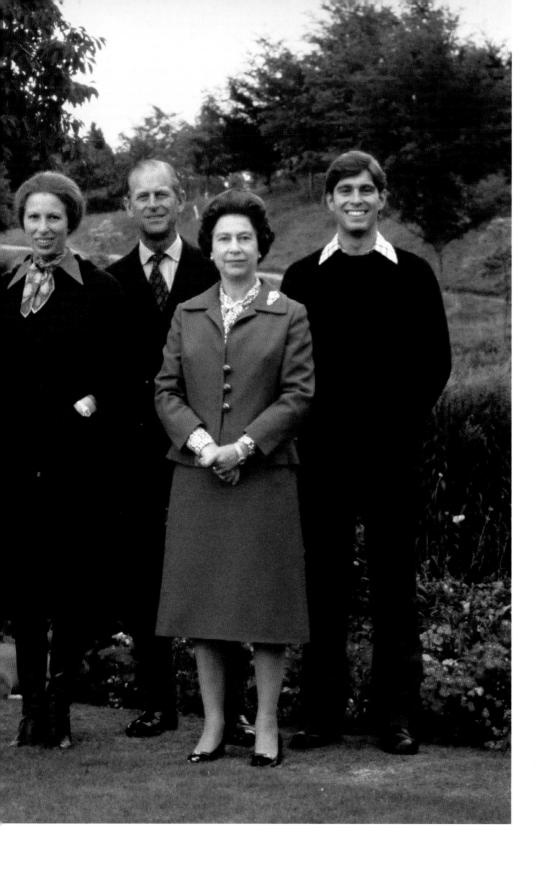

4

Coronation

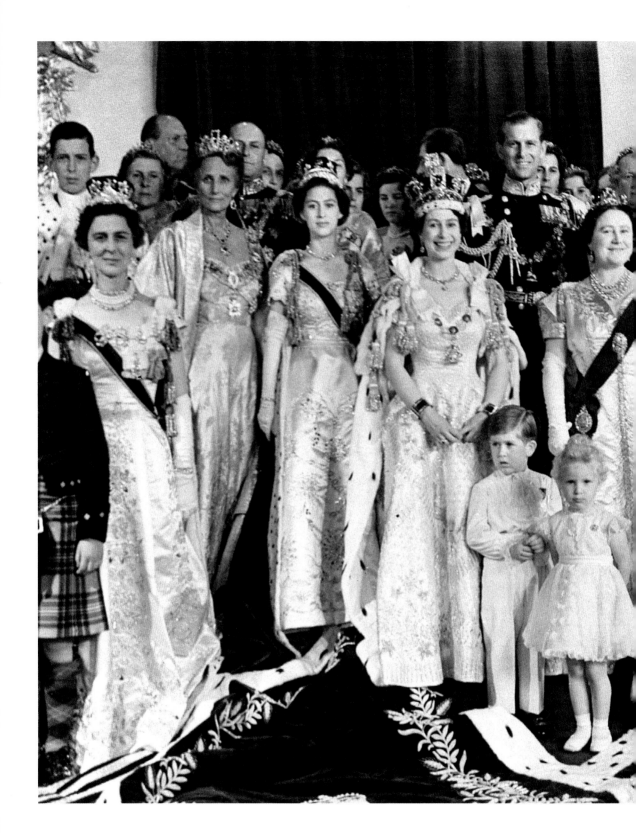

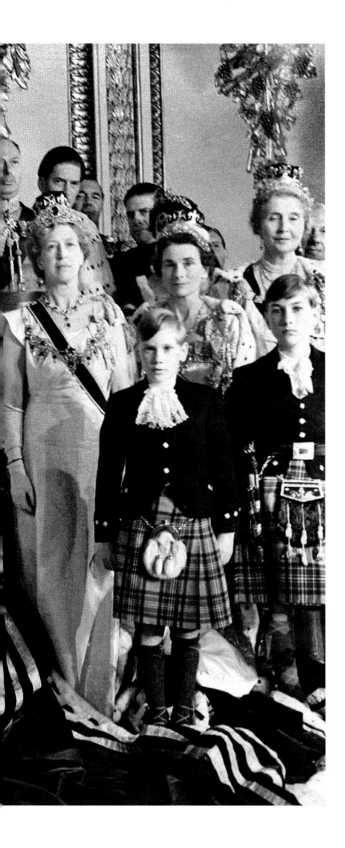

2 June, 1953, the day of
the coronation of
Queen Elizabeth II.

Arriving at
Westminster Abbey. ♔

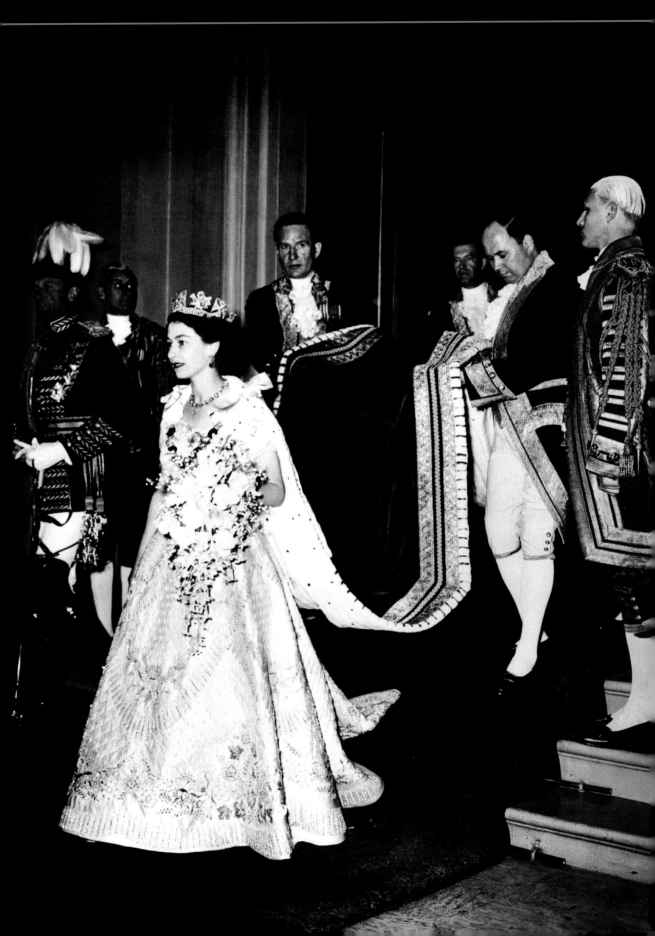

The moment of crowning. ♕

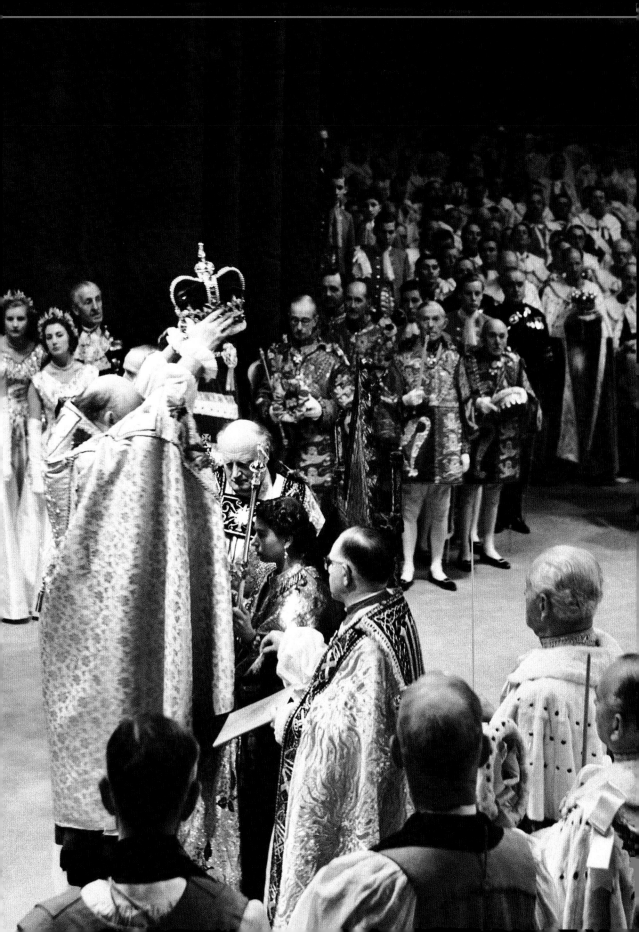

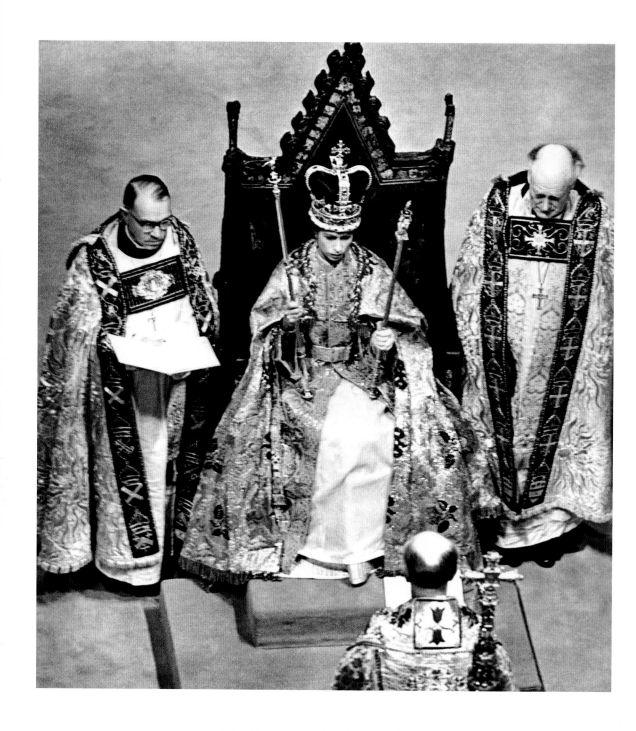

The Queen wearing the St Edward
Crown, and holding the sceptre
and the rod. ♛

The bishops pay

homage to her.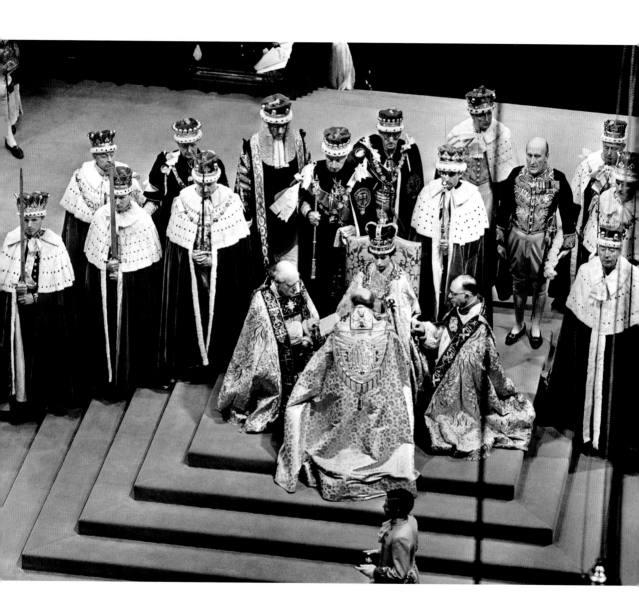

She receives homage from her husband,

the Duke of Edinburgh. ♔

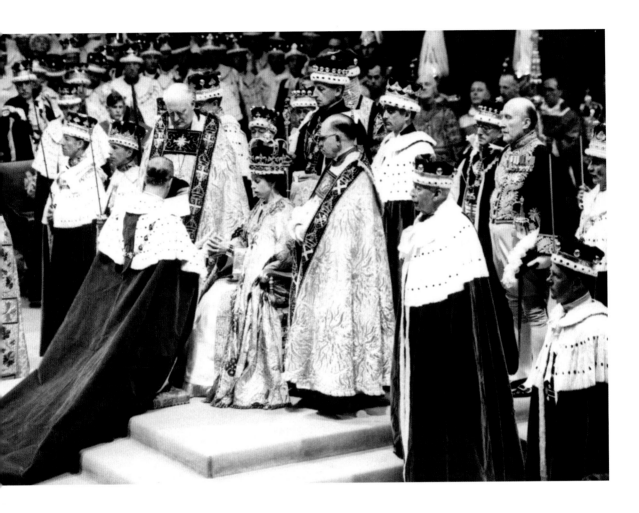

The procession down

the aisle after the coronation. ♔

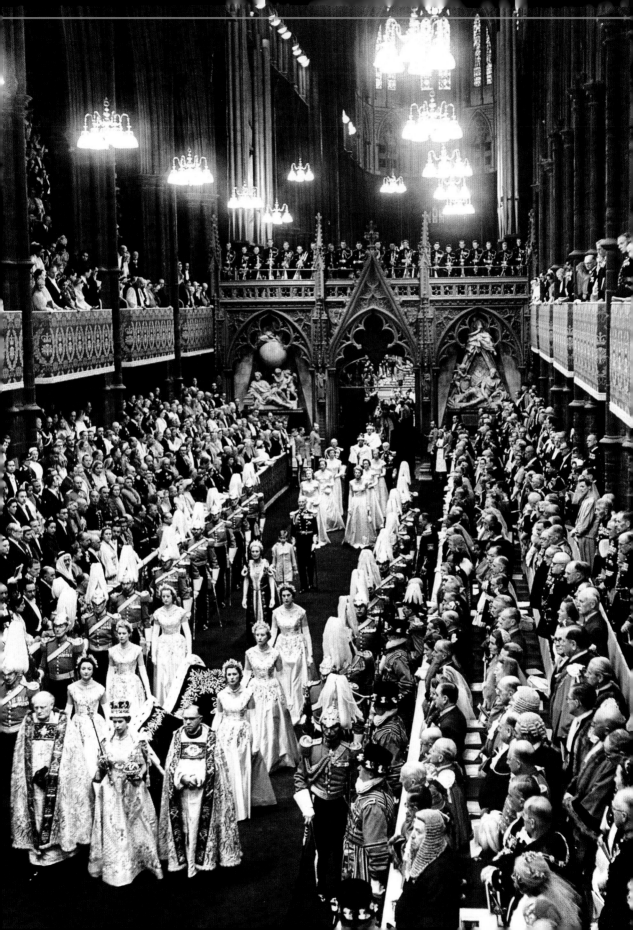

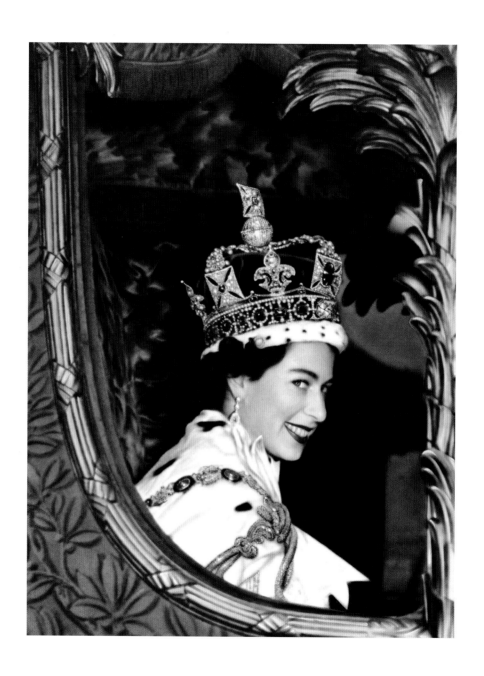

The new Queen smiles as she leaves Westminster Abbey. ♛

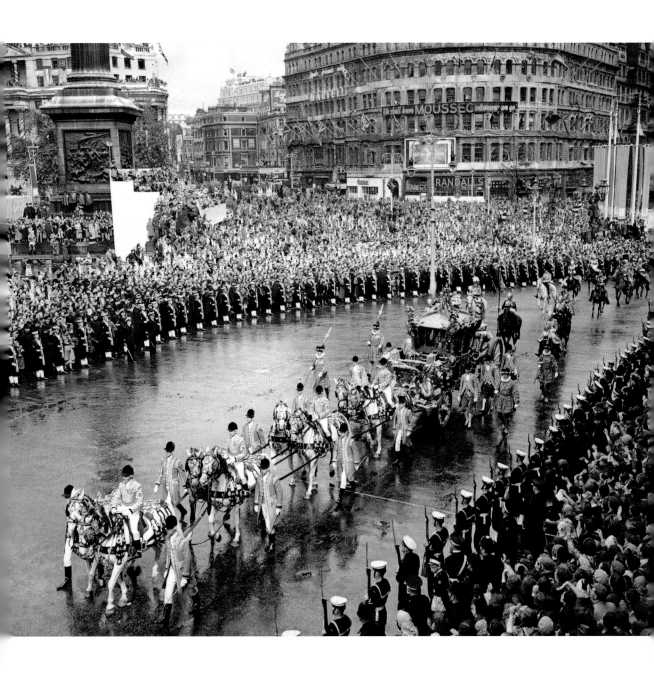

The Gold State Coach, carrying the Queen
and the Duke of Edinburgh, passes through the cheering
crowds that, despite the rain, pack Trafalgar Square to greet
her on her way from Westminster Abbey to Buckingham
Palace after the coronation. 👑

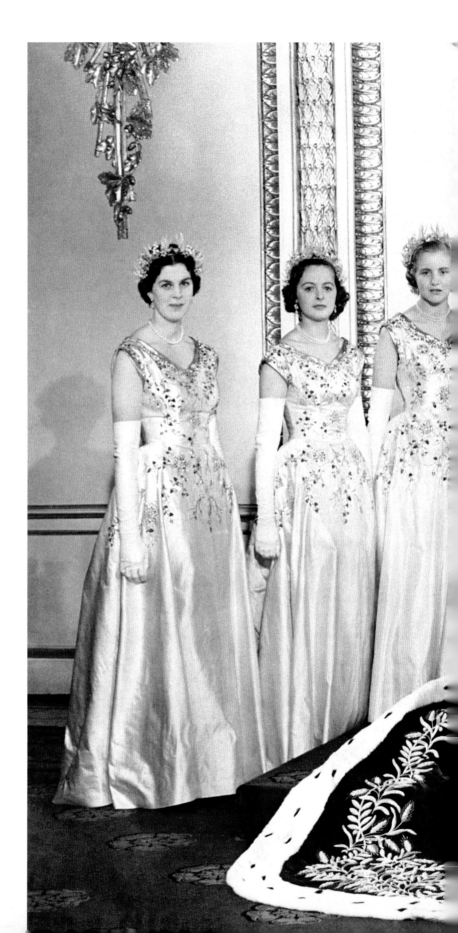

The Queen
with her coronation
maids of honour at
Buckingham Palace.

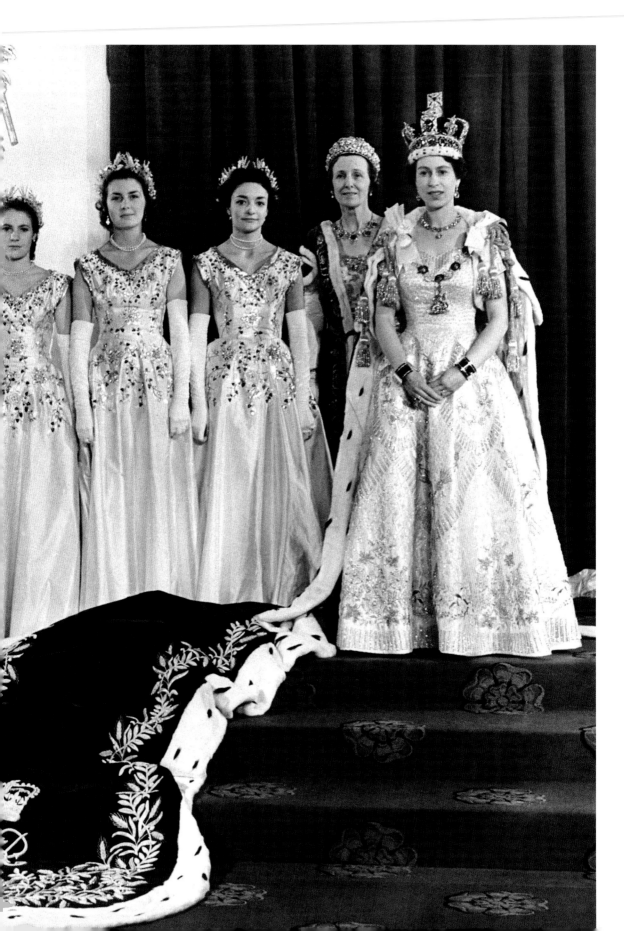

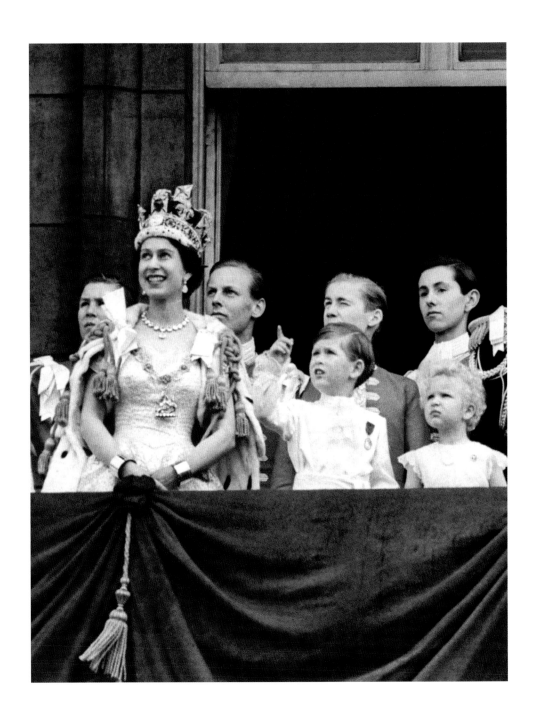

The Queen with Prince Charles and
Princess Anne on the balcony of
Buckingham Palace as 168 jet fighters fly over
in the Royal Air Force salute. ♕

The Queen wearing the Imperial State Crown
and the Duke of Edinburgh in the uniform of Admiral of
the Fleet wave from the balcony to the onlooking crowds.

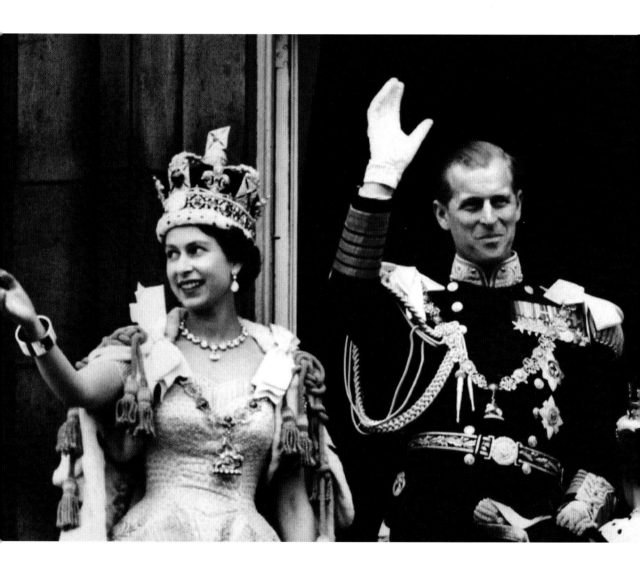

5

The young Queen

Queen Elizabeth II's first
Trooping the Colour as Queen – 5 June, 1952 – before
her official coronation the following year. ♔

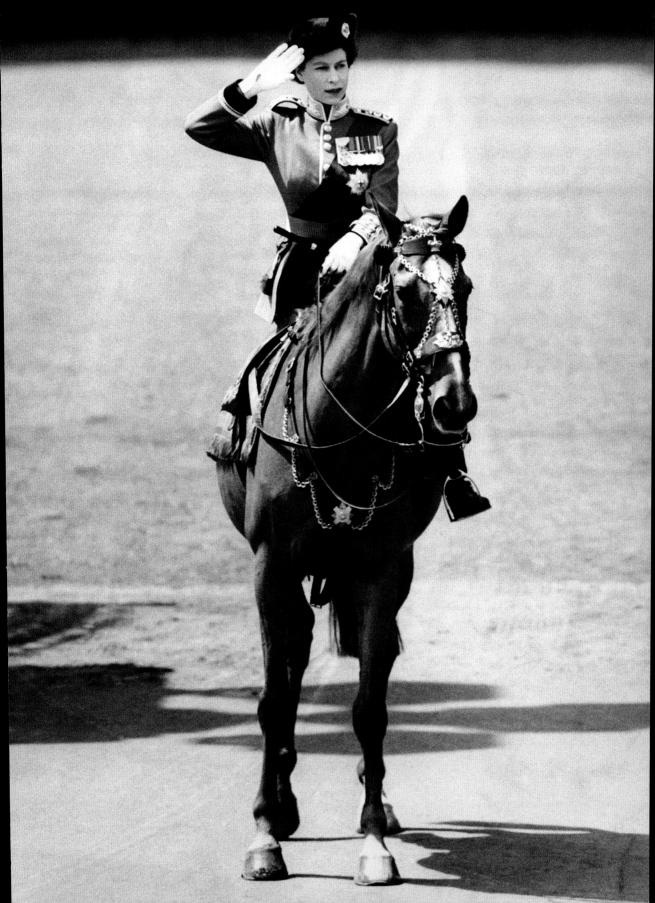

The Queen makes her first Christmas broadcast at Sandringham House. December, 1952

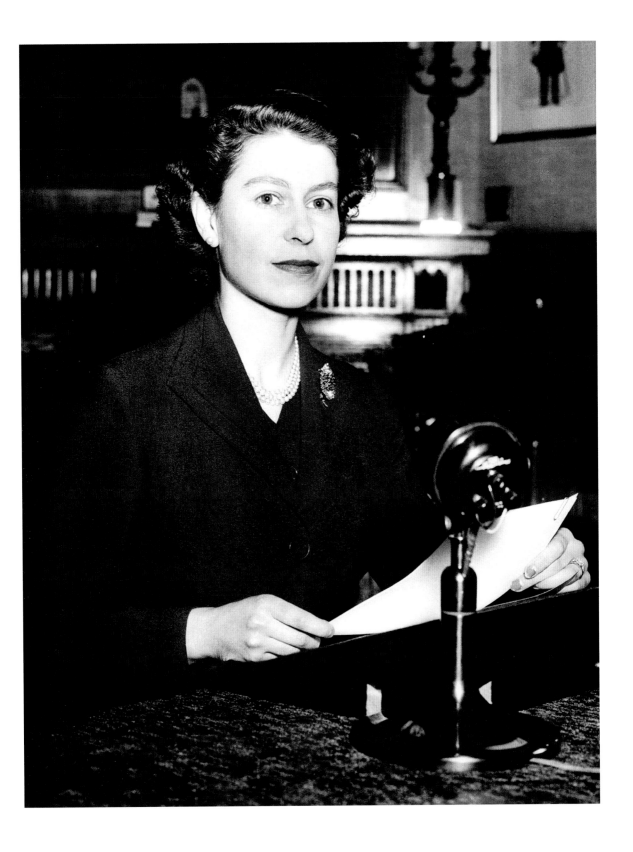

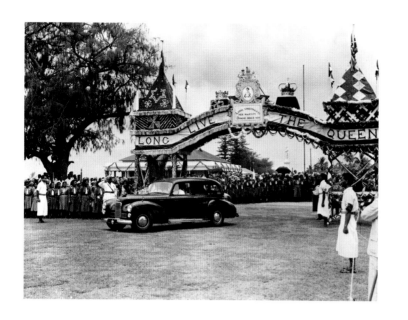

A car of the Royal procession passing through the ornate triumphal arch, part of the decorations for the visit of the Queen and the Duke of Edinburgh to Nukualofa, capital of Queen Salote, on the island of Tonga. 1954 ♛

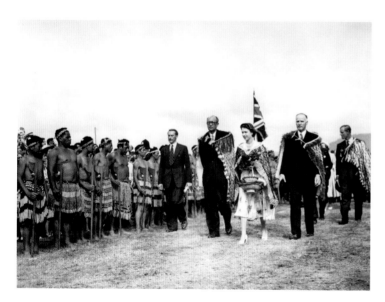

The Queen, wearing the Korowai Cloak, symbol of paramount rank, inspects Maoris at the reception held in her honour in Arawa Park, Rotorua, during the Royal tour of New Zealand. 7 January, 1954 ♛

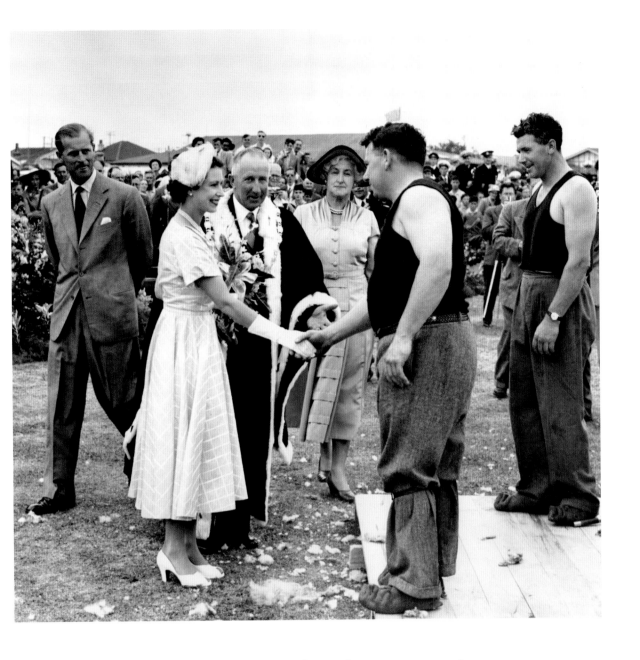

The Duke of Edinburgh watches as the Queen congratulates
world champion sheep shearers, brothers Ivan and Godfrey Bowen,
after they have demonstrated their skill at McLean Park, Napier in
New Zealand during the Royal tour of the Commonwealth.

12 January, 1954 ♛

Crowds of cheering people press forward as the Queen
and the Duke of Edinburgh (*behind*) walk from
the platform erected in the main street back to
the railway station after a reception
in Stratford, New Zealand. 13 January, 1954

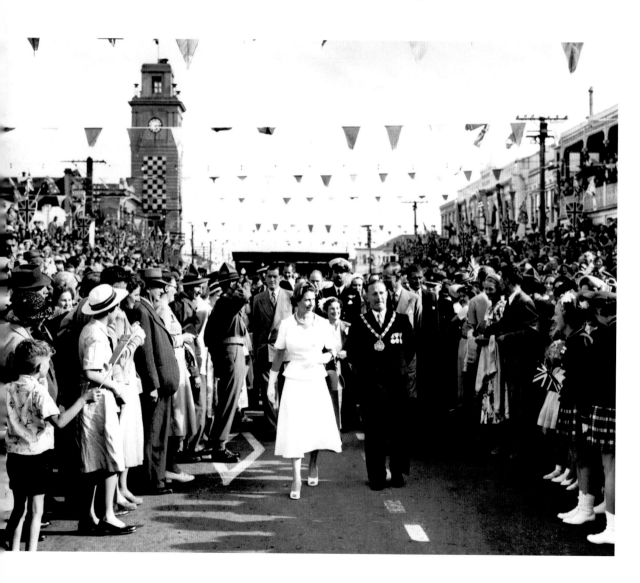

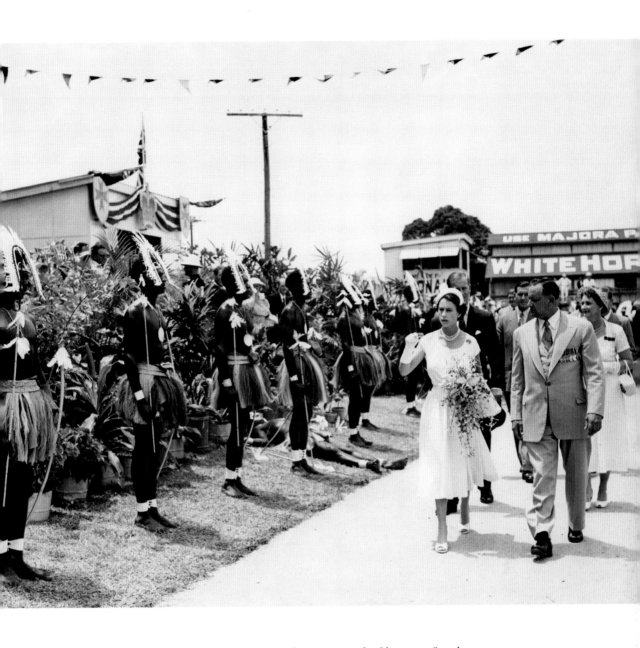

Torres Strait Islanders form a guard of honour for the
Queen as she arrives at Cairns, Queensland in Australia
during the Royal Tour. 20 March, 1954 ♕

The Queen and Duke of Edinburgh with the ship's
company during an official visit to HMAS *Australia*,
flagship of the Royal Australian Navy, during their visit to
Cairns, Queensland. 20 March, 1954

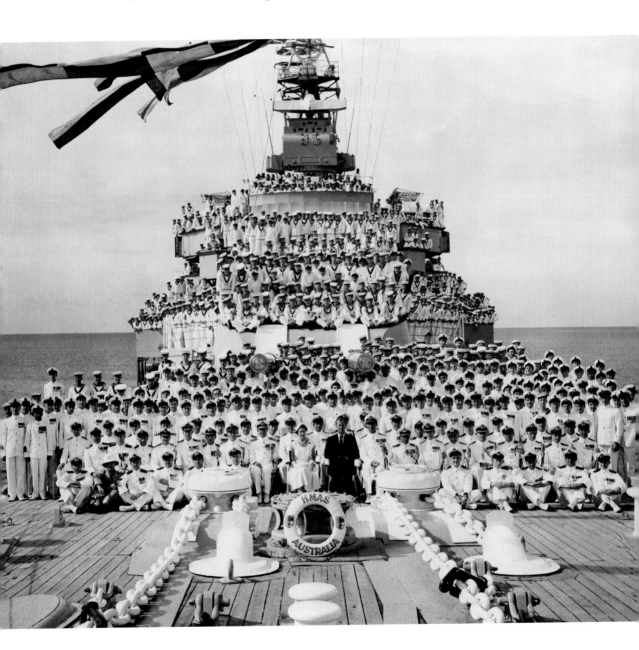

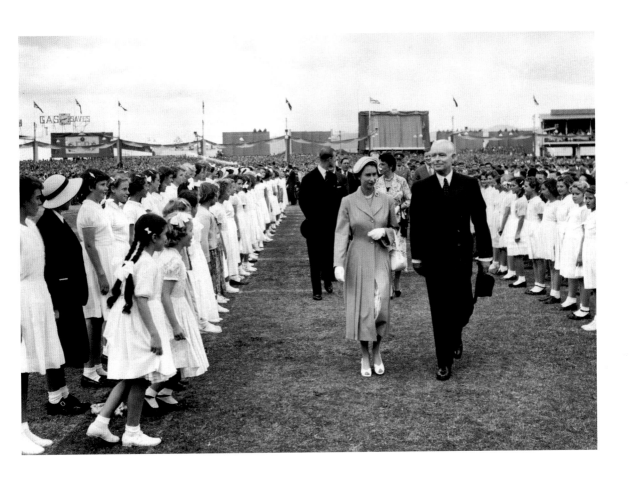

Children curtsey to the Queen as she walks through the
guard of honour at Wayside Oval, the
Adelaide cricket ground, South Australia. The rally was
the largest of its kind staged during the Royal Tour.
29 March, 1954

The Queen and Queen Mother watch the parade before
the Epsom Derby is run. 2 June, 1954 ♛

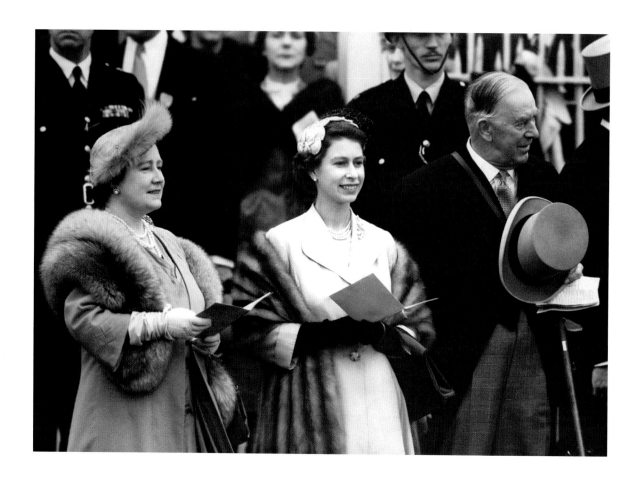

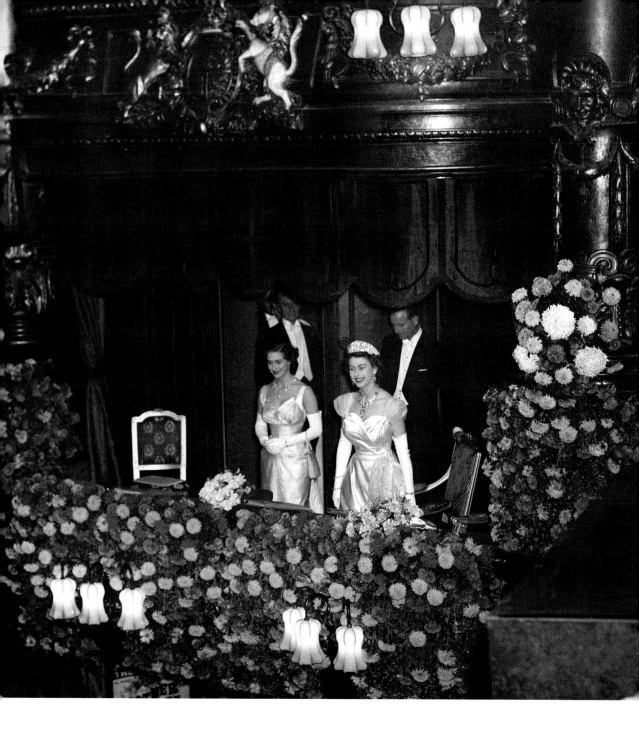

The Queen and Princess Margaret, with the
Duke of Edinburgh, take their seats in the Royal box for
a Royal Variety Performance at the London Palladium.

November, 1954

Watched by Lady Churchill, Prime Minister
Sir Winston Churchill bows to the Queen as
he welcomes her and the Duke of Edinburgh to
10 Downing Street for dinner. 4 April 1955 ♛

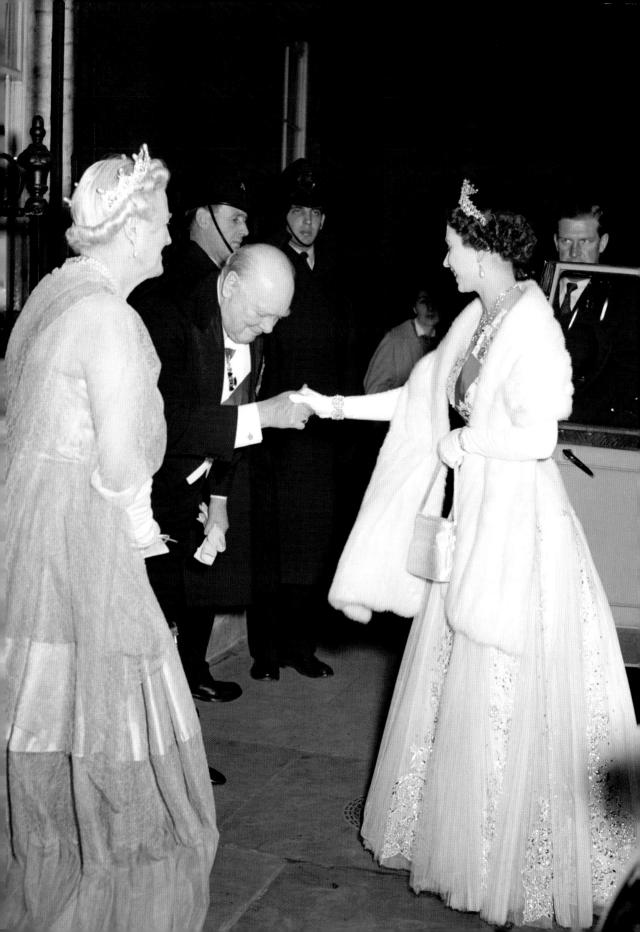

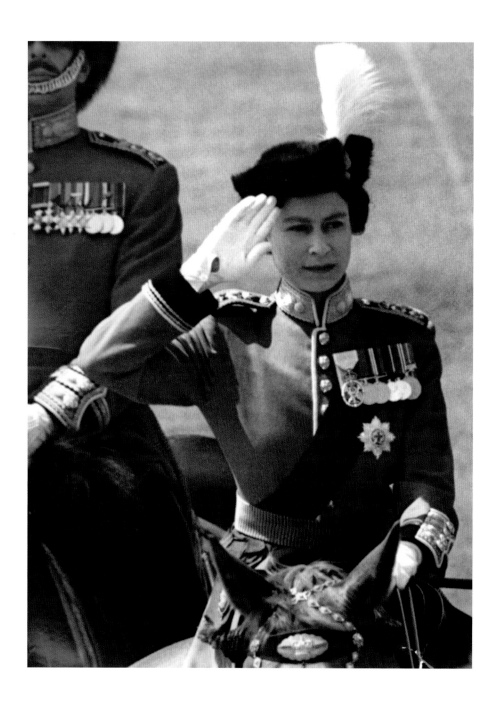

The Queen, wearing her uniform as Colonel-in-Chief
of the Grenadier Guards, takes the salute at the gates
of Buckingham Palace as the Guards march past on
her return from the Trooping the Colour ceremony
at Horse Guards Parade. 31 May, 1956 ♔

The Queen shakes hands with
Hollywood star
Mario Lanza when artists
taking part in the Royal
Variety Performance are
presented to her at the
London Palladium.
18 November, 1957 ♕

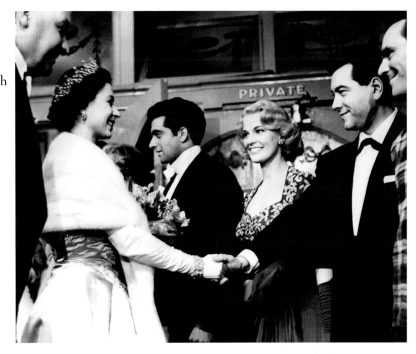

The Queen, speaking
in French, responds to
the toast made by French
President René Coty (*centre*)
at a dinner held at the
Elysée Palace, Paris,
on the first day of a
four-day state visit.
9 April, 1957 ♕

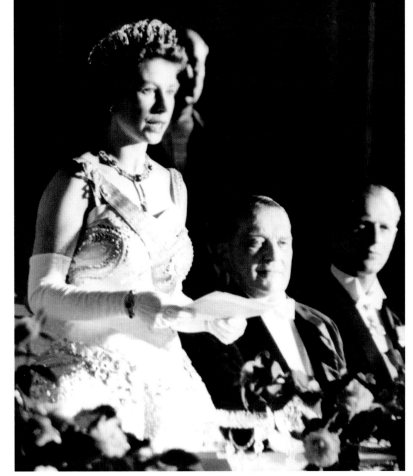

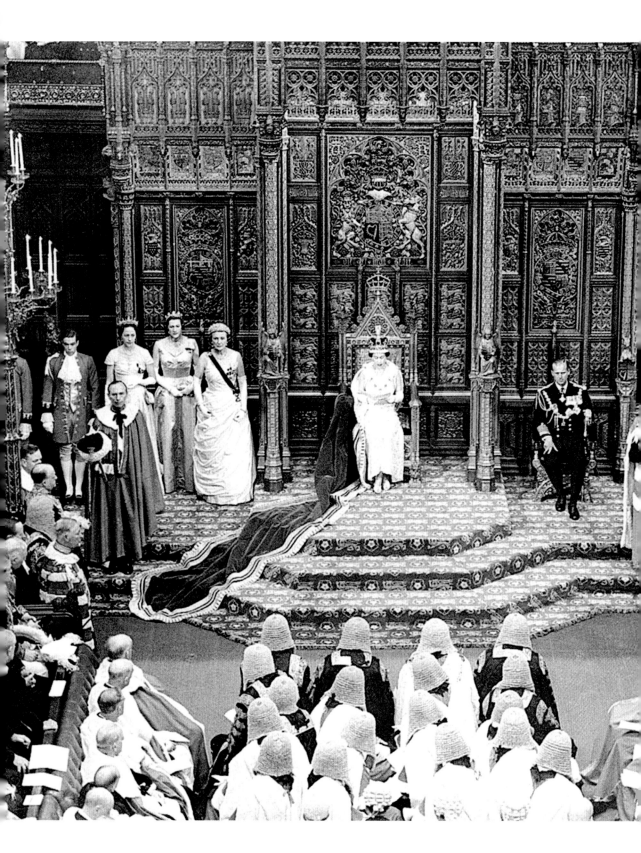

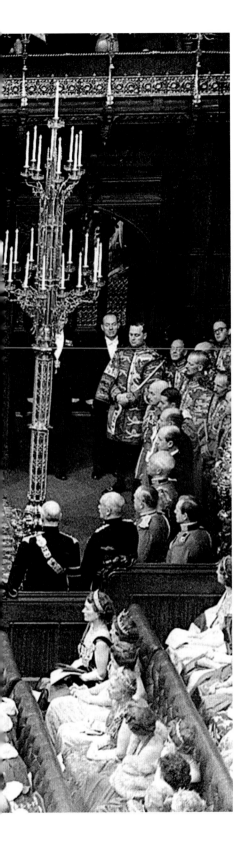

For the first time in history, the Sovereign is photographed reading the speech from the throne in the House of Lords chamber during the State Opening of Parliament. The ceremony is also being televised for the first time. The Queen is wearing the Royal robes and the Imperial crown. To the right is the Duke of Edinburgh, wearing the uniform of the Admiral of the Fleet. 28 October, 1958

The Queen and Princess Margaret make a fuss of the
Queen's colt, Restoration, in the unsaddling enclosure
after he won the King Edward VII Stakes at
Royal Ascot. 19 June, 1958

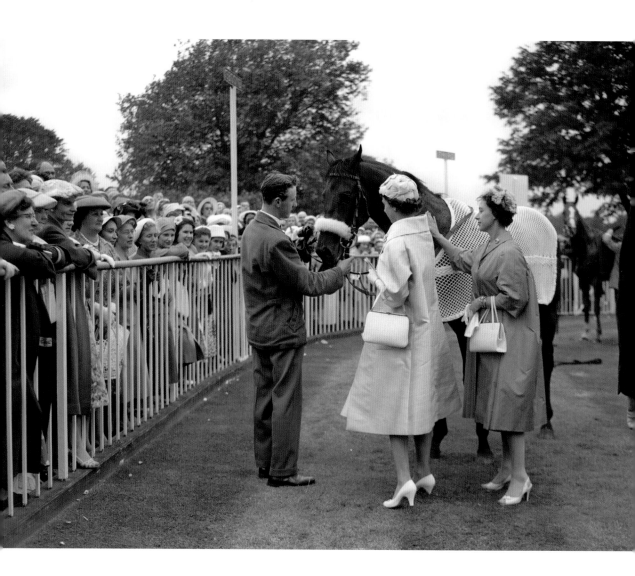

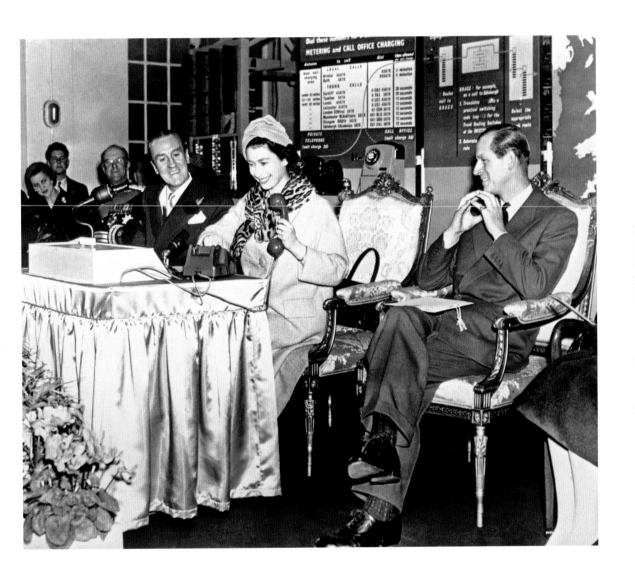

The Queen makes the first subscriber trunk dialled telephone
call from the Bristol Telephone Exchange. 5 December, 1958

The Shah of Iran rides in an open carriage
with the Queen and the Duke of Edinburgh,
to Buckingham Palace from Victoria railway
station, London. 5 May, 1959

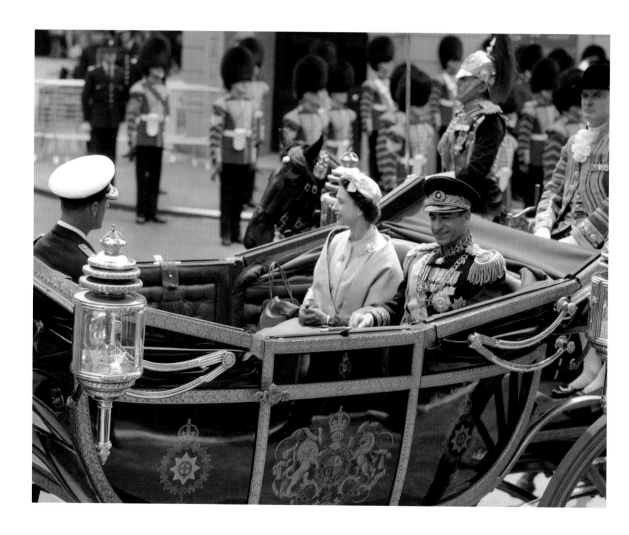

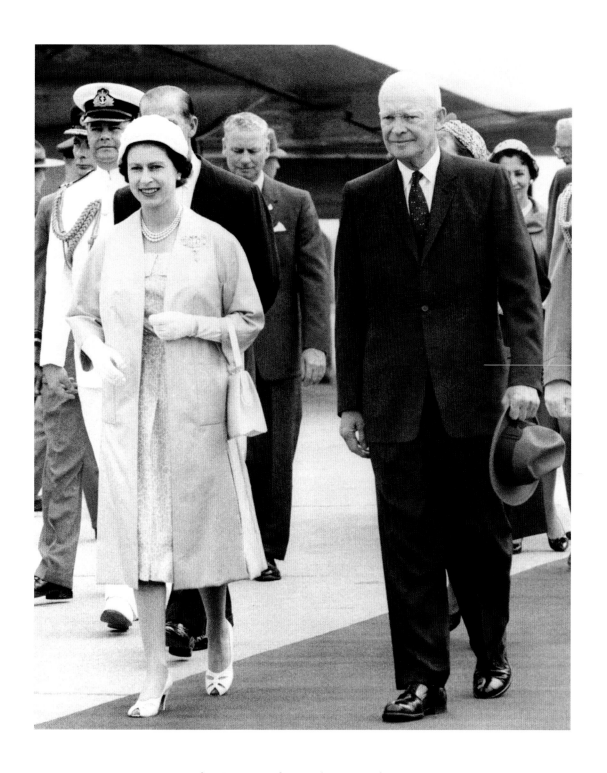

The Queen and President Eisenhower
of America leaving the airport at
St Hubert, Quebec, Canada. 29 June, 1959 👑

The Queen at her desk in Buckingham Palace
with her corgi, Susan. 25 January, 1959 ♔

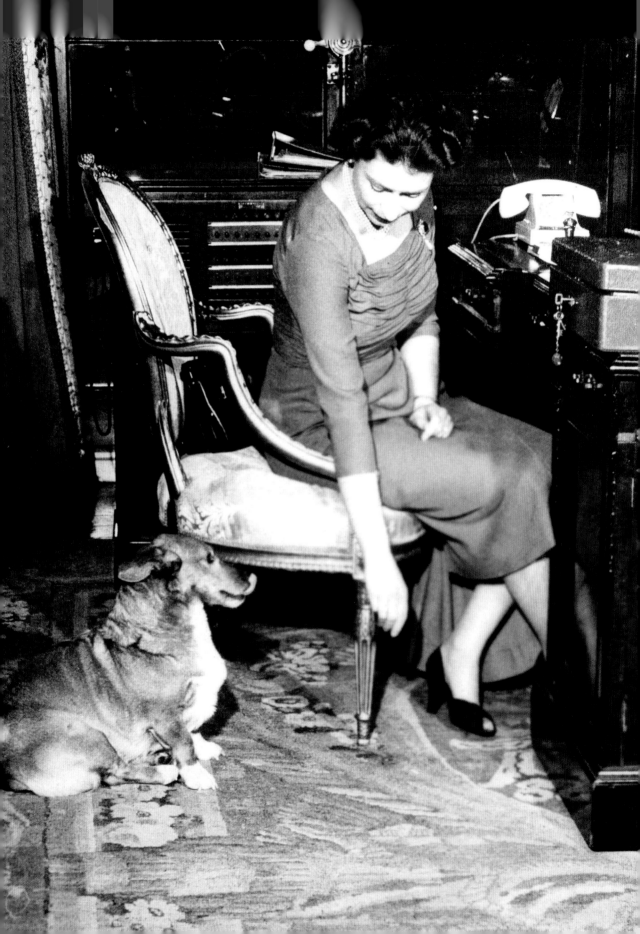

6

Off duty

127

OFF DUTY

Prince Charles, watched by the Queen, feeds a pony
during a break in the polo tournament in which
the Duke of Edinburgh is playing at Smith's Lawn
in Windsor Great Park. 13 May, 1956

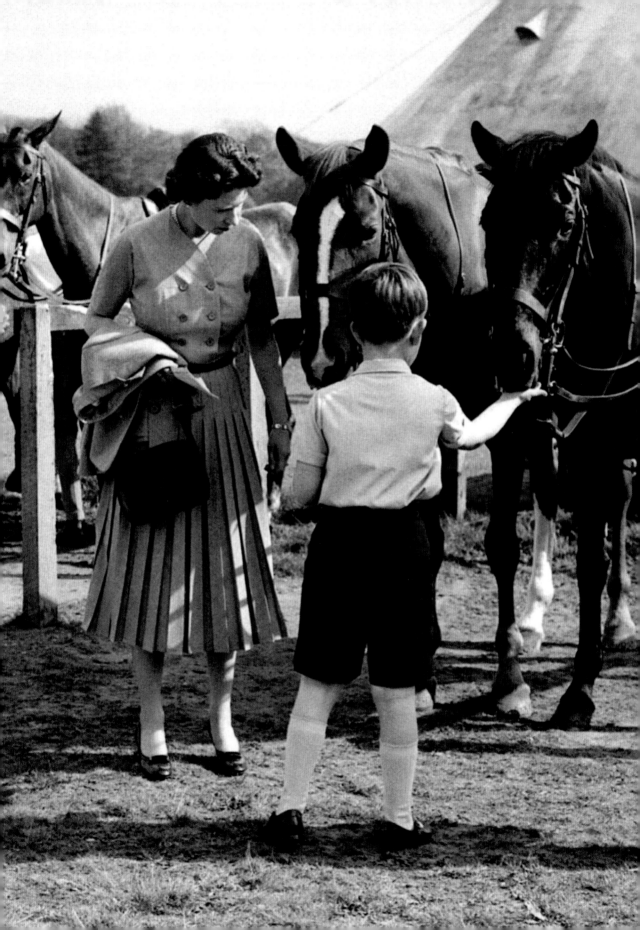

The Queen leads her Oaks winner, Carrozza,
with Lester Piggott in the saddle at Epsom.
7 October, 1957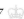

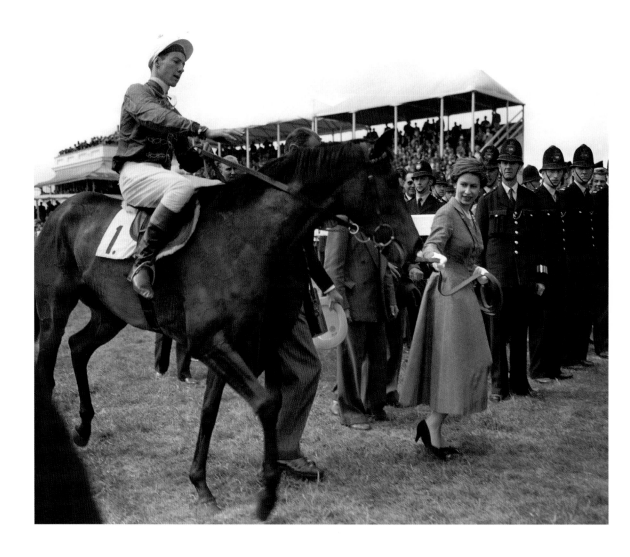

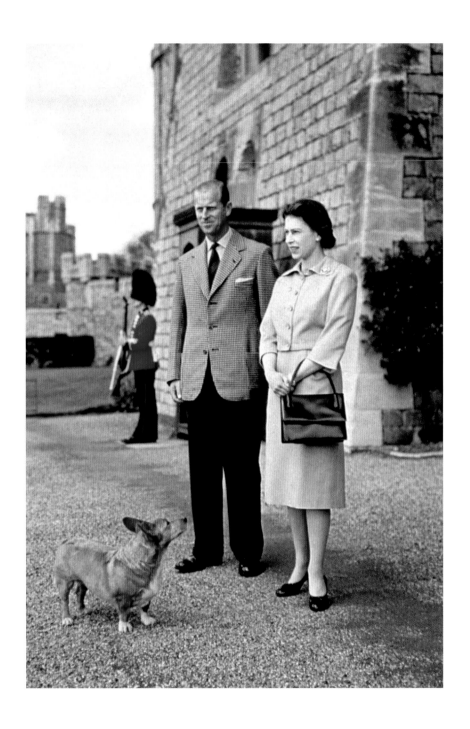

The Queen and Duke of Edinburgh
at Windsor. 1959

The Queen with her four corgis as she arrives at
Liverpool Street Station on her return from Sandringham
with the Duke of Edinburgh. 8 February, 1968 ♛

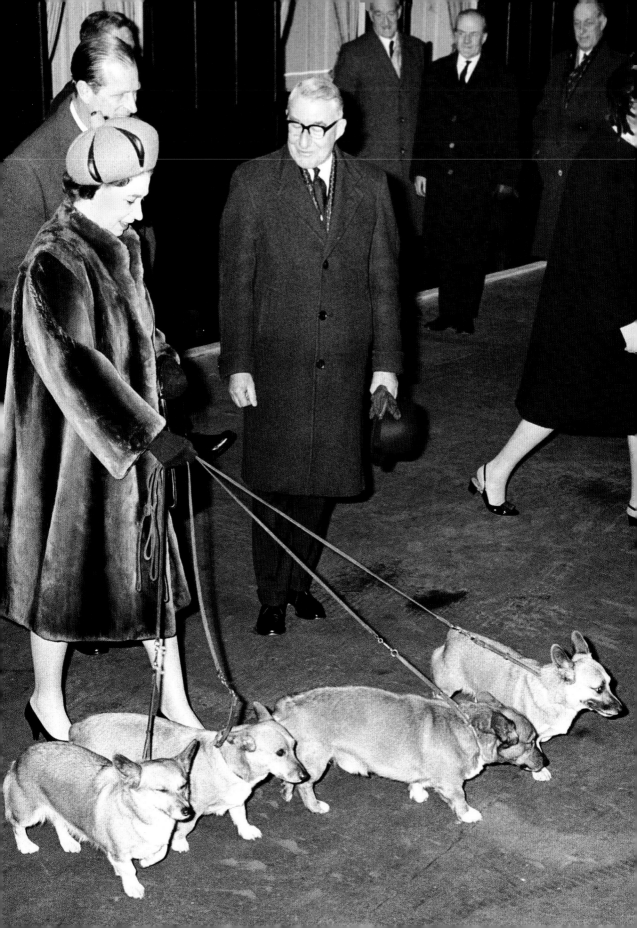

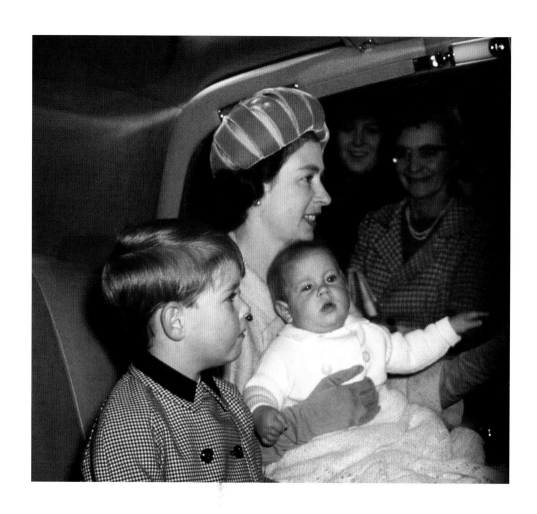

The Queen with Prince Andrew and Prince Edward
drive from Euston Station on their return to London from
Balmoral. 5 October, 1964 👑

The Queen and the Duke of Edinburgh are joined
by the Duke of Beaufort and Prince Edward as they
watch the cross-country course from a farm cart at
the Badminton Horse Trials. 21 April, 1973 👑

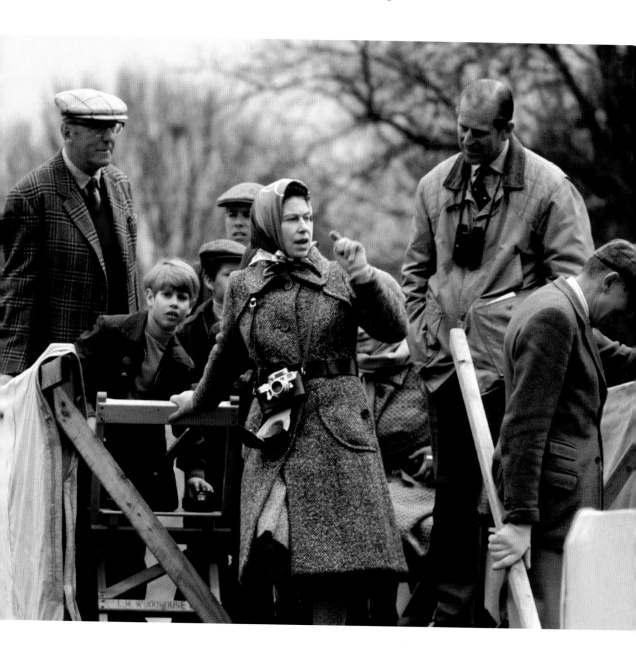

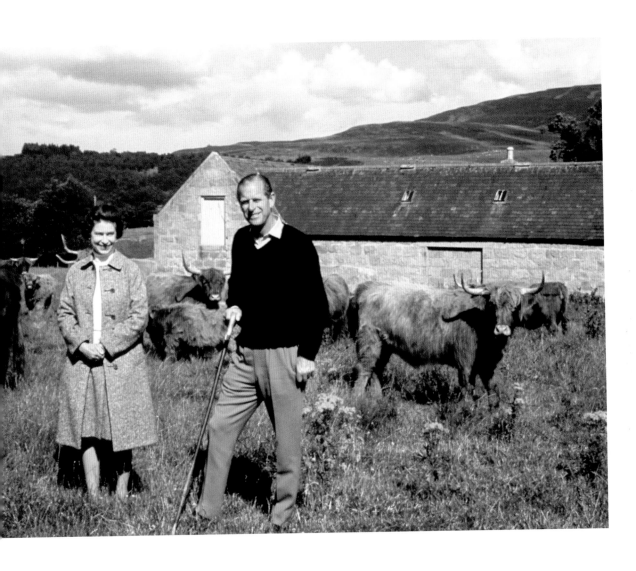

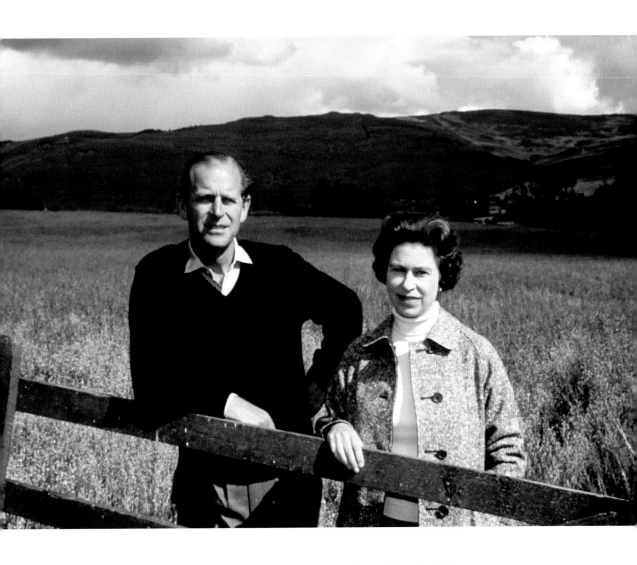

Above and above left: The Queen and the Duke of Edinburgh
visit a farm on the Balmoral estate during their stay to
celebrate their silver wedding anniversary.
1 September, 1972 ♛

The Queen and Prince Andrew, followed by
the Duke of Edinburgh and Prince Edward, walk their dogs
in the grounds of Balmoral Castle. 5 September, 1972 ♔

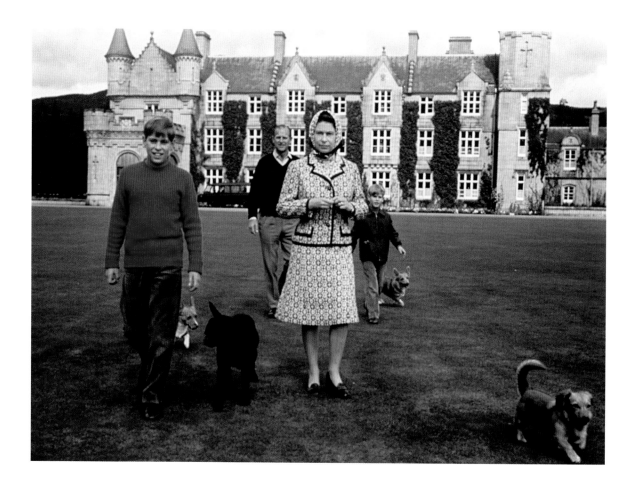

The Queen and the Duke of Edinburgh during their
traditional summer break at Balmoral Castle.
26 September, 1976 ♔

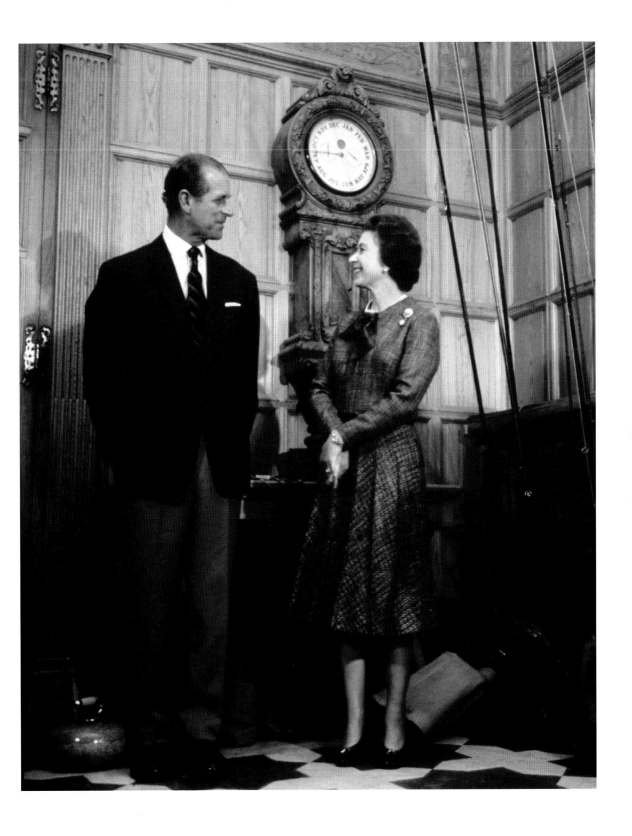

The Queen with her corgis walking
the Cross Country course during the second day
of the Windsor Horse Trials. 17 May, 1980 ♔

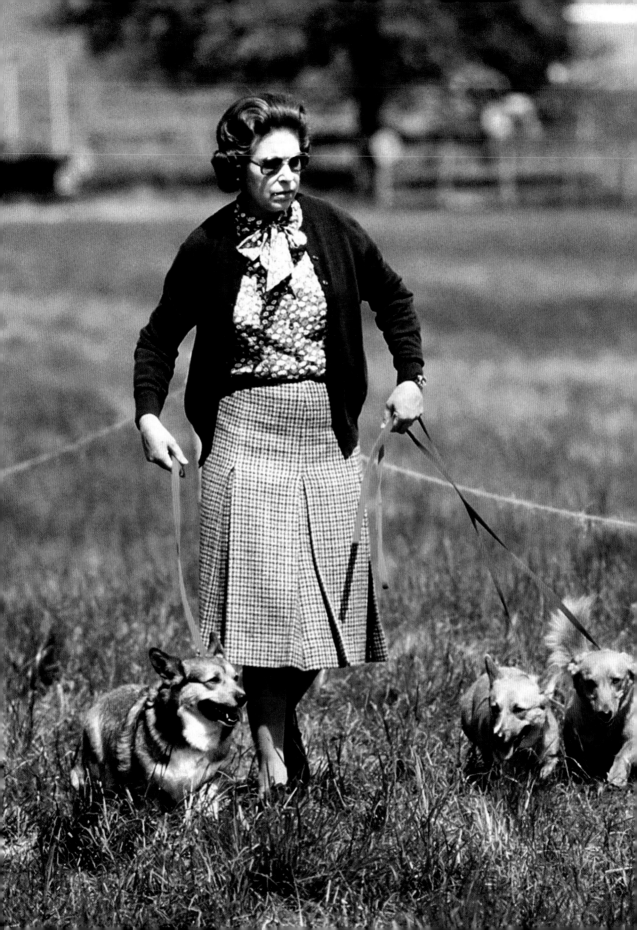

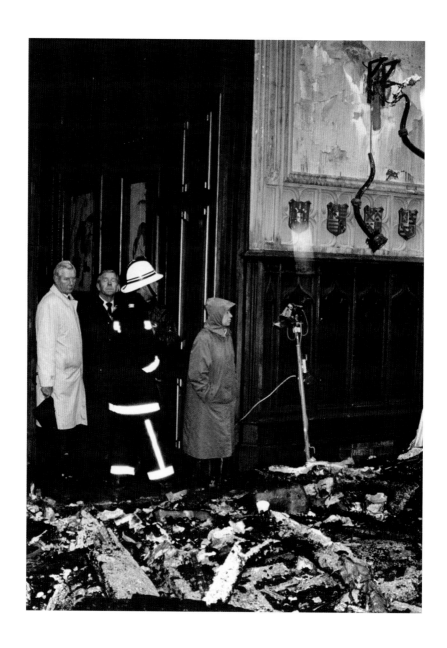

The Queen surveys the damage caused by fire
at Windsor Castle. 21 November, 1992 ♕

The Queen with the Duke of York (*left*) and
Prince Edward wave from on board the Royal yacht
Britannia as they leave Portsmouth at the start of their
cruise through the Western Isles. 7 August 1991 👑

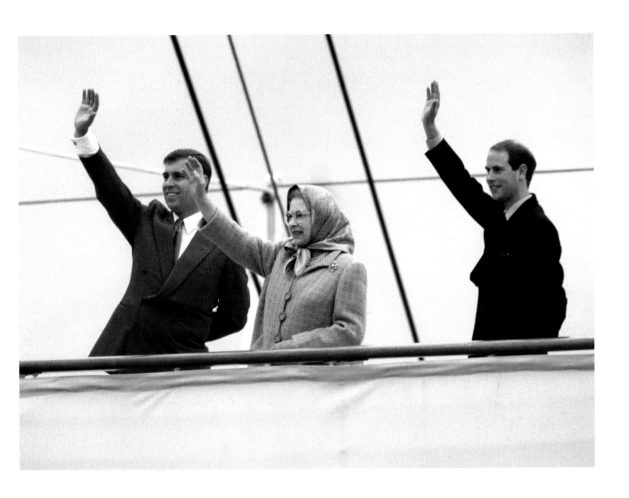

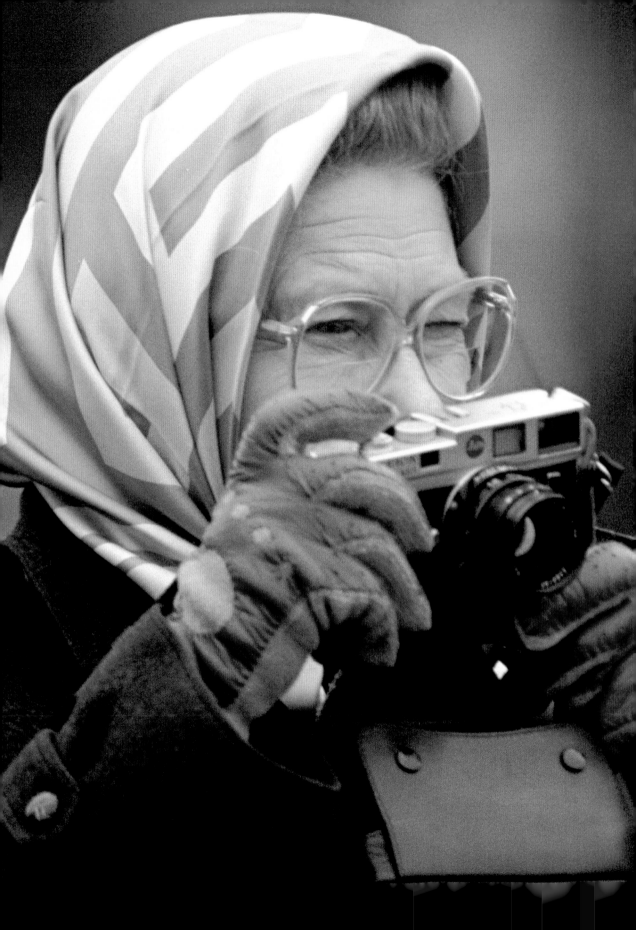

The Queen keeps a close eye on a barn owl that has
landed close by her as she watches a display of birds of
prey during the Royal Windsor Horse Show. ♛

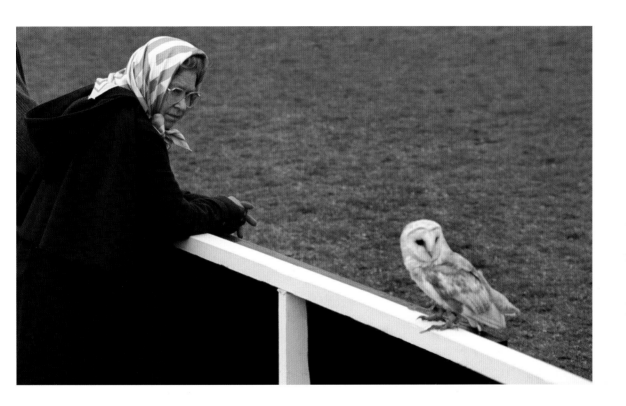

The Queen, a keen photographer, uses a Leica camera
to take a photograph of the Duke of Edinburgh as
he competes in the Dressage of the Carriage Driving
Championships at the Royal Windsor Horse Show.
12 May, 1995 ♛

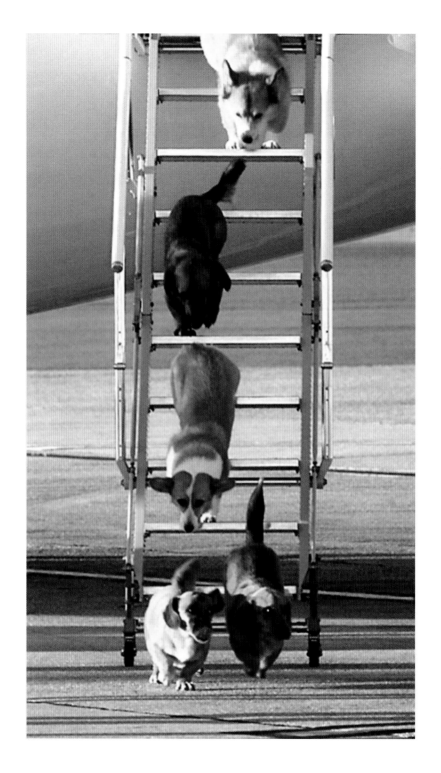

The Queen's corgis arrive at Heathrow after
flying back from Balmoral with her. ♛

The Queen encounters an old acquaintance –
a corgi bred by her. 20 May, 1998 ♔

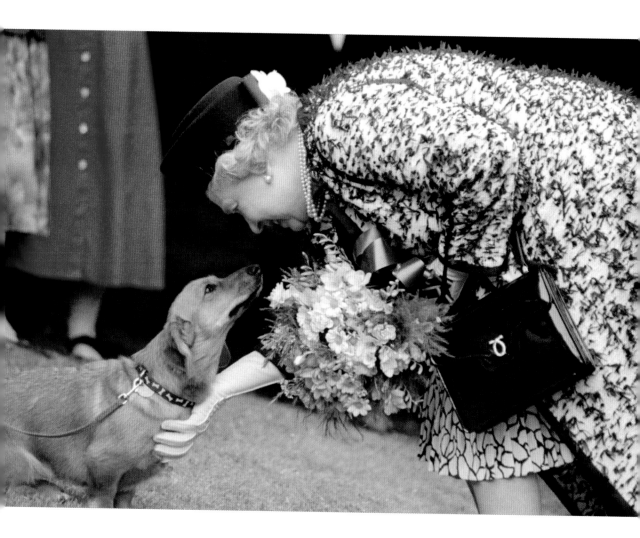

The Queen chats to the Queen Mother on the balcony at Epsom, prior to the running of the 219th Derby. 6 June, 1998 ♔

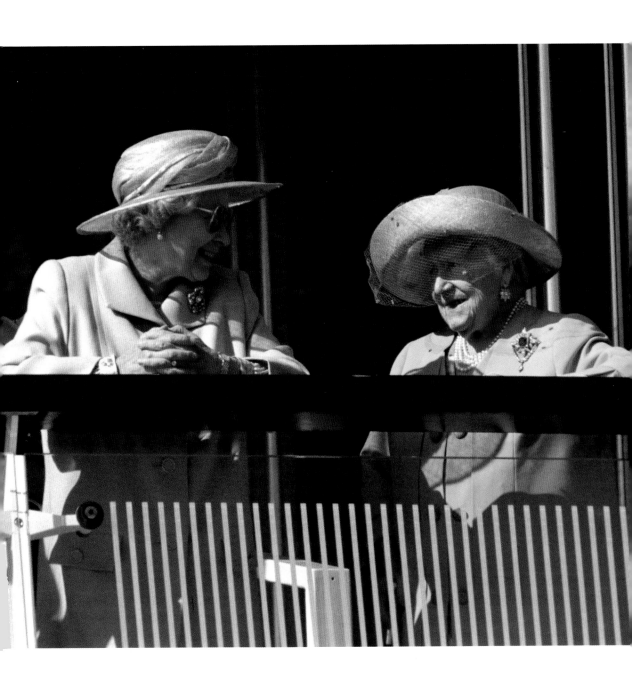

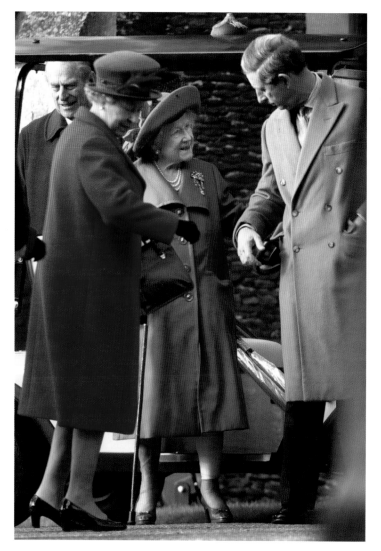

The Queen and her mother,
accompanied by Prince Charles
and the Duke of Edinburgh after
a Christmas Day church service at
St Mary Magdalene Church
at Sandringham.
25 December, 2000 ♛

The Queen at
Balmoral Castle.
11 August, 2000 ♔

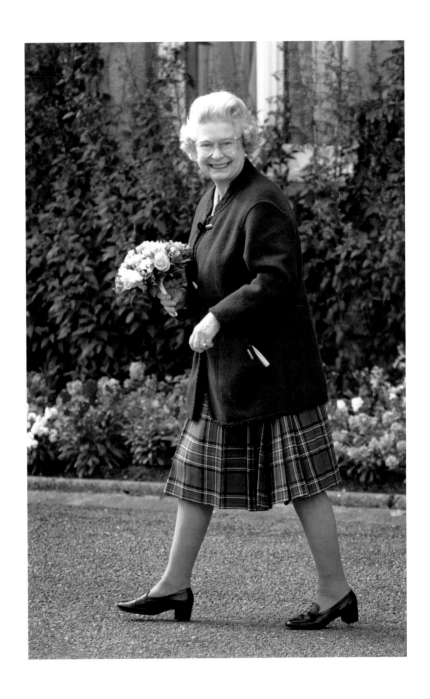

The Queen and her family celebrate the 101st birthday of the Queen Mother at Clarence House. 4 August, 2001 ♛

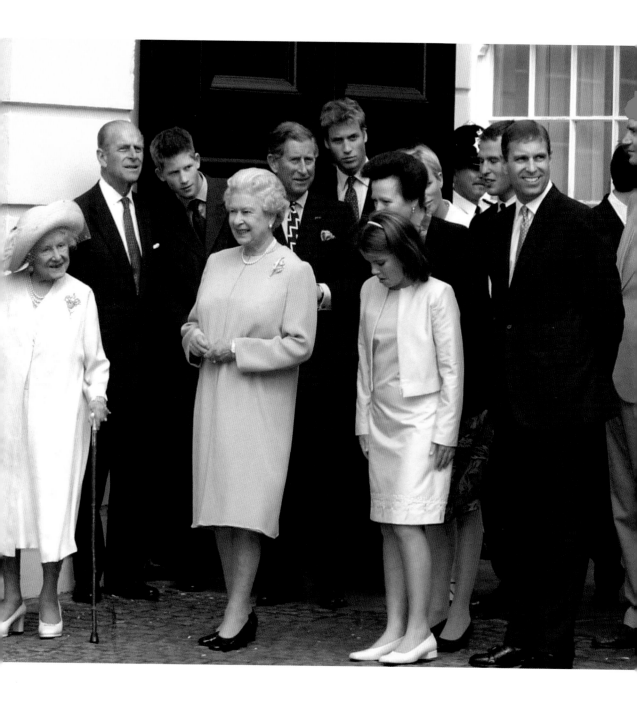

The Queen, the Duke of Edinburgh and Prince Charles
watch the Braemar Highland Games. 4 September, 2004

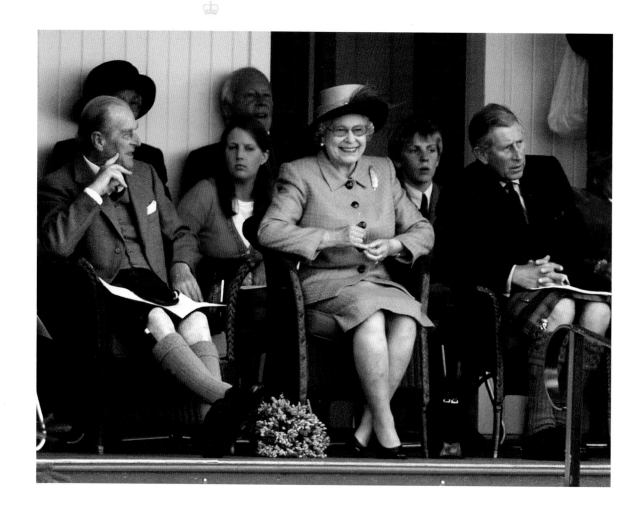

The Queen arrives to embark on the *Hebridean
Princess* at Port Ellen on Islay for a week-long cruise
around the Western Isles with her family to celebrate her
80th birthday. 21 July 2006

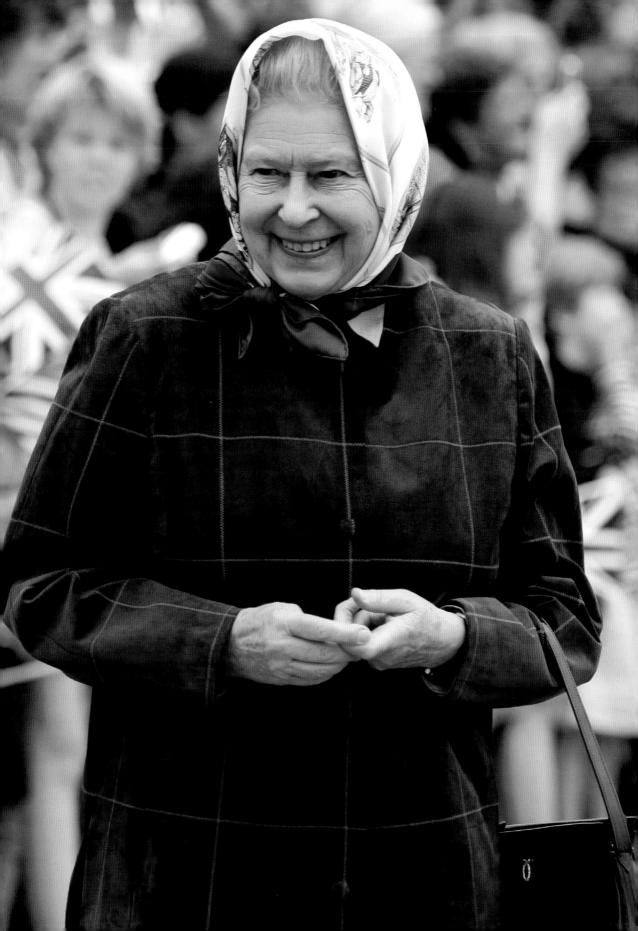

7

A Silver Jubilee

Earl Mountbatten joins the Queen and the Duke of Edinburgh as they wave to the crowds from the balcony at Buckingham Palace after the Queen's Silver Jubilee procession. *7 June, 1977*

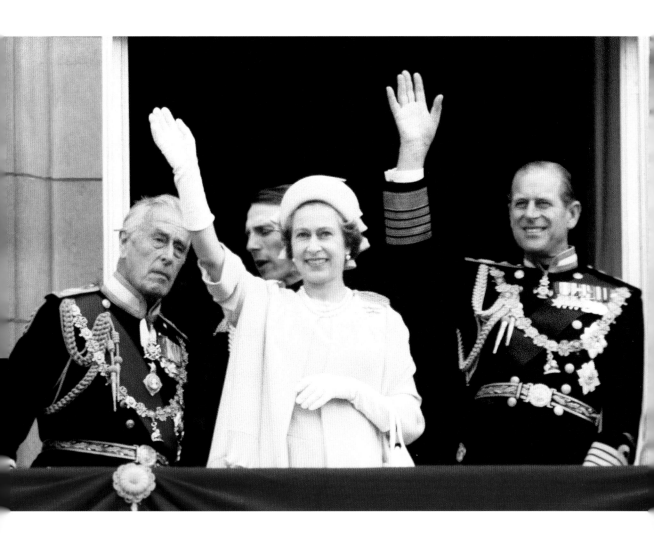

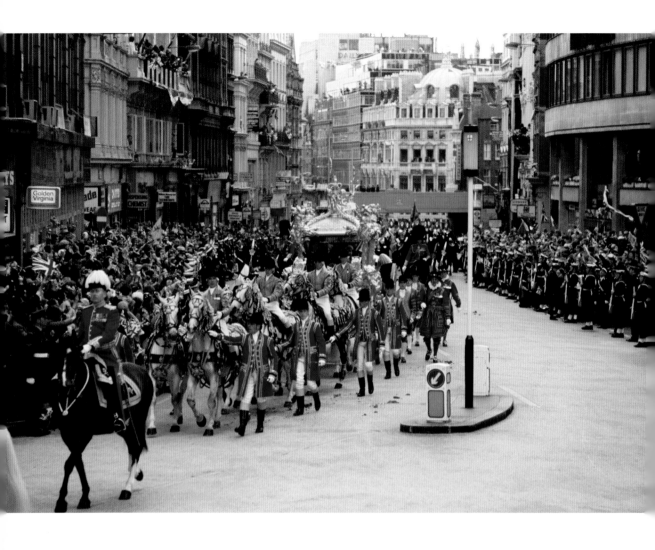

The Gold State Coach on its way from Buckingham
Palace to St Paul's Cathedral, where the Queen
and the Duke of Edinburgh will attend a service of
thanksgiving for the Silver Jubilee. ♔

The Gold State Coach arrives at St Paul's.

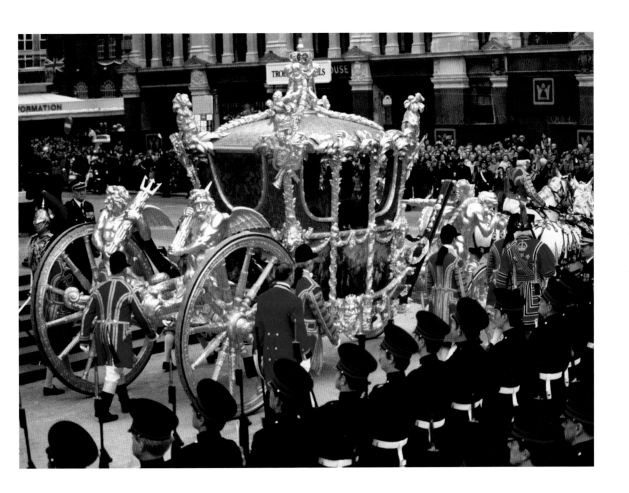

The Queen turns and surveys the scene
from the steps of St Paul's Cathedral.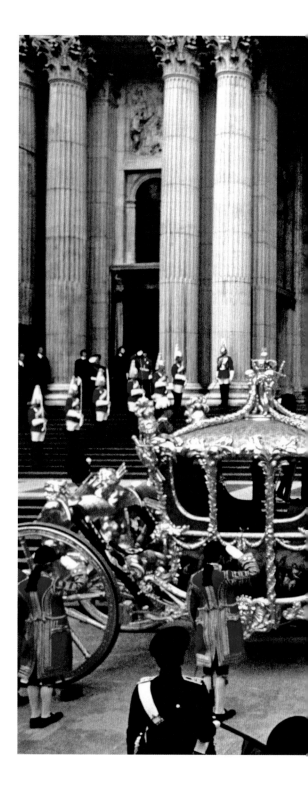

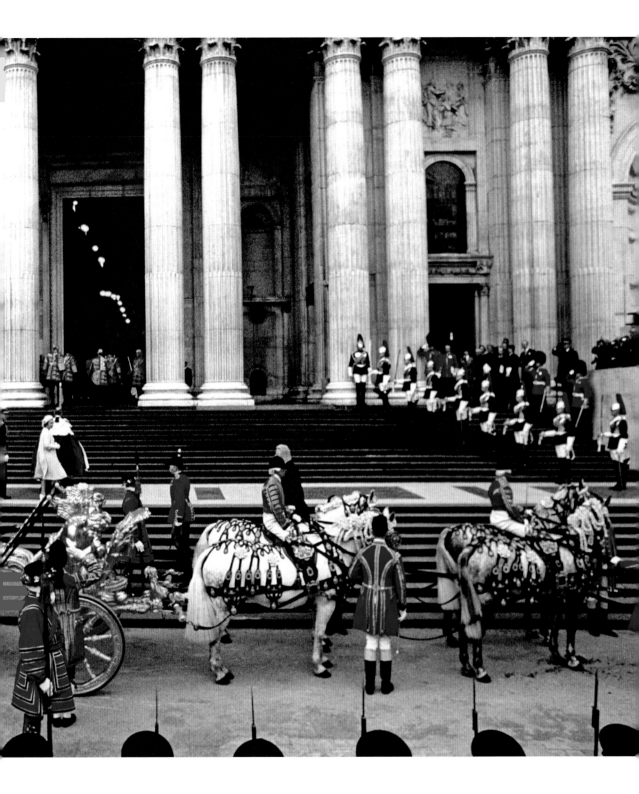

The Queen and the Duke of Edinburgh kneel
during the service of thanksgiving at St Paul's. 👑

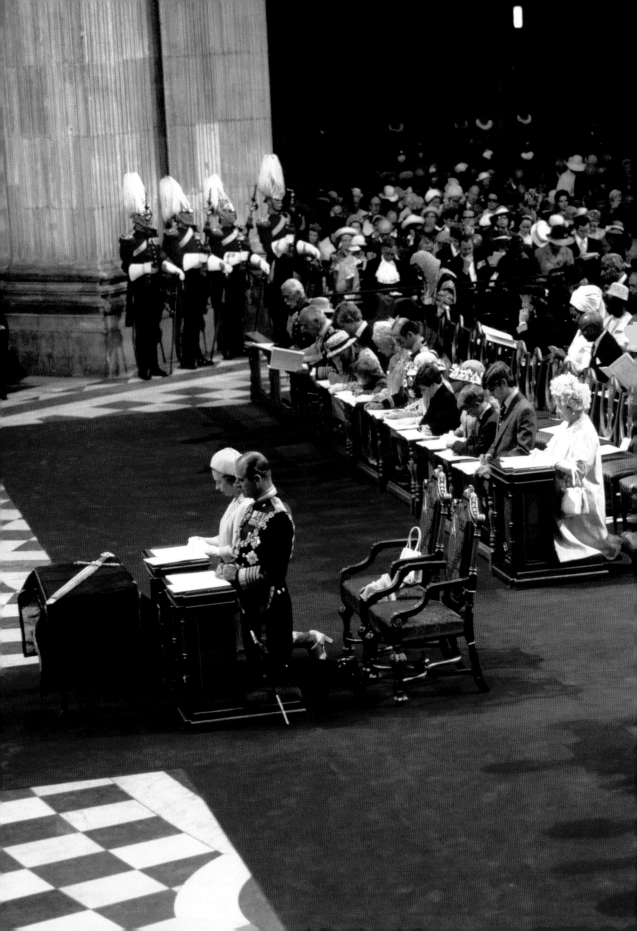

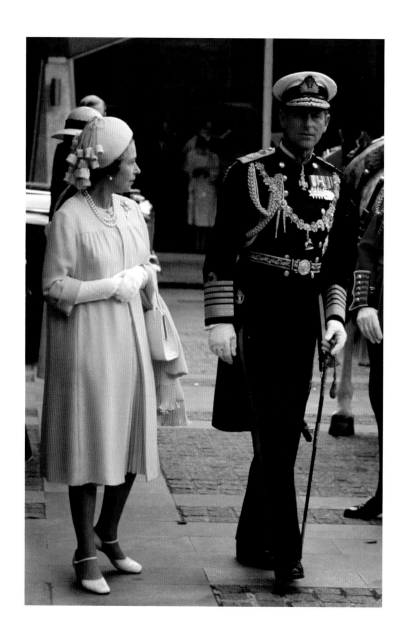

The Queen and the Duke of Edinburgh leaving
Guildhall after lunch to return in a procession of
open carriages to Buckingham Palace.

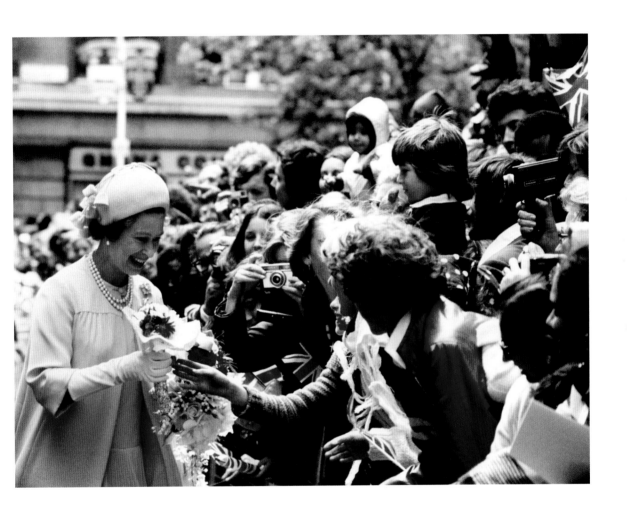

The crowds press forward with offerings of flowers.

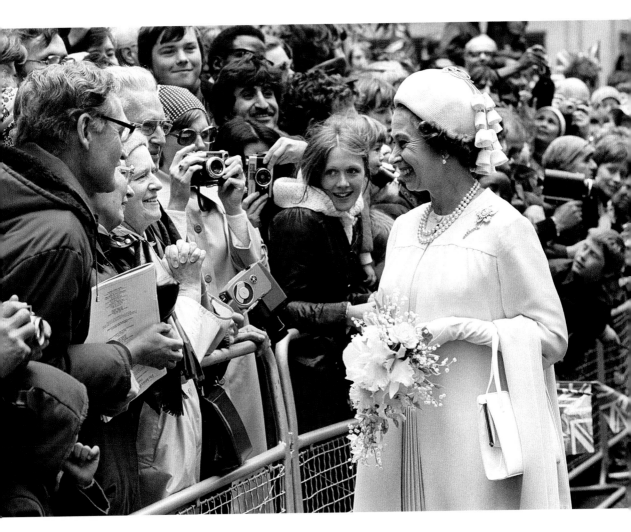

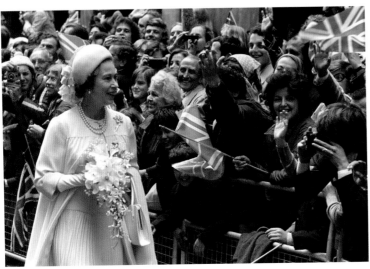

The Queen
continues her walk. 👑

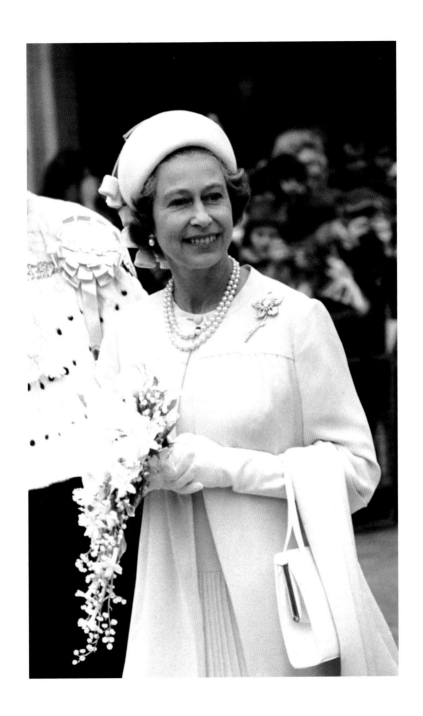

The Duke of Edinburgh accompanies the Queen in an
open landau on the drive back to Buckingham Palace.

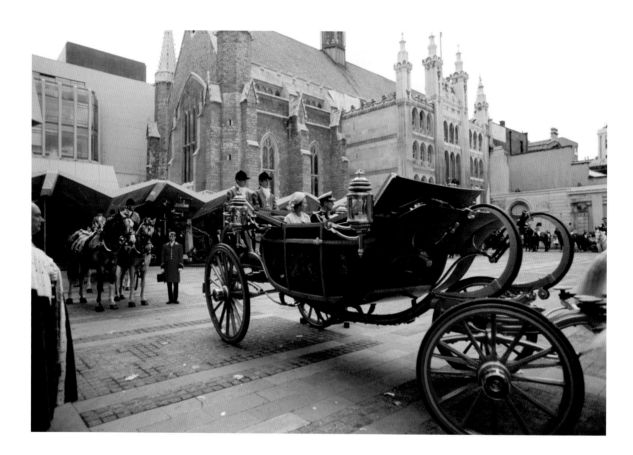

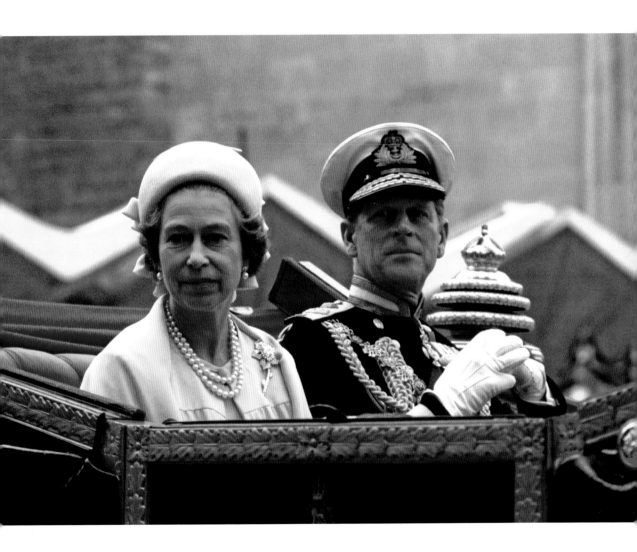

The Queen and her family appear on the balcony at
Buckingham Palace. *Left to right*: Prince Charles,
Prince Edward, Princess Anne,
Lord Mountbatten, the Queen, the Duke of Edinburgh,
Princess Margaret, Prince Andrew and
the Queen Mother.

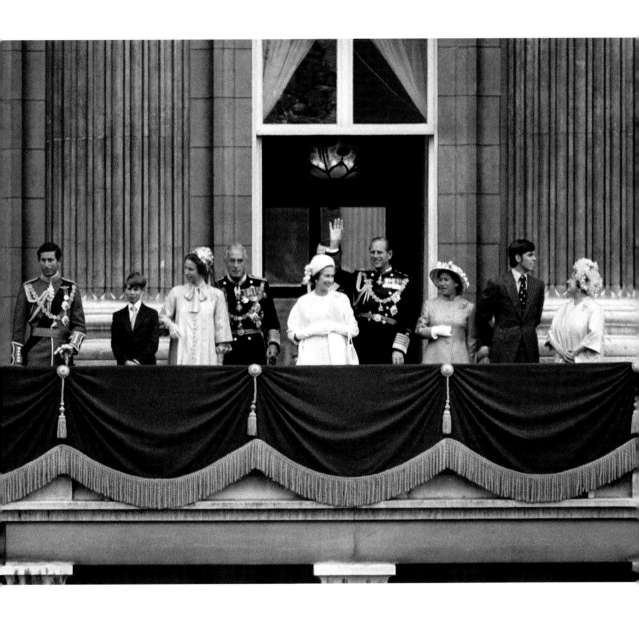

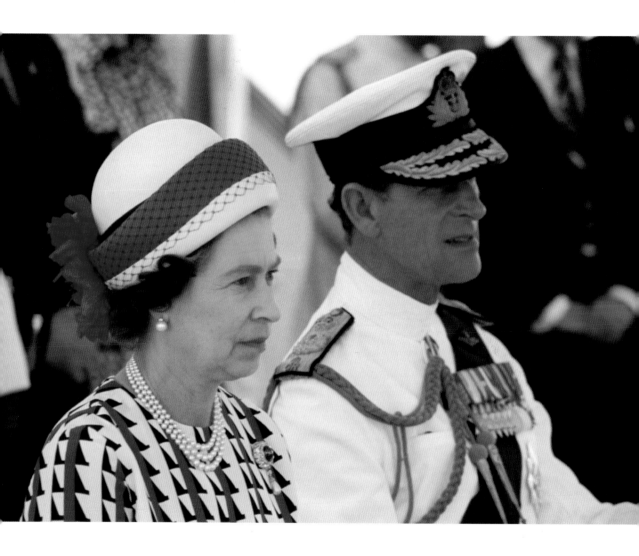

The Queen and the Duke of Edinburgh as they
receive a traditional Fijian welcome on board the
Royal yacht *Britannia* on their arrival at Suva
during the Silver Jubilee tour.
16 February, 1977

The Queen, wearing a cloak of brown kiwi feathers, receives
a New Zealand Maori welcome at the opening of the
Royal New Zealand Polynesian Festival. 1 February, 1977 ♔

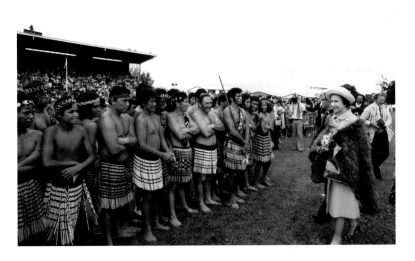

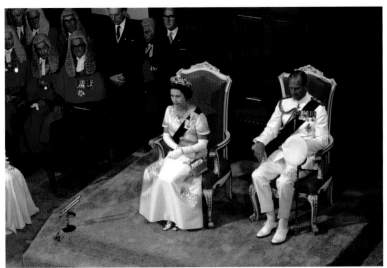

The Queen and the Duke of Edinburgh
in Parliament House, Wellington at the opening
of the New Zealand Parliament. 1 March, 1977 ♔

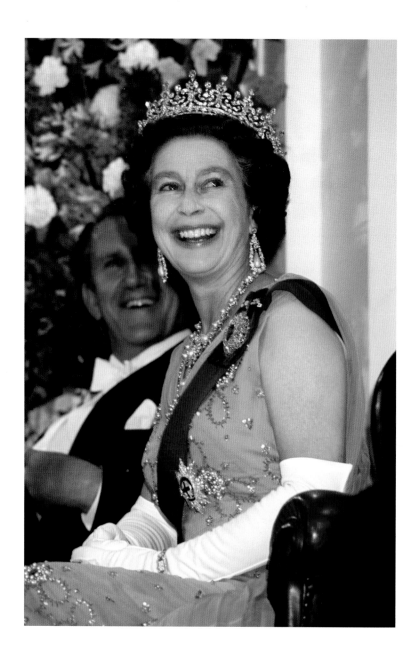

The Queen attends a government reception
at Parliament House, Canberra. 8 March, 1977

The Queen meets the
people of Hobart,
Tasmania, during her
Silver Jubilee tour.
14 March, 1977

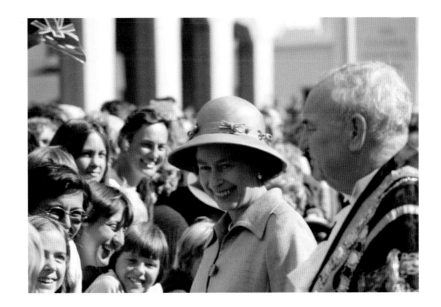

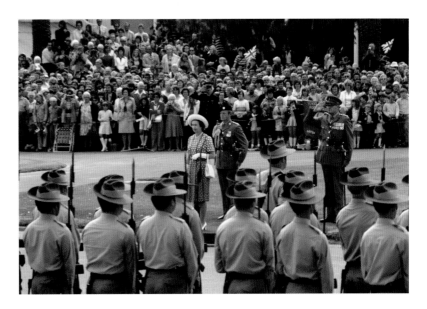

Inspecting a guard of honour in Adelaide, Australia.

22 March, 1977

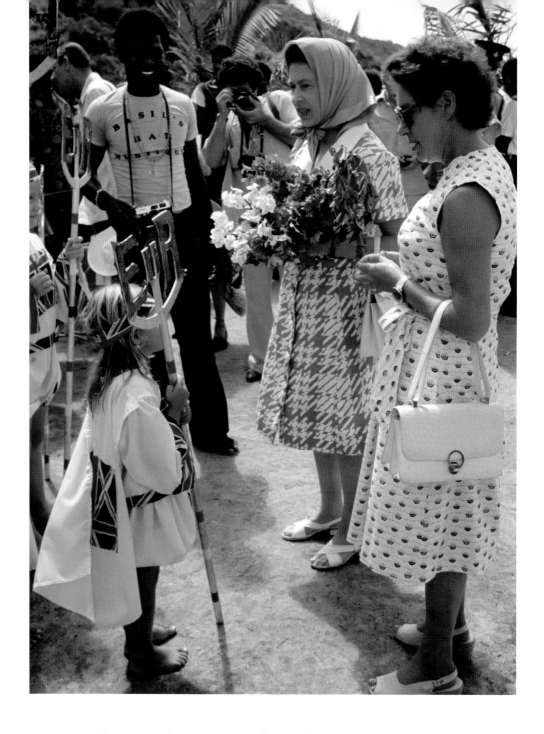

The Queen (*centre*) receives flowers from a young islander in
fancy dress on the island of Mustique. With her is Princess Margaret,
who has a villa on the island. The picture was taken during
the Queen's Silver Jubilee tour of the West Indies. 1 October, 1977

The Queen pauses for a word with
local people in Tortola during
a visit the British Virgin Islands. 28 October, 1977 👑

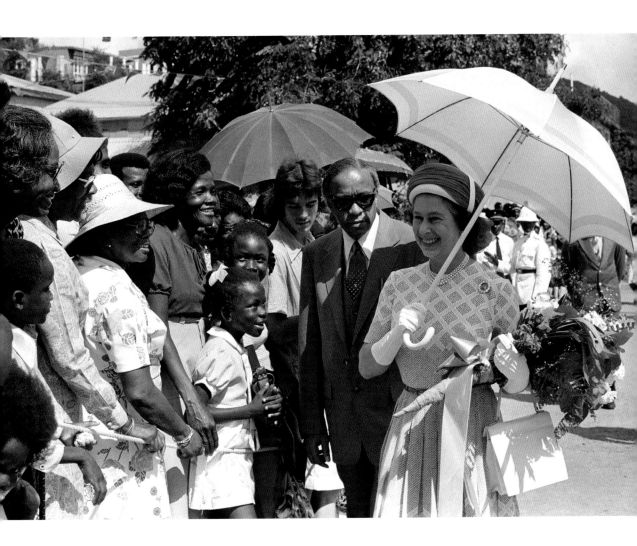

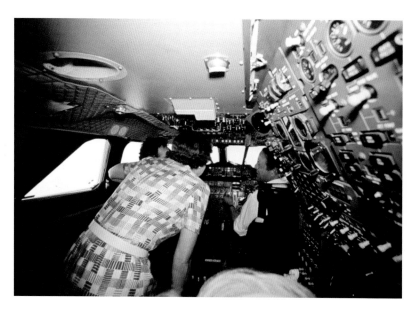

The Queen visits the flight deck during
her flight home from Bridgetown, Barbados,
in the supersonic Concorde after her
Silver Jubilee tour of Canada and the West Indies.
2 November, 1977

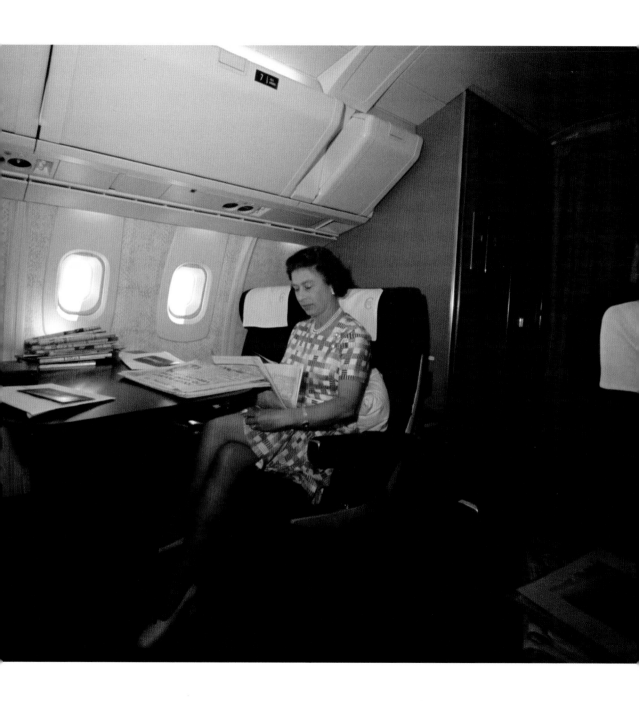

…time to read the newspapers. ♛

8

Goodbye

Queen Elizabeth the Queen Mother arrives
with the Queen at Royal Ascot. They have
long shared a love of horse racing. 20 June, 1997

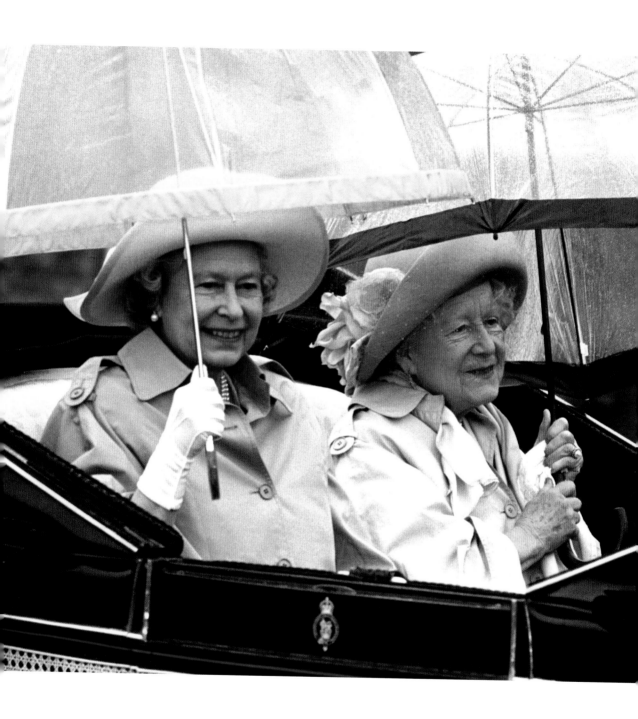

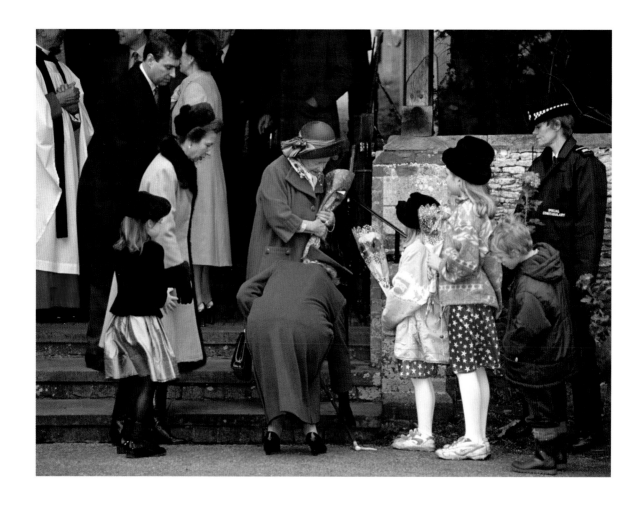

The Queen stoops to pick up her mother's walking stick as
the Princess Royal, Princess Beatrice and
Prince Andrew look on. Around 1,000 people gather
outside the church on the Sandringham Estate
to see the Royals as they leave after attending
morning service. 25 December, 1997 ♛

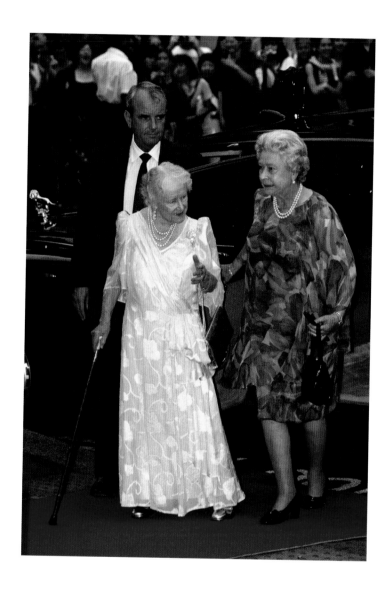

The Queen accompanies her mother, on
her 99th birthday, to the theatre in London's
Haymarket to see *The Importance of Being Earnest*
by Oscar Wilde. 4 August, 1999 👑

The Queen Mother is pictured on the balcony of
Buckingham Palace with her daughter during
celebrations for her 100th birthday. Thousands of people
gather outside the Palace to cheer her – the longest living
Royal in the history of the British monarchy.
4 August, 2000 ♔

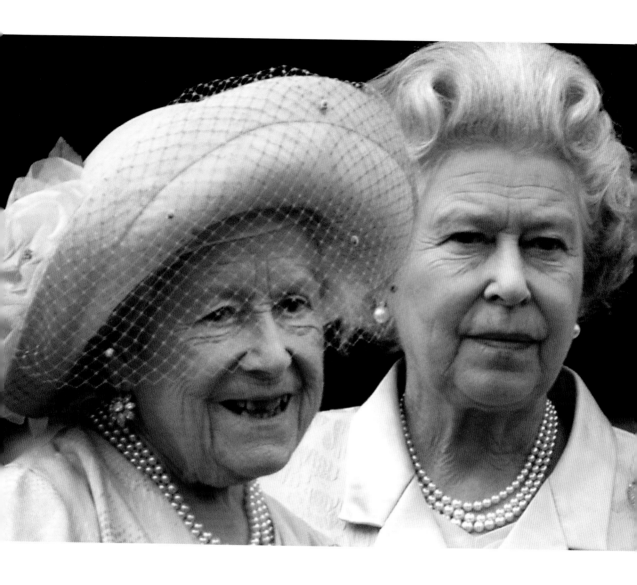

GOODBYE

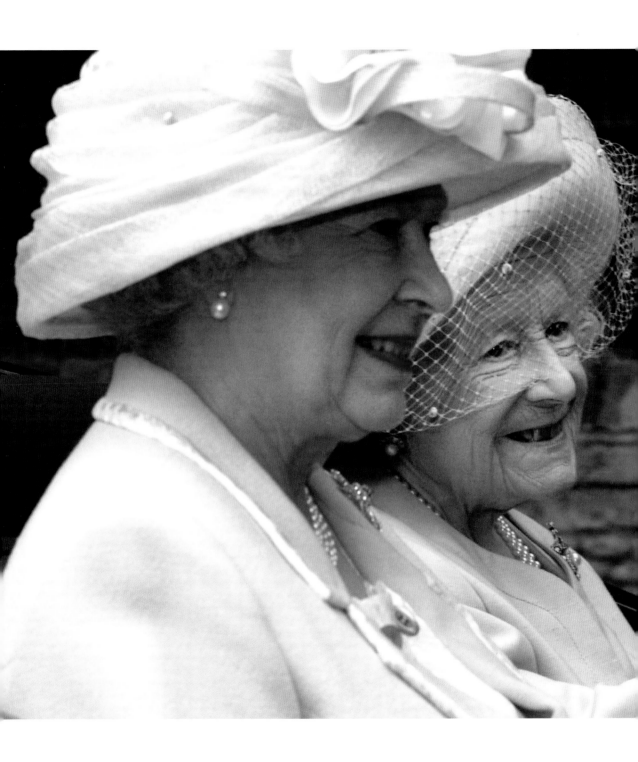

The Queen and Queen Mother greet the crowds
as they leave church at Sandringham in an open-topped
horse-drawn carriage. 22 July, 2001

The Queen accompanies her mother to the ballet
on her 101st birthday. 4 August, 2001 ♔

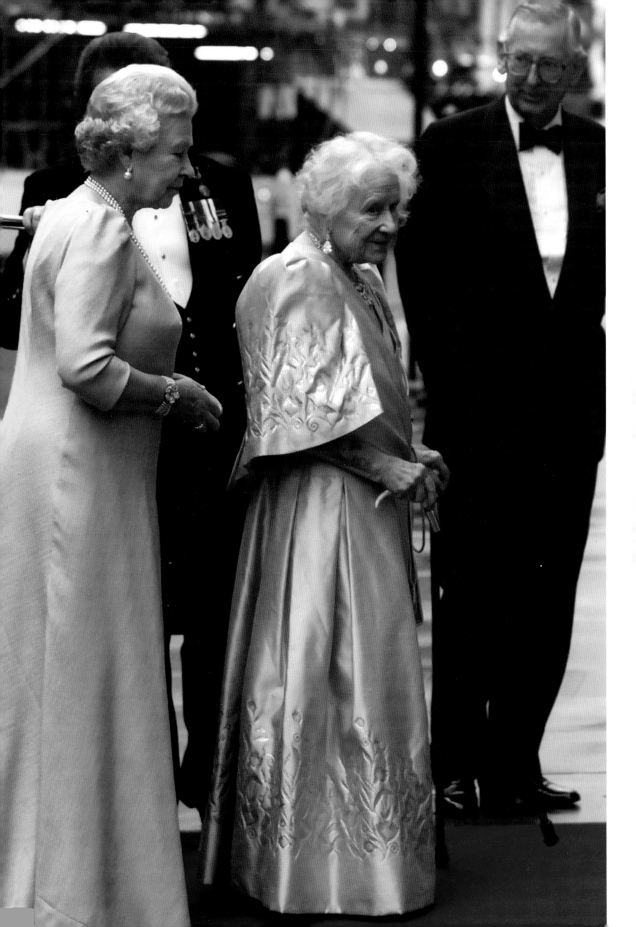

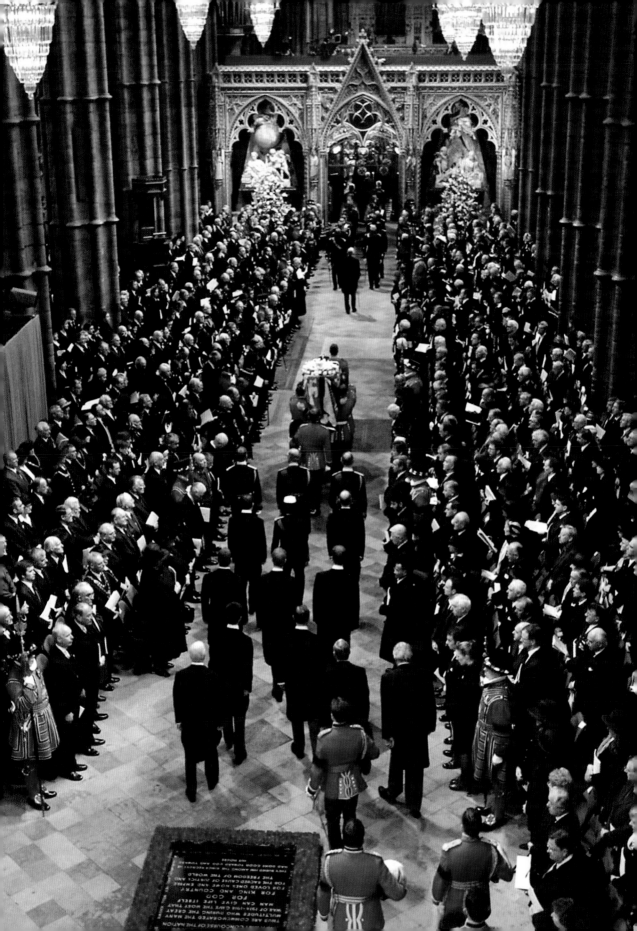

The Queen watches as her mother's coffin is driven
from Westminster Abbey after the funeral service.
It is to be taken to St George's Chapel in Windsor,
where the Queen Mother will lie next to her husband,
King George VI. ♔

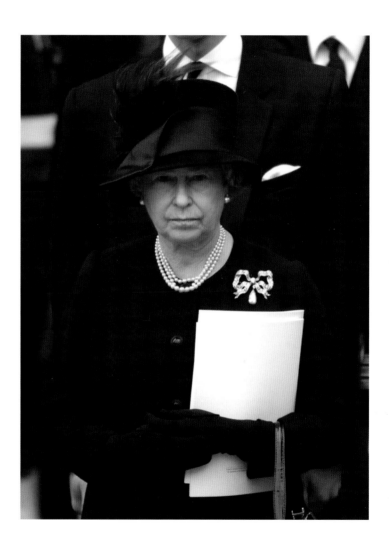

The coffin of the Queen Mother is carried
out of Westminster Abbey. 9 March, 2002 ♔

9

A Golden Jubilee

The Queen leaves Buckingham Palace in
the Gold State Coach on her way to St Paul's Cathedral
for a service of thanksgiving to celebrate her 50 years
on the throne. The coach has only been used by the Queen
twice before – for her coronation and her Silver Jubilee.
4 June, 2002

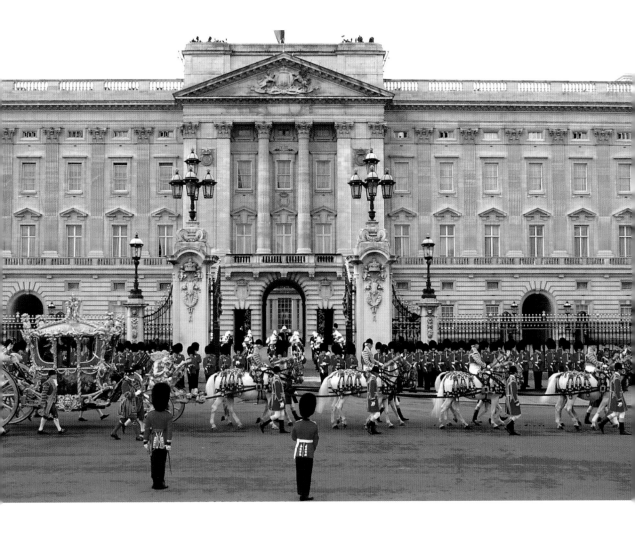

The Gold State Coach
makes its way up The Mall. ♛

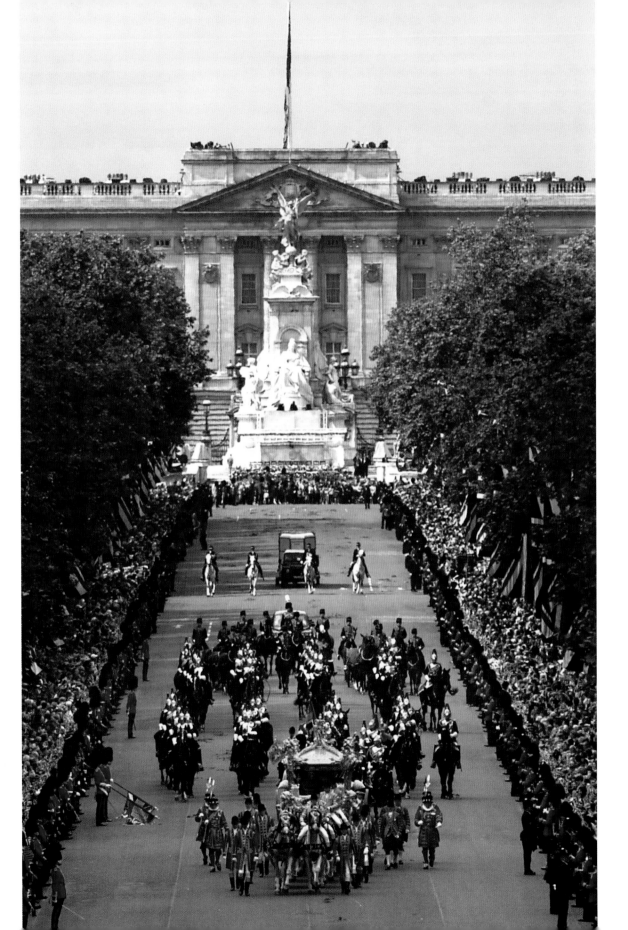

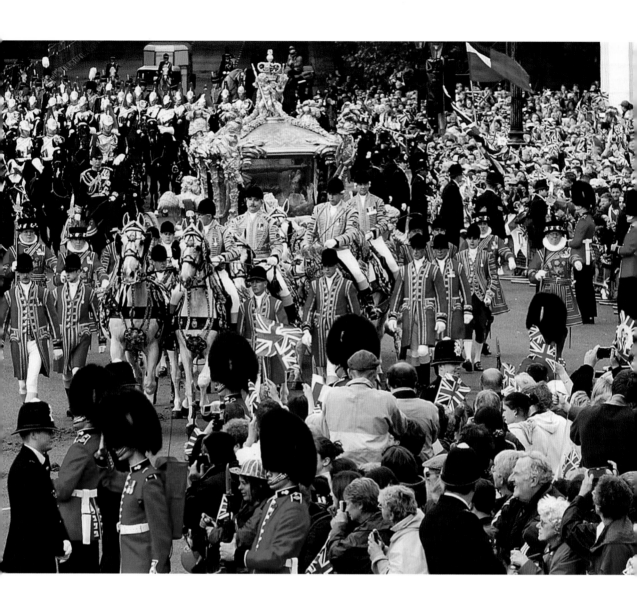

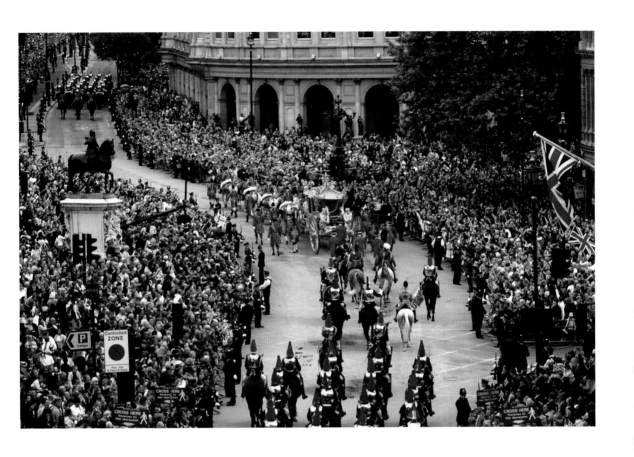

Crowds line the streets to watch

as the procession passes. ♔

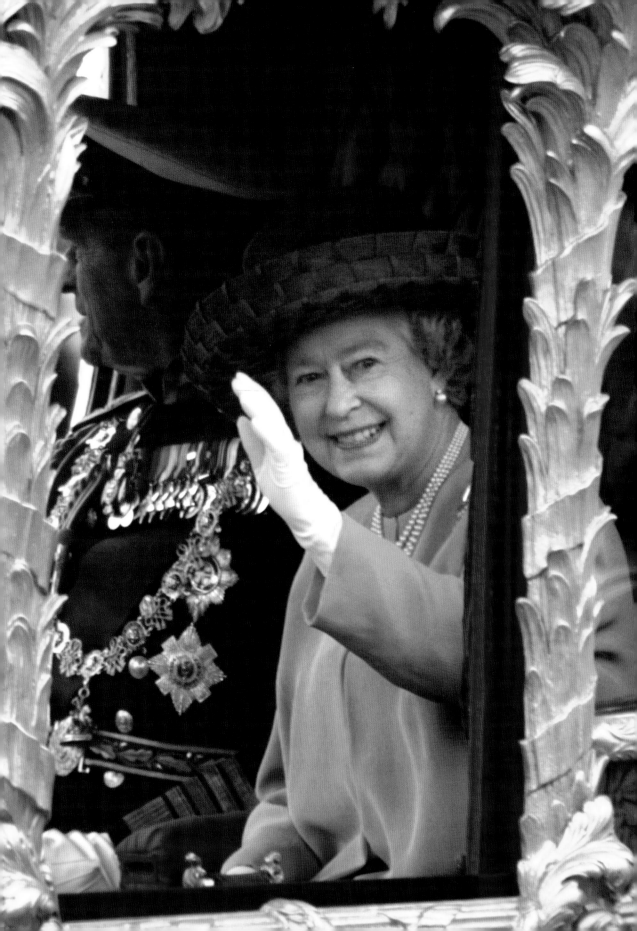

The Queen and Prince Philip
wave to the crowds.

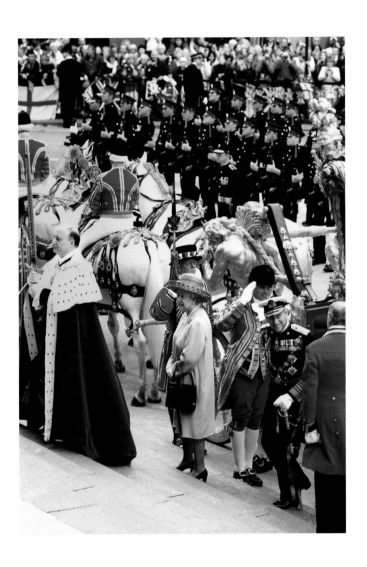

They arrive at
St Paul's Cathedral.

The service in the Cathedral is attended by
members of the Royal family and many heads of state.

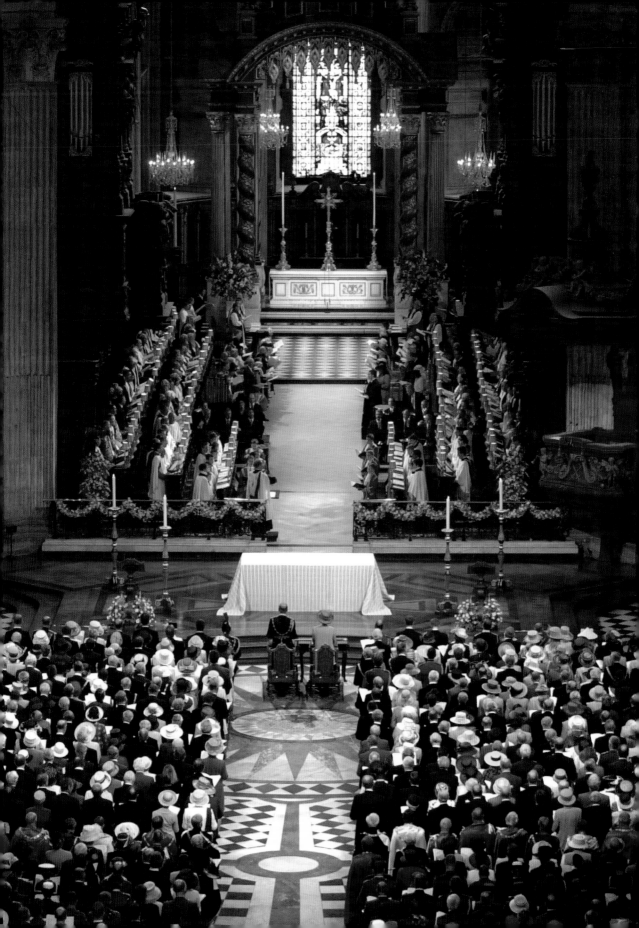

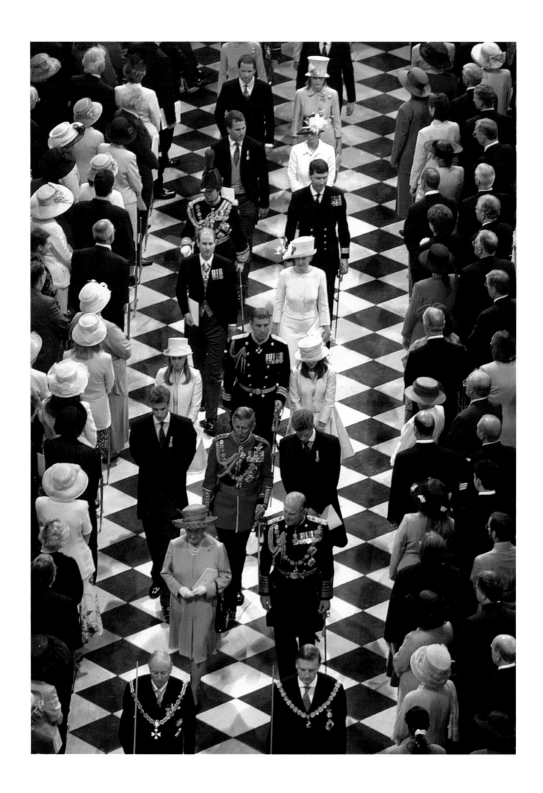

The Royal family leave St Paul's. ♔

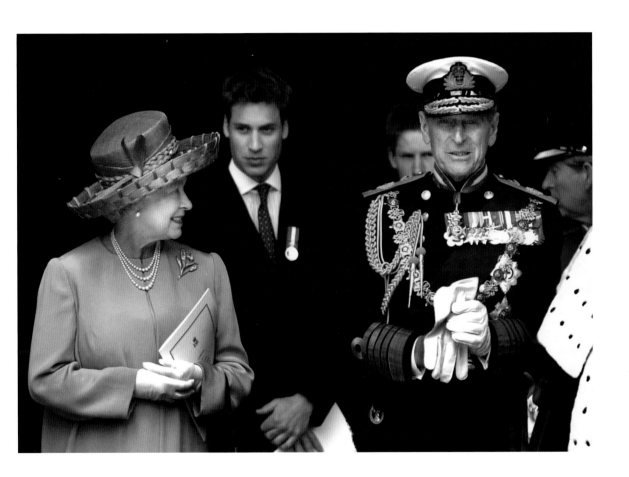

The Queen and Duke of Edinburgh with
their grandsons, Princes William and Harry,
pause on the steps of the cathedral. ♔

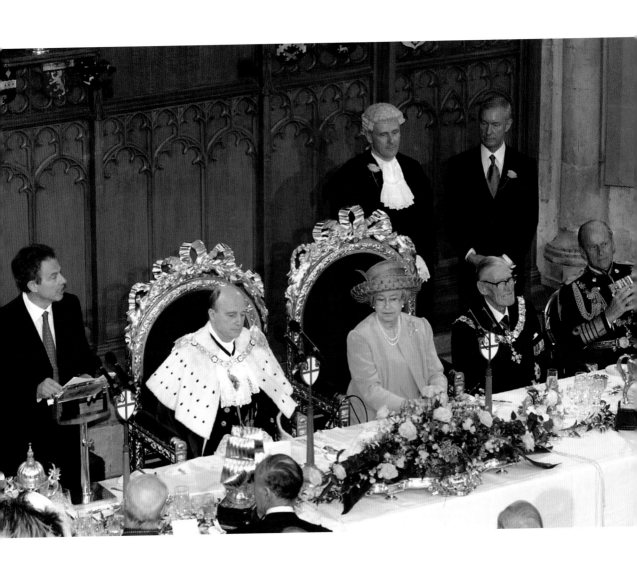

The Prime Minister, Tony Blair, makes a speech
during a banquet at the Guildhall following
the ceremony at St Paul's. ♛

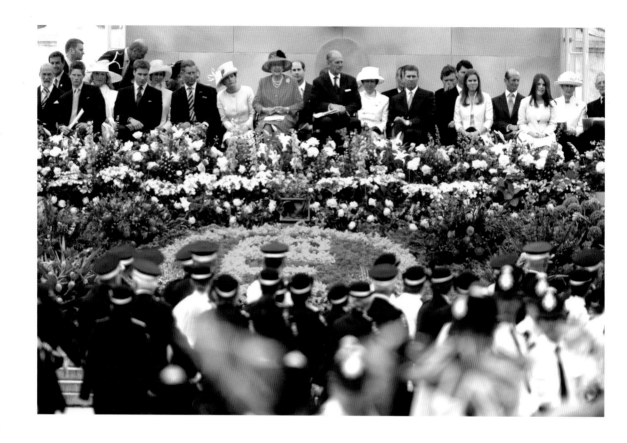

The Royal family take their seats to watch the celebrations
in The Mall following the banquet at Guildhall. *From left
to right*: Prince Michael of Kent, Prince Harry, Princess
Michael, Prince William, the Duchess of Gloucester, the
Prince of Wales, the Countess of Wessex, the Queen, the
Earl of Wessex, the Duke of Edinburgh, the Princess Royal,
the Duke of York, Commander Tim Laurence, Princess
Beatrice, the Duke of Kent, Princess Eugenie, Princess
Alexandra and Angus Ogilvy. ♛

The Queen chats to the Prince of Wales during the event.

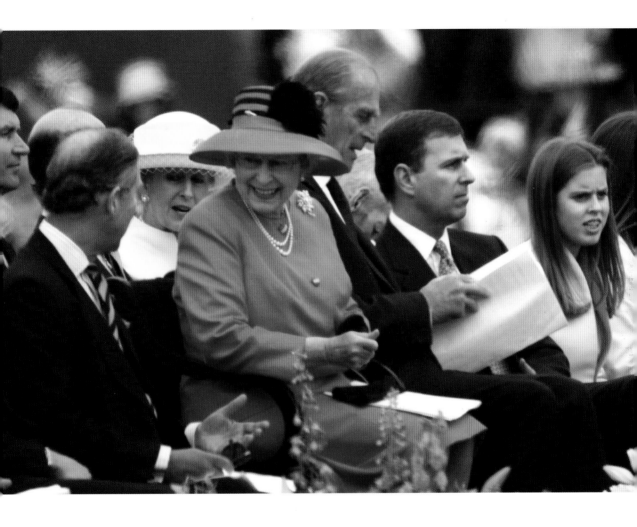

On their return to Buckingham Palace,
the Queen and members of the Royal family gather
on the balcony to watch as Concorde and
the Red Arrows fly overhead in celebration. 👑

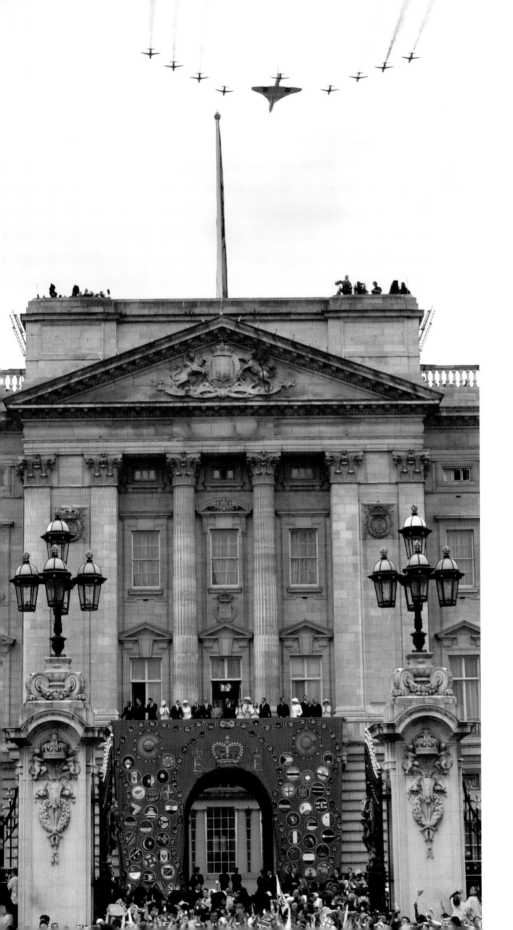

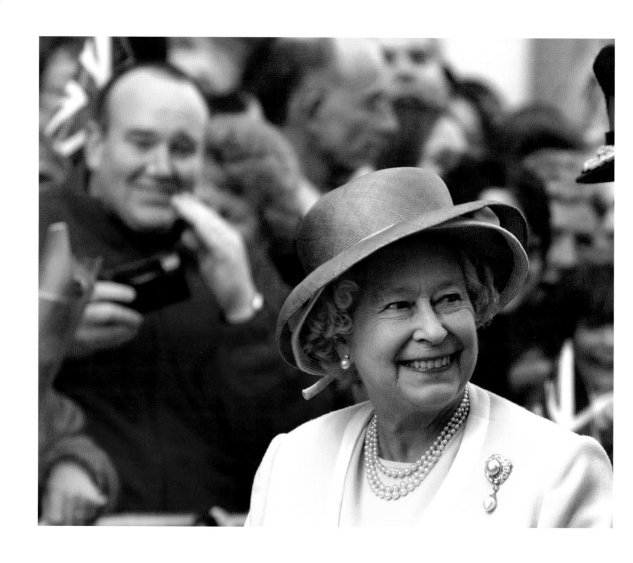

The Queen is greeted by well wishers in Exeter,
where she is to confer Lord Mayoralty status on
the city as part of her Golden Jubilee tour of the UK.
1 May, 2002 ♔

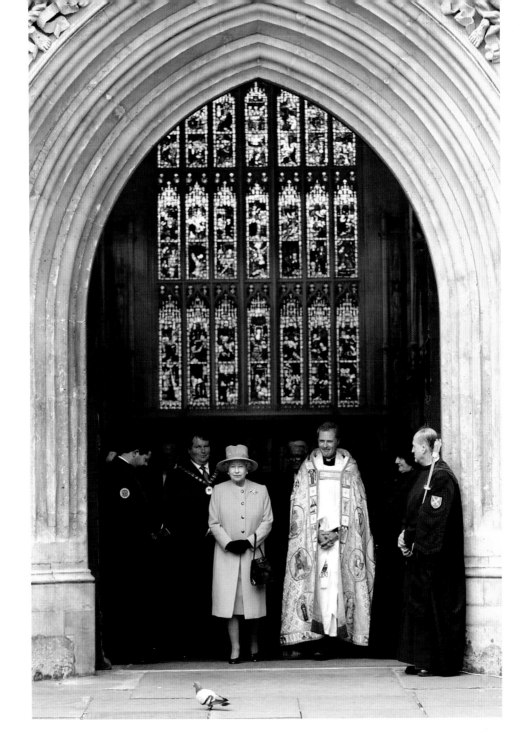

The Queen walks with the Rector of Bath Abbey,
Reverend Simon Oberst, during her tour. 2 May, 2002

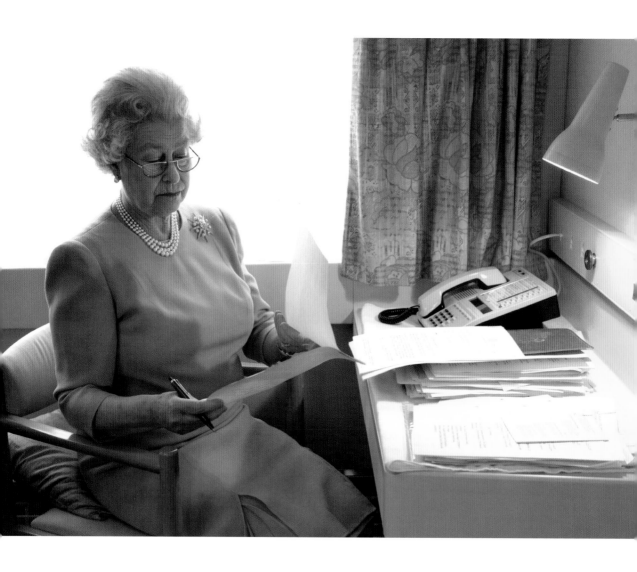

The Queen at work aboard the Royal train,
near Darlington, during her tour. 7 May, 2002 ♛

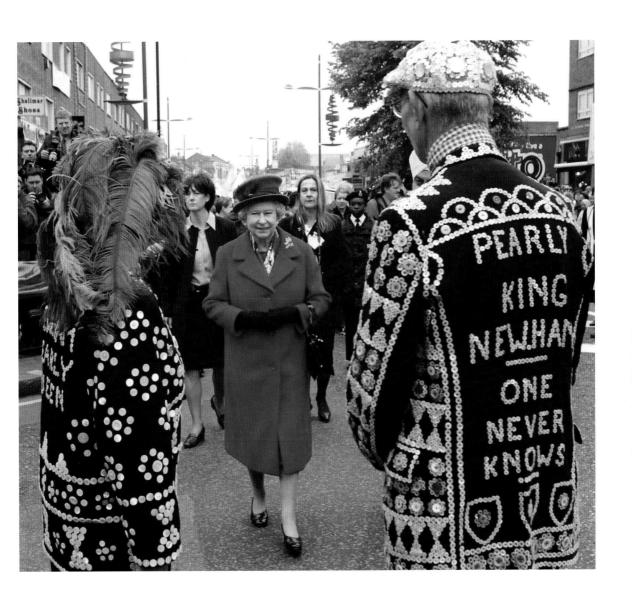

The Queen meets two of the 'Royalty of the East End' –
a Pearly King and Queen – during her visit to
Green Street in Newham, East London.
The Pearly Kings and Queens trace their history back
more than 120 years and are known for raising money
for local charities. 9 May, 2002

As the Queen continues her tour, she and the
Duke of Edinburgh are accompanied by
Northern Ireland First Minister David Trimble,
on the steps of Stormont Parliament building
in Belfast, Northern Ireland. 14 May, 2002 👑

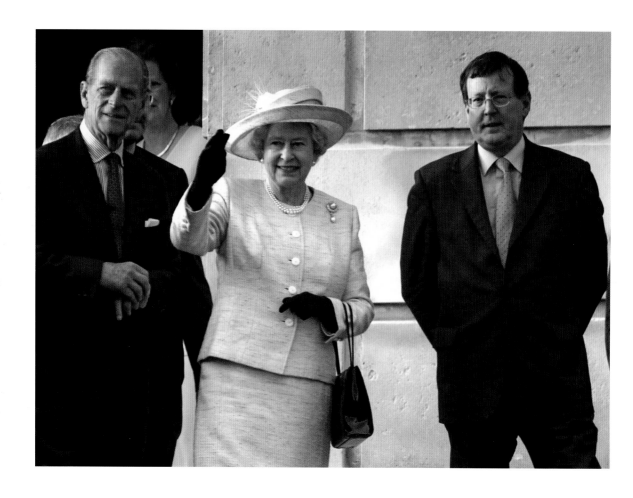

The Queen smiles as she accepts a bunch of flowers
on the second day of her visit to Scotland. 24 May, 2002

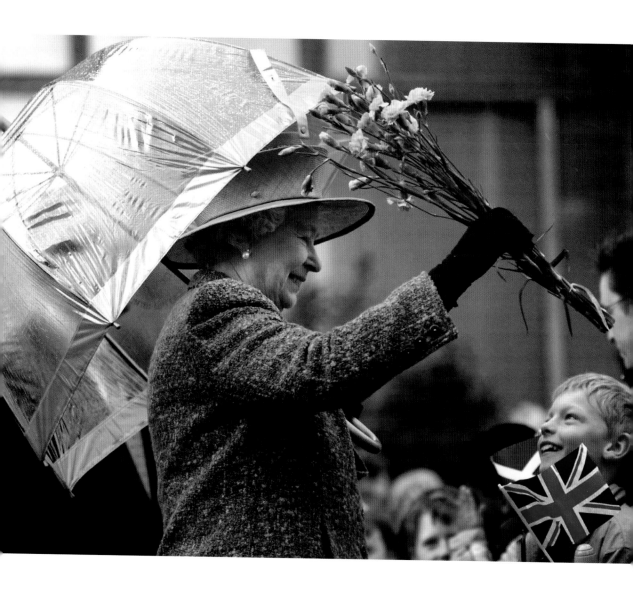

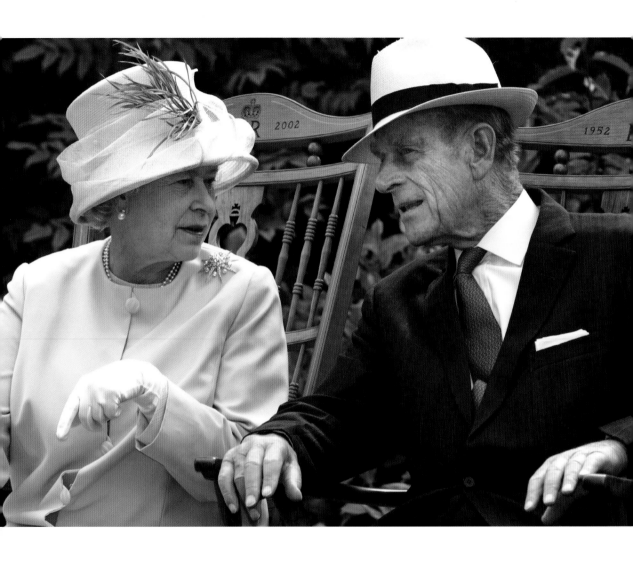

A quiet chat in the Abbey Gardens
at Bury St Edmunds towards the end of
the tour of the UK. 17 July, 2002 👑

The Queen and Prince Philip leave
Balmoral Castle at the end of the
Golden Jubilee tour of the UK. 7 August, 2002 ♛

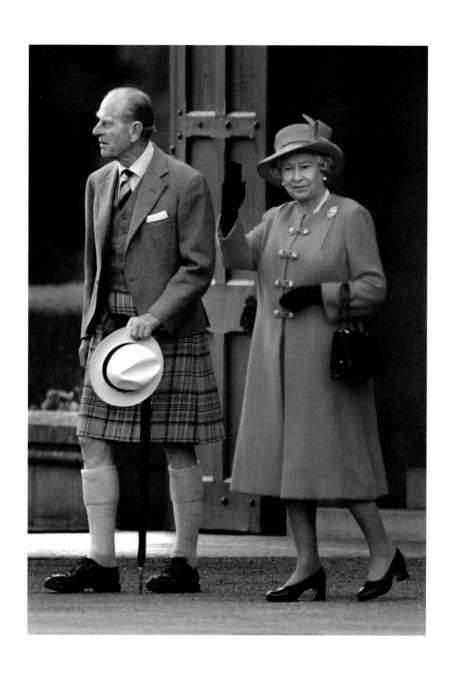

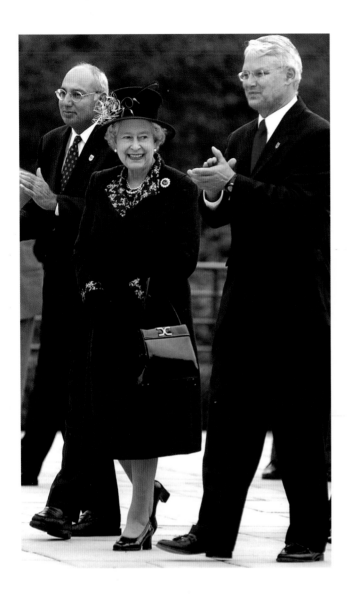

The Queen walks with Premier of
British Columbia Gordon Campbell at
the University of British Columbia in Canada,
during her visit to the country to celebrate her
Golden Jubilee. 8 October, 2002 ♔

On the last leg of her two-week tour of
Canada, the Queen visits the Canadian
Broadcasting Centre in Toronto.
11 October, 2002 ♔

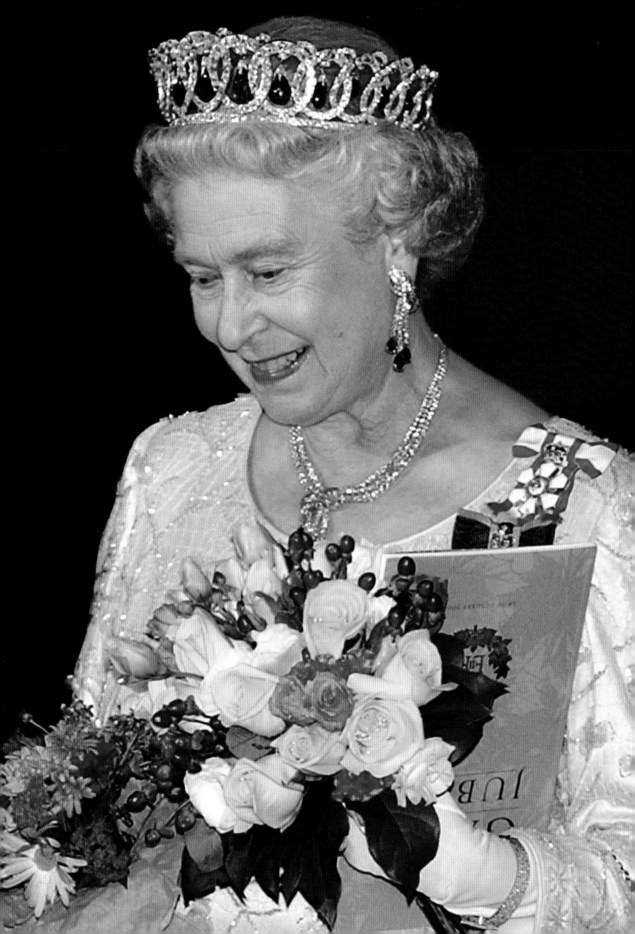

10

An 80th birthday

The Queen opens some of her birthday cards
on her 80th birthday. 21 April, 2006

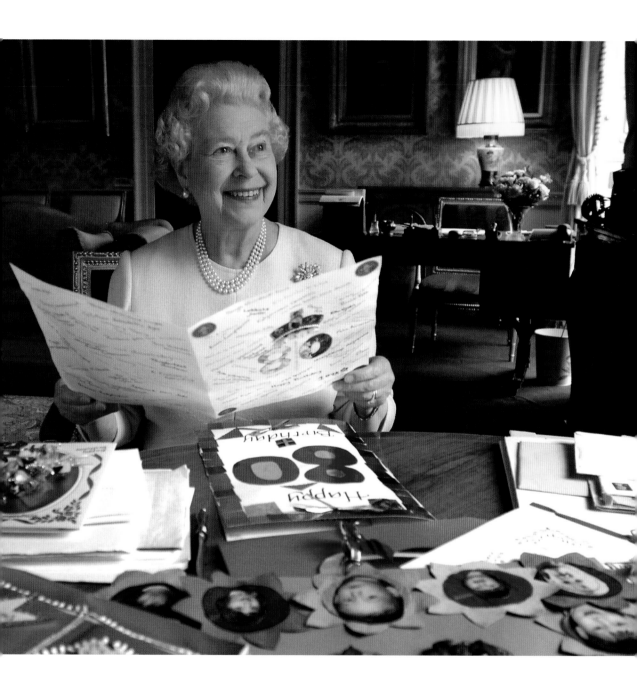

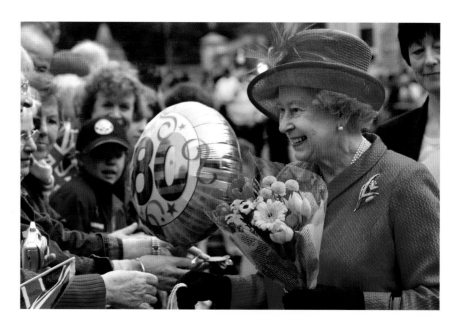

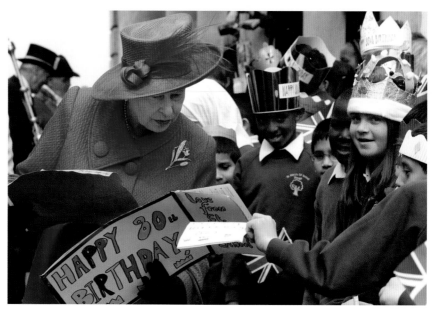

The Queen greets the crowds during a walkabout
to celebrate her 80th birthday at Windsor. 21 April, 2006

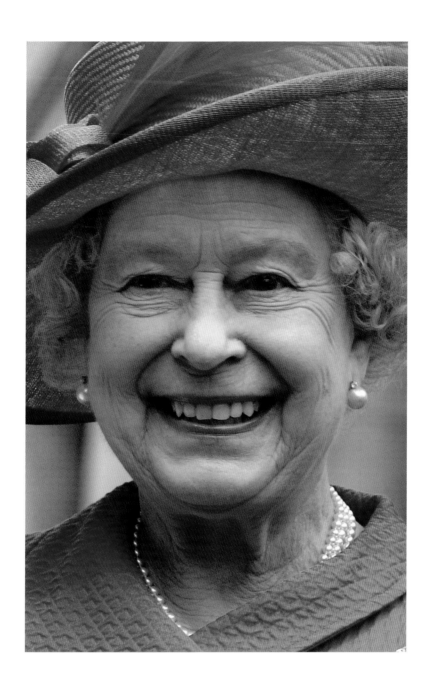

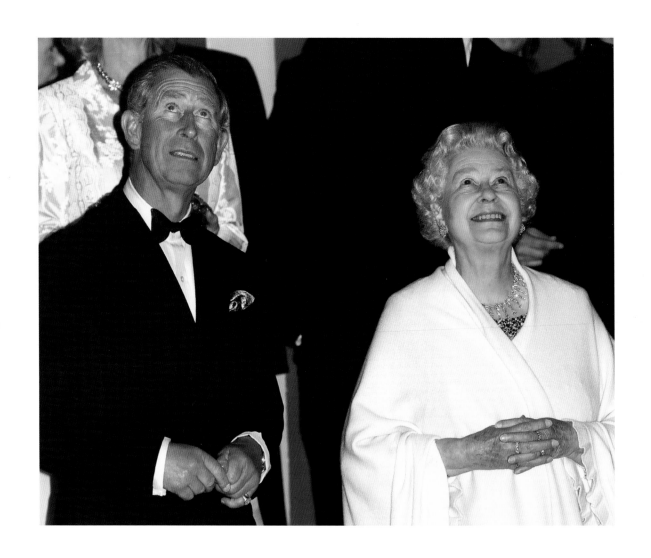

The Queen and the Prince of Wales watch
a firework display at Kew Palace in London
on the evening of her birthday. 21 April, 2006

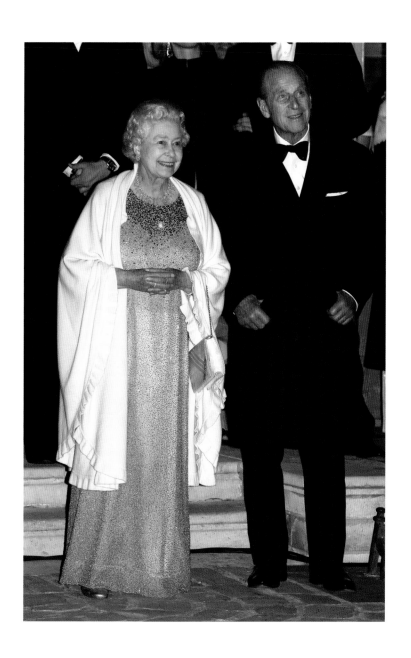

The Queen and the Duke of Edinburgh

enjoy the fireworks.

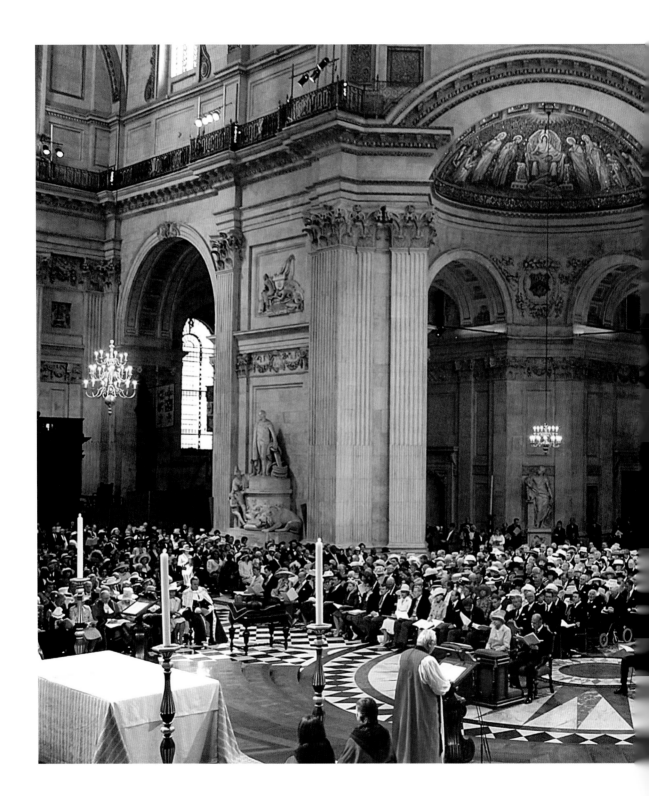

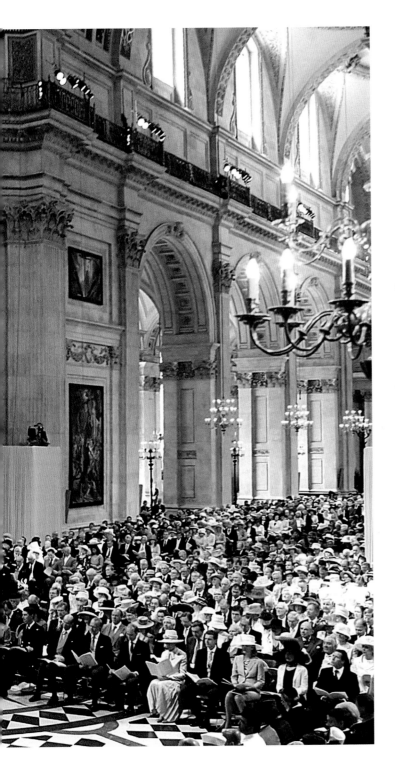

The Queen and the Royal family
attend a service of thanksgiving at
St Paul's Cathedral in honour
of the Queen's 80th year. More
than 2,300 people pack into
the cathedral, including the Prime
Minister, Tony Blair, military
chiefs and many faith leaders.
15 June, 2006

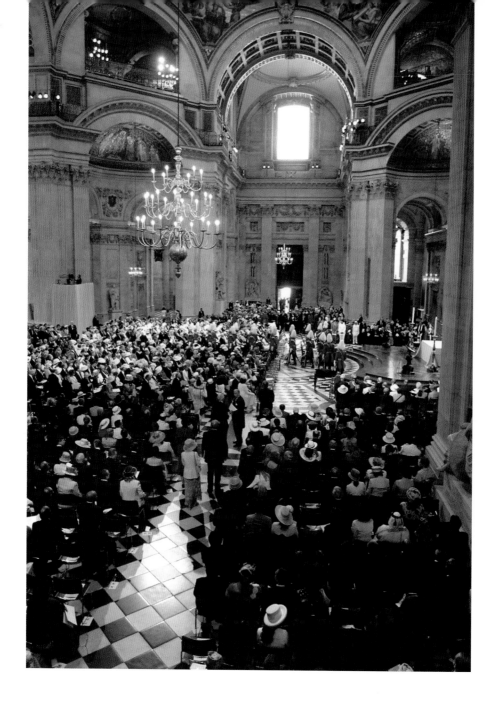

The Queen is joined for the service by more than 30
members of the Royal family, including the
Duke of Edinburgh, the Prince of Wales, and
grandsons Princes William and Harry.

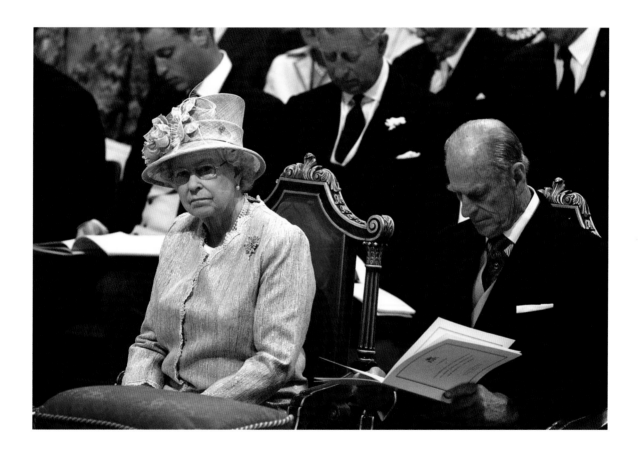

The Queen chats with the Lord Mayor of London as she leaves the cathedral, followed by (*middle left to right*) the Prince of Wales and the Duke of Edinburgh, and (*back left to right*) Princes Harry and William. ♛

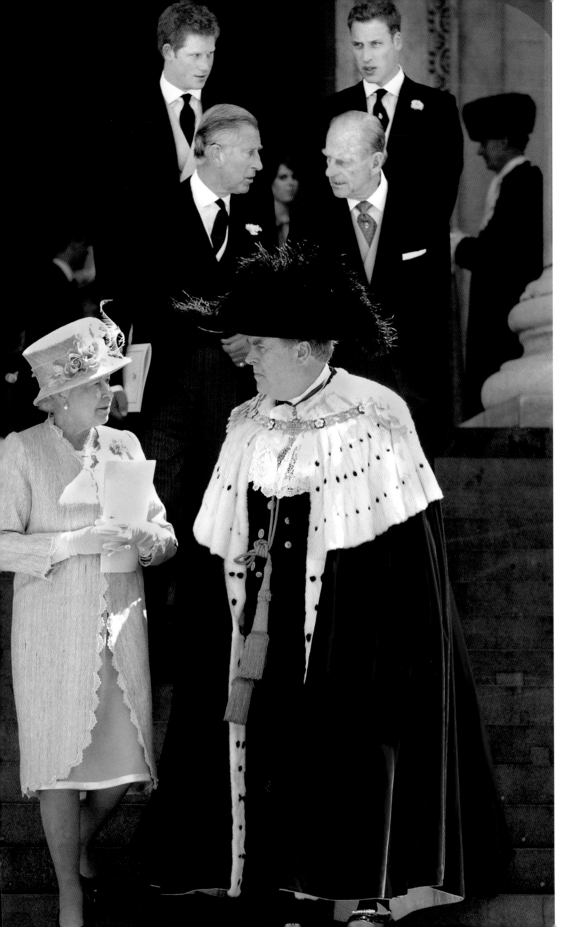

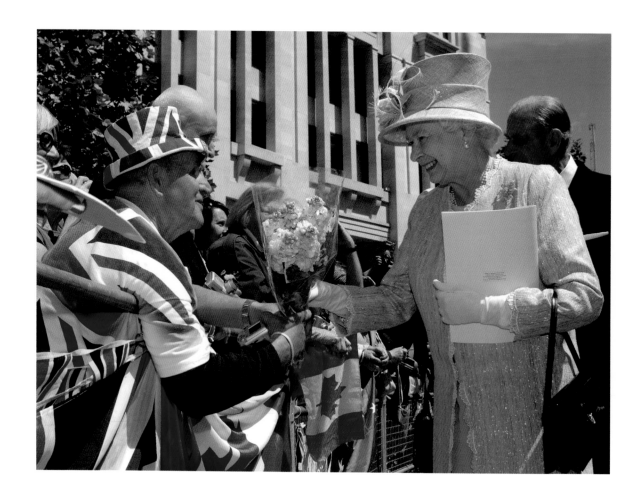

The Queen accepts a bunch of flowers
from a Royal fan on her walkabout after the service.

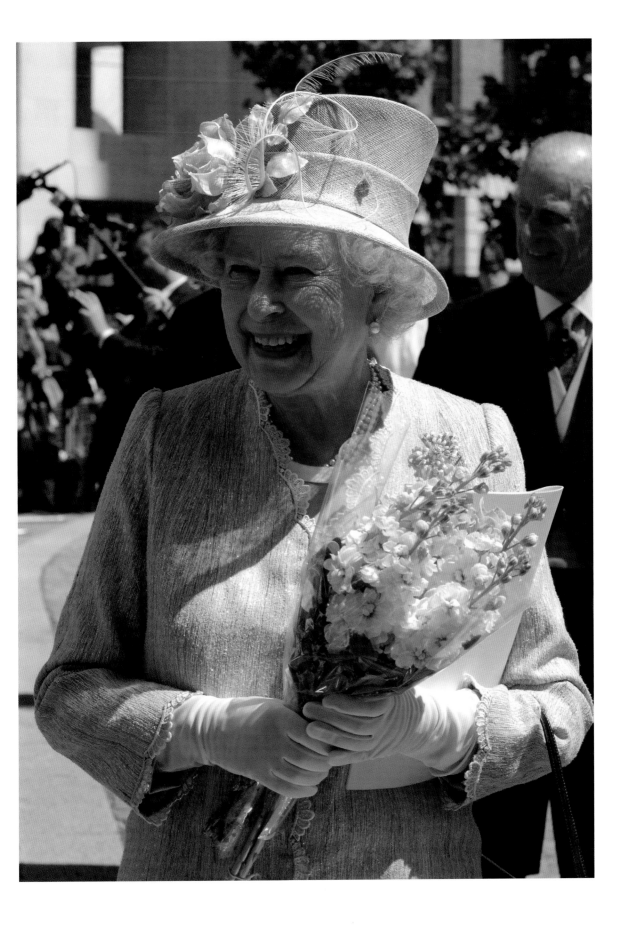

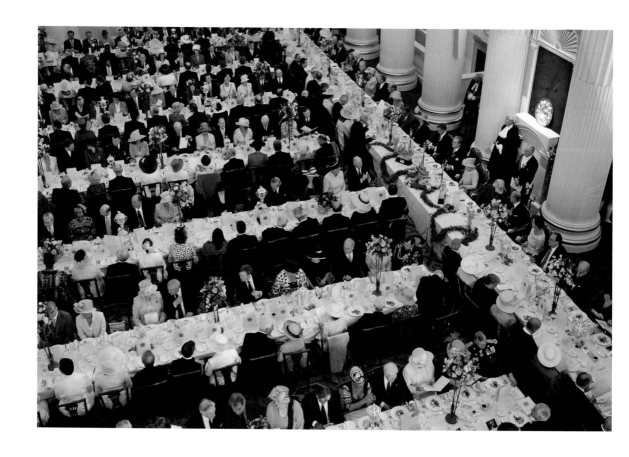

The Queen is joined by guests at a lunch
hosted by the Lord Mayor and Corporation
of London after the service at St Paul's. 👑

The Queen makes a speech
during the lunch. 👑

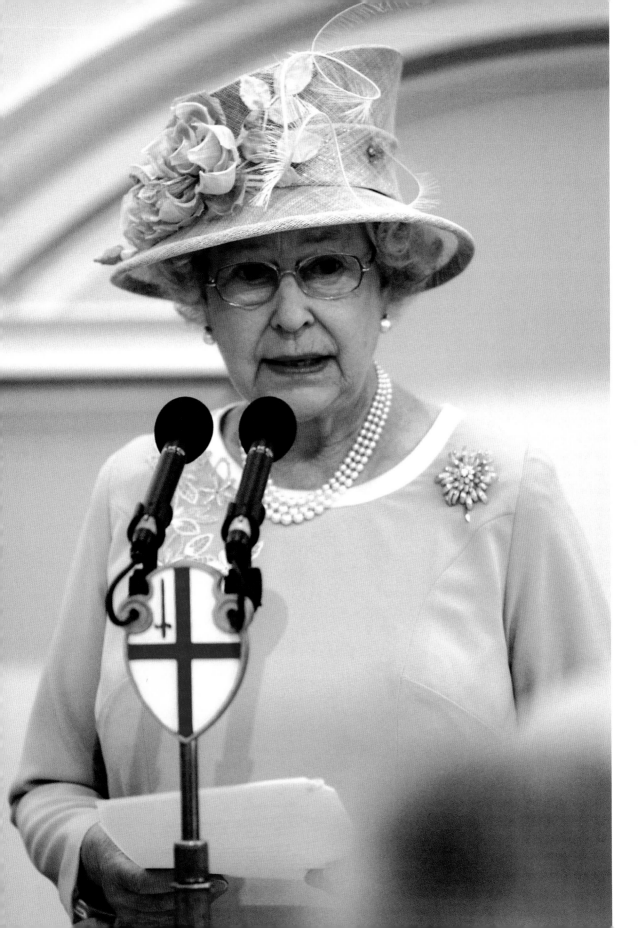

The Queen and the Duke of Edinburgh
arrive to inspect the troops during the annual
Trooping the Colour ceremony at Horse Guards
Parade on the Queen's official 80th birthday.
More than 1,000 soldiers take part in the
annual display. 17 June, 2006 ♔

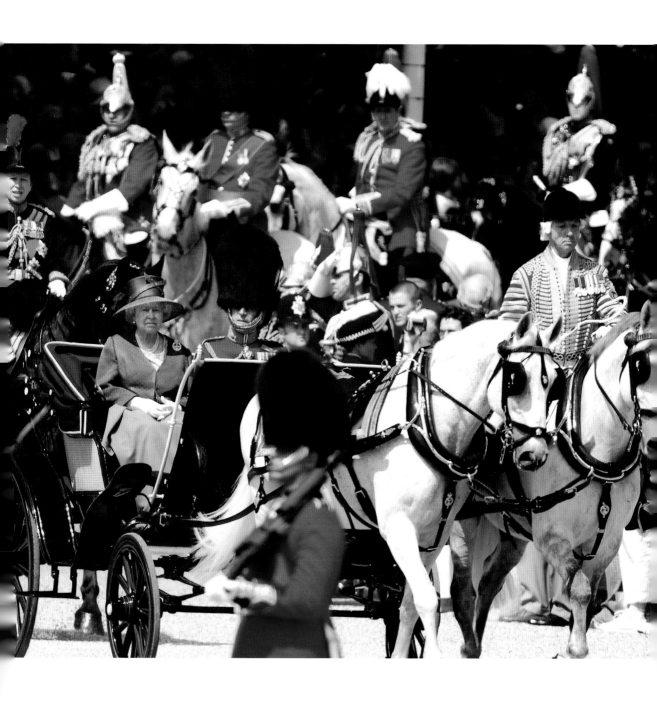

The Queen and members of the Royal family watch from the balcony at Buckingham Palace as soldiers from the Welsh Guards fire a *feu de joie* (fire of joy) as part of the Queen's official 80th birthday celebrations. 17 June, 2006 ♔

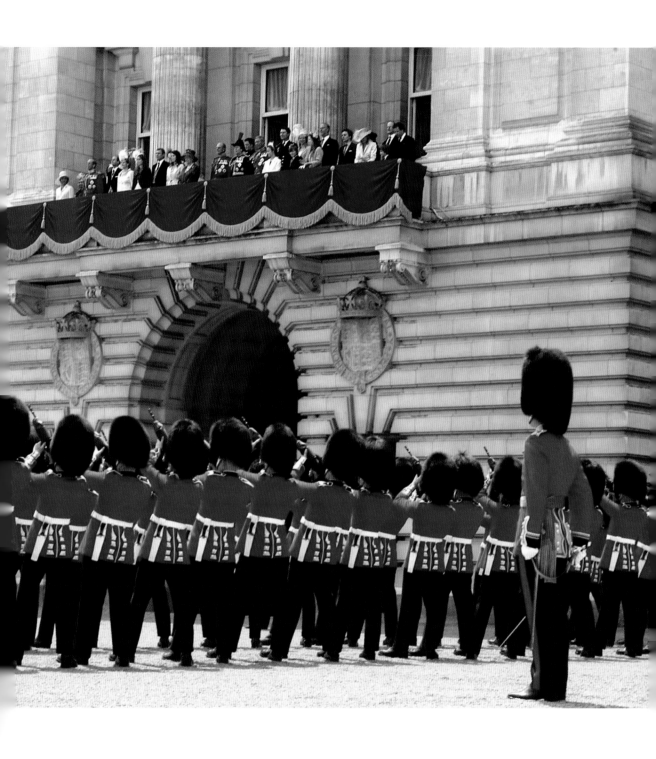

11

A long reign

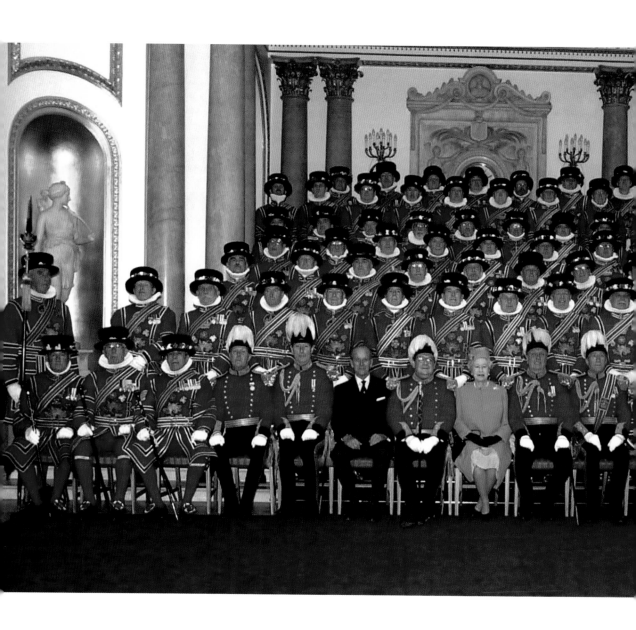

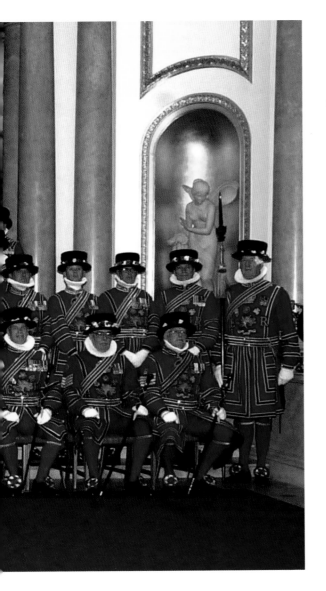

The Queen and the Duke of Edinburgh
sit with the Yeomen of the Guard at
Buckingham Palace. The Yeomen of the
Guard are probably the oldest military corps
still active in the world and dress in
traditional Tudor uniform of scarlet doublet
and breeches with red stockings, white ruff
and black velvet hat. They form the Queen's
ceremonial bodyguard, which dates back to
1485. They are made up of retired warrant
officers or non-commissioned officers of the
regular army, Royal Marines or Royal Air
Force with a distinguished record, and
Long Service and Good Conduct medals.
With the Yeomen Warders, they are
popularly known as 'Beefeaters'.

2 May, 2001

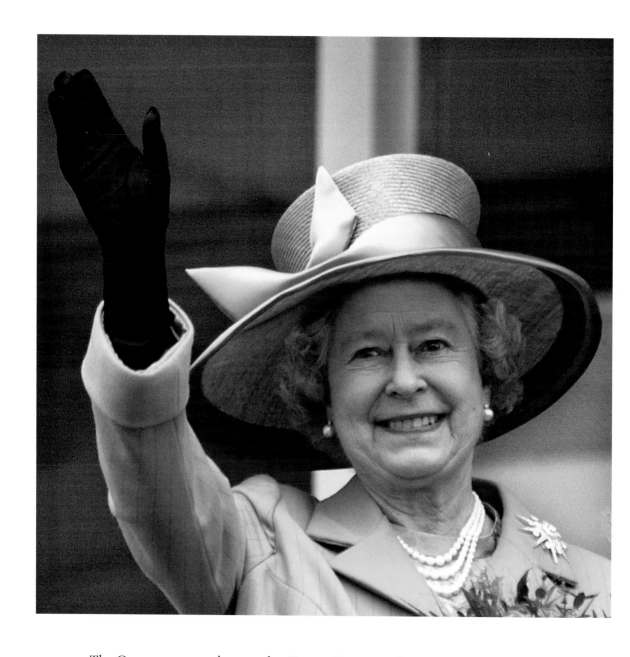

The Queen waves to the crowd at Epsom Downs at the running of the Derby.

Today she becomes the fourth longest reigning monarch in 1,000 years.

Only three Royal ancestors have reigned longer on the throne – Queen Victoria,

George III and Henry III. Taking into account leap years, she has reigned for

50 years and 149 days, overtaking Edward III, who was made King on 25 January, 1327

and died on 21 June, 1377, having reigned for 50 years and 148 days. 8 June, 2002 ♔

The Queen attends the 50th anniversary of
the world's longest running play, *The Mousetrap*,
at St Martin's Theatre in London. 25 November, 2002 ♕

The Queen records her annual
Commonwealth Day broadcast.
11 February, 2003 ♔

A moment of hilarity for the Queen and Prince Philip
at Windsor Castle when a swarm of bees invaded the
Queen's Company Review. Luckily, they were swiftly
dealt with by a beekeeper. 15 April, 2003 ♔

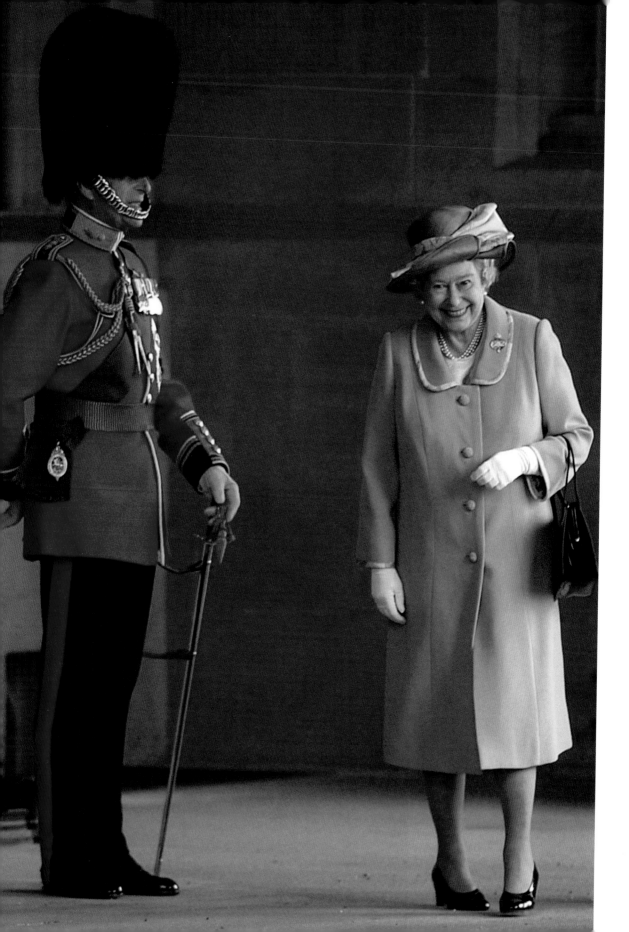

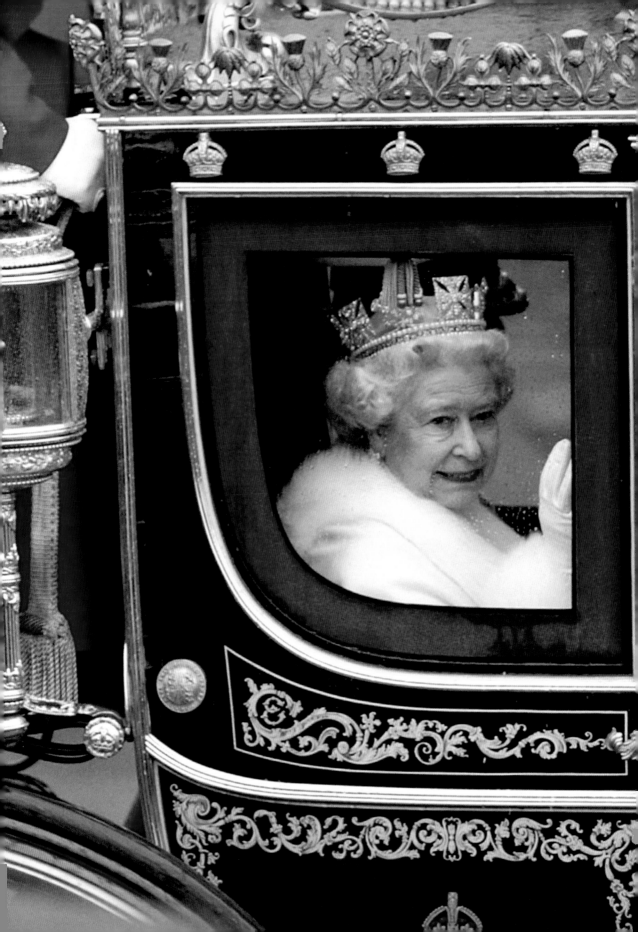

The Queen on her way to Parliament to deliver
the Queen's Speech to members of the House of Lords
and the House of Commons at the opening of the
new parliamentary session. 26 November, 2003

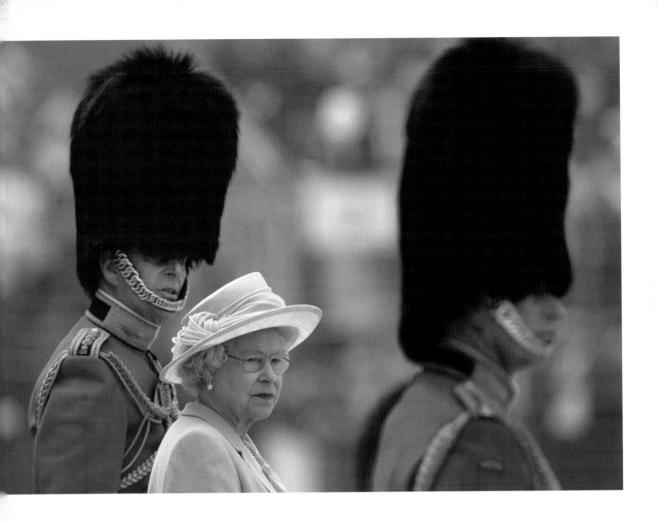

The Queen, accompanied by the Duke of Edinburgh
and the Prince of Wales (*right*), watches the annual
Trooping the Colour parade. 11 June, 2005

The Queen makes her speech in the House of Lords
during the State Opening of Parliament, at the beginning
of the new parliamentary session following the Labour
Party's return to power. 17 May, 2005

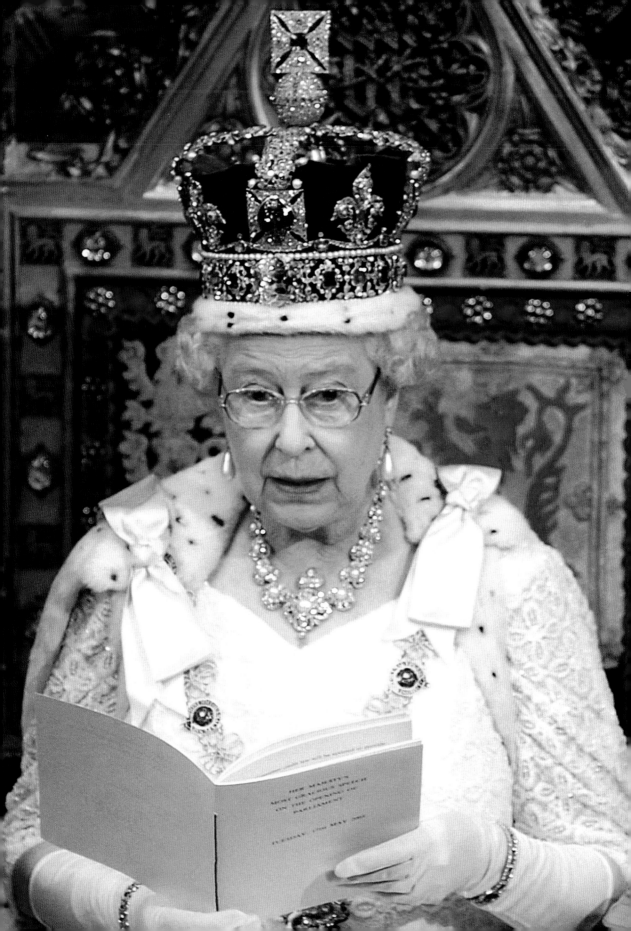

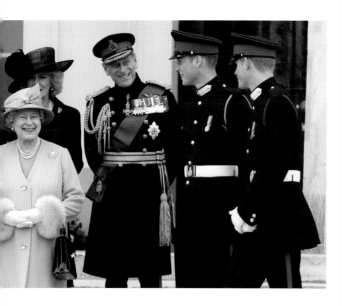

The Queen is joined by the Duchess
of Cornwall, the Duke of Edinburgh,
Prince William and Prince Harry at
Sandhurst Royal Military Academy after
The Sovereign's Parade that marked
the completion of Prince Harry's officer
training. The Prince is one of 220 cadets
passing out and receiving their commissions
into the British Army. 12 April, 2006 ♔

Prince Harry smiles as
his grandmother reviews him and
other officers during the ceremony. ♔

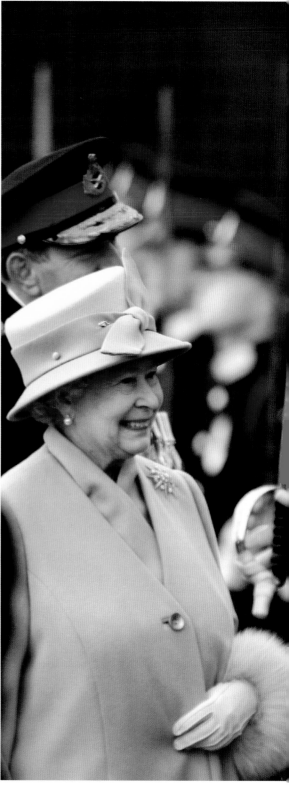

The Queen shares a joke with
the Bishop of Manchester,
Nigel McCulloch (*centre*), and
the Dean of Guildford Cathedral,
the Very Reverend Victor Stock at
the annual Maundy Thursday
service at the cathedral. During
the centuries-old Holy Week
ceremony, the monarch gives bags
of newly minted coins to 80 men
and 80 women, who are all specially
chosen to take part. 13 April, 2006

OVERLEAF

The Queen inspects Chelsea
Pensioners during the Founder's
Day Parade at the Royal Hospital
Chelsea. The hospital was founded
by King Charles II in 1682 as a
home for soldiers no longer fit
for service. 8 June, 2006

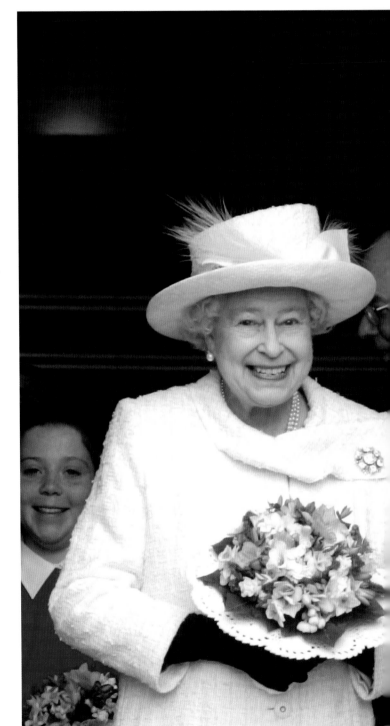

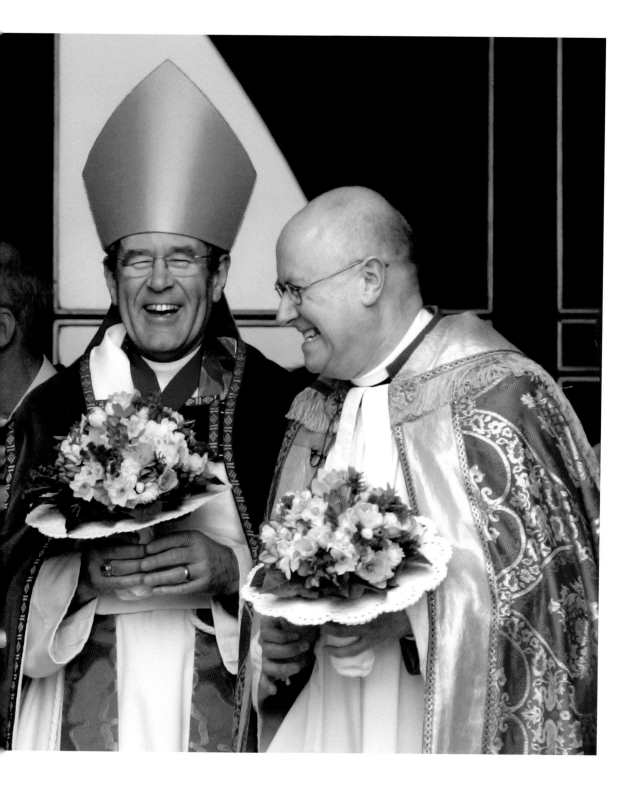

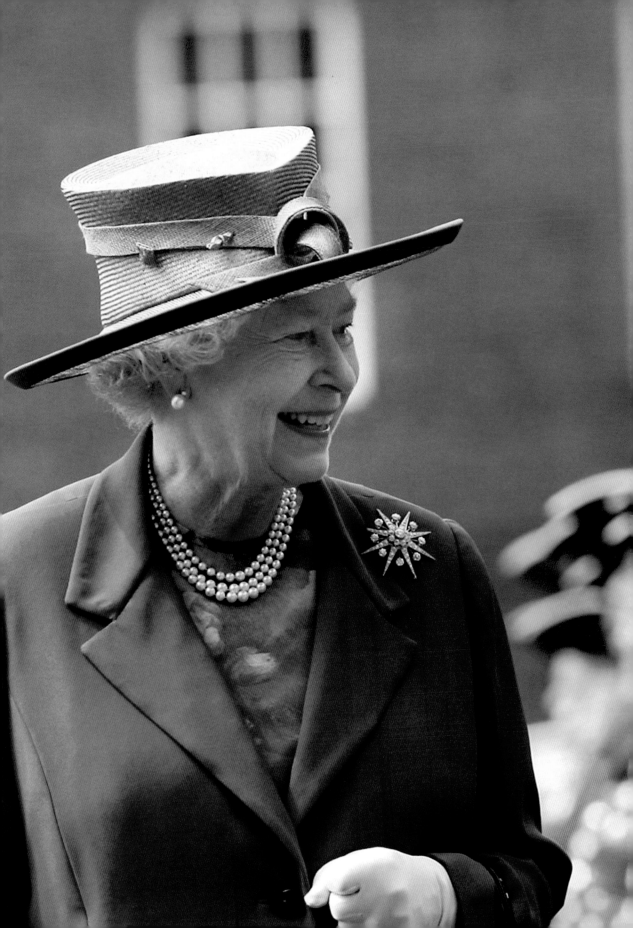

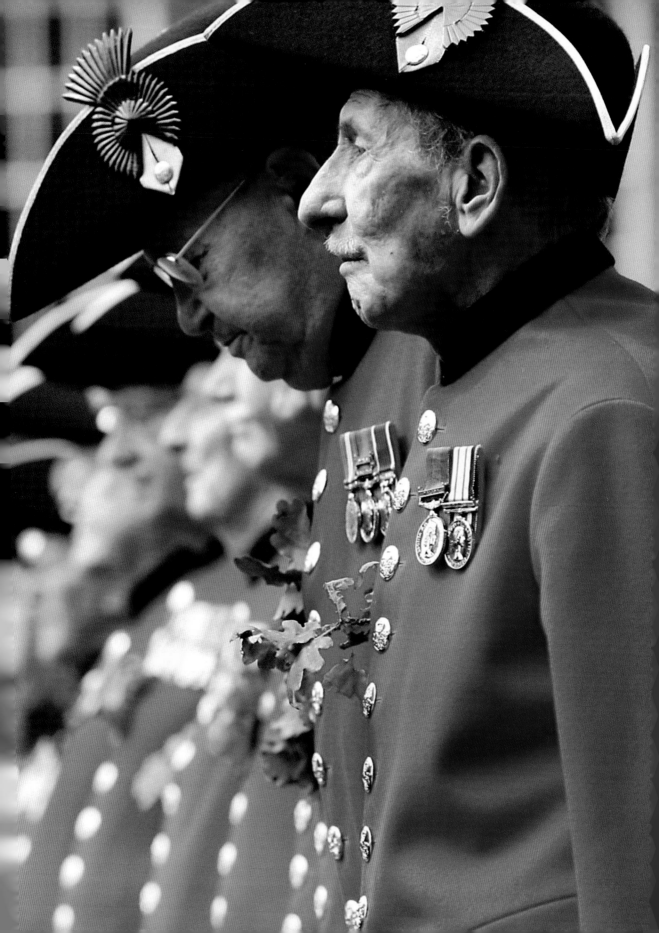

The Queen is joined by Prince Charles and the Duchess of
Cornwall at the Braemar Highland Games at the Princess Royal
and Duke of Fife Memorial Park in Aberdeenshire.
The Royal family have been regular visitors to the games
since Queen Victoria first attended in 1848. 2 September, 2006

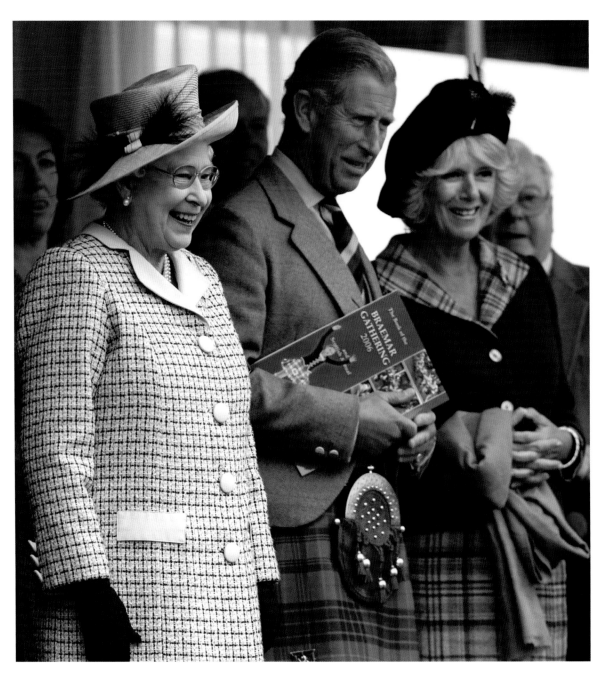

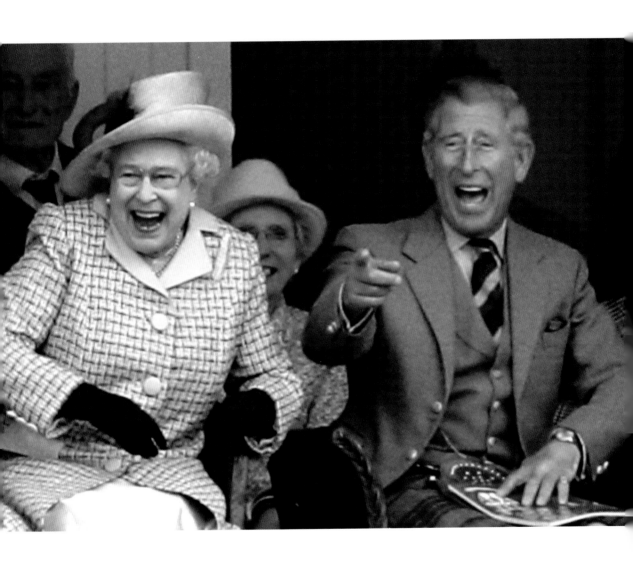

The Queen and Prince Charles enjoy

an amusing sight at the games. ♔

The Queen attends the Remembrance Sunday
ceremony in Whitehall, where she leads the nation
in two minutes' silence in honour of Britain's war dead.
12 November, 2006

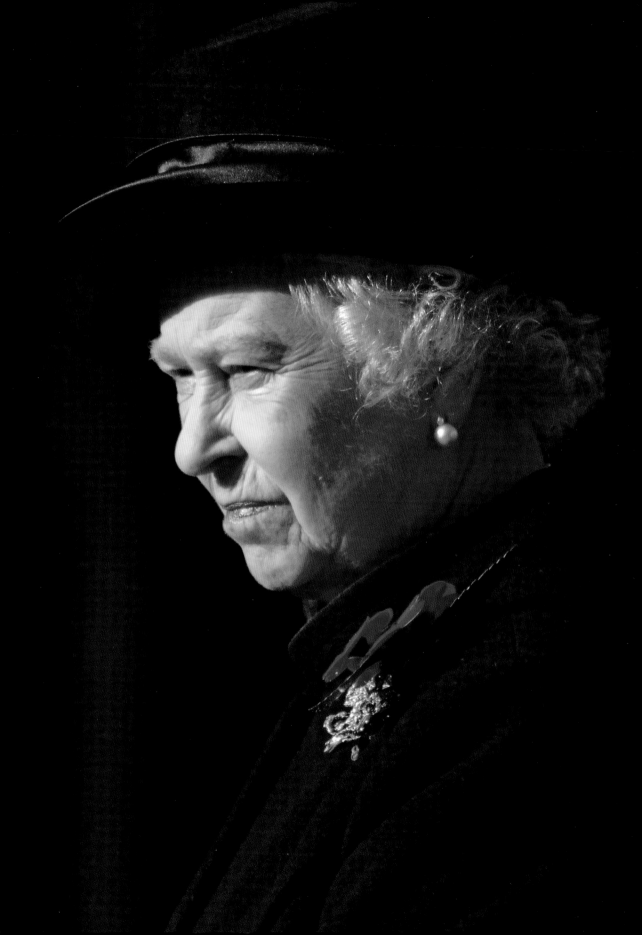

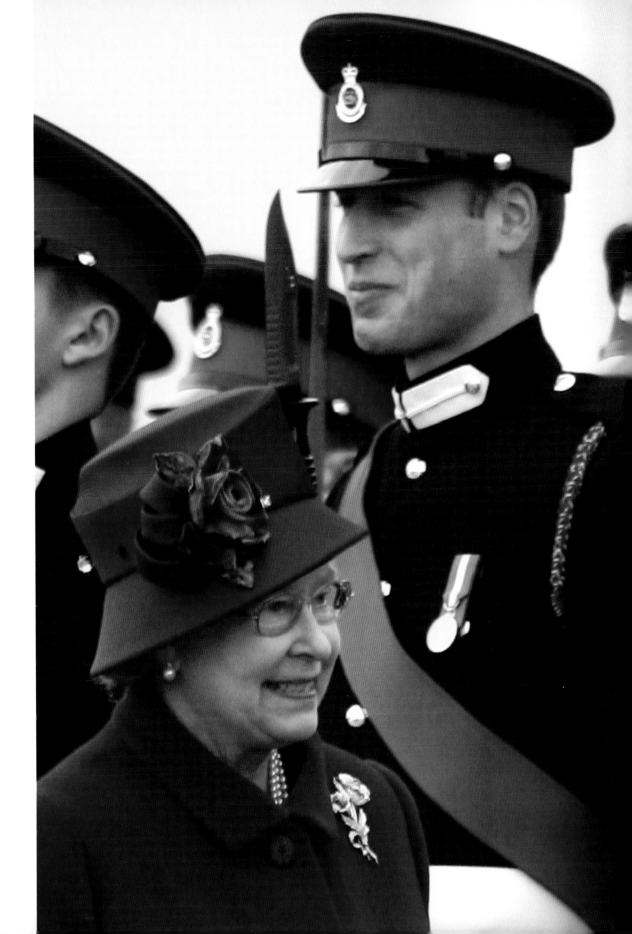

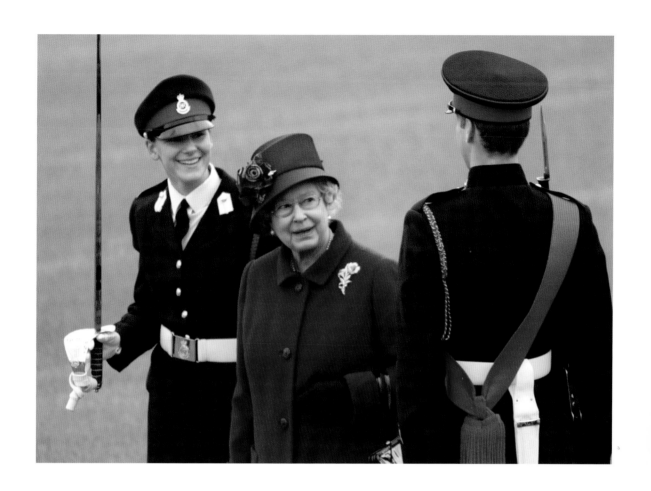

The Queen has a special smile for her grandson
at his passing out parade. 👑

The Queen inspects the graduates, including
Prince William, at The Sovereign's Parade at Sandhurst.
15 December, 2006 👑

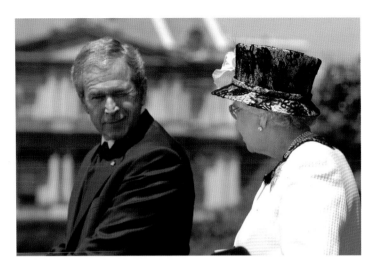

The Queen with President George W. Bush at
the White House, Washington, on the sixth day of her
state visit to America. 7 May, 2007 👑

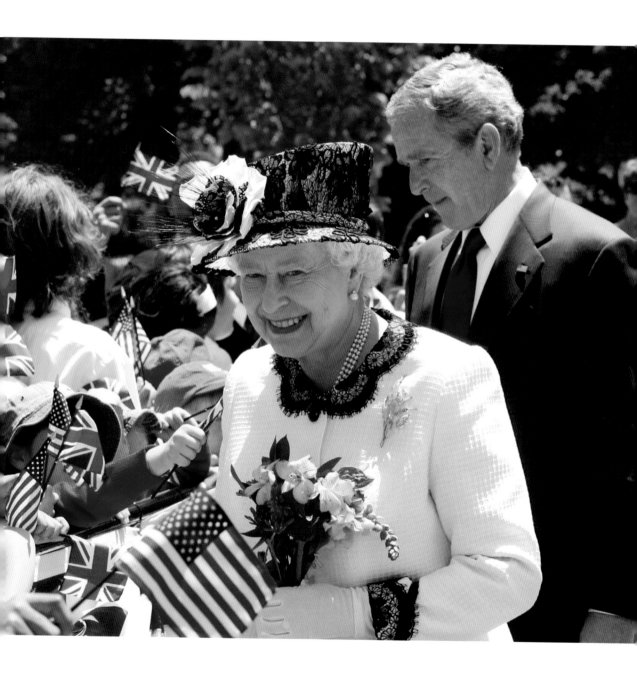

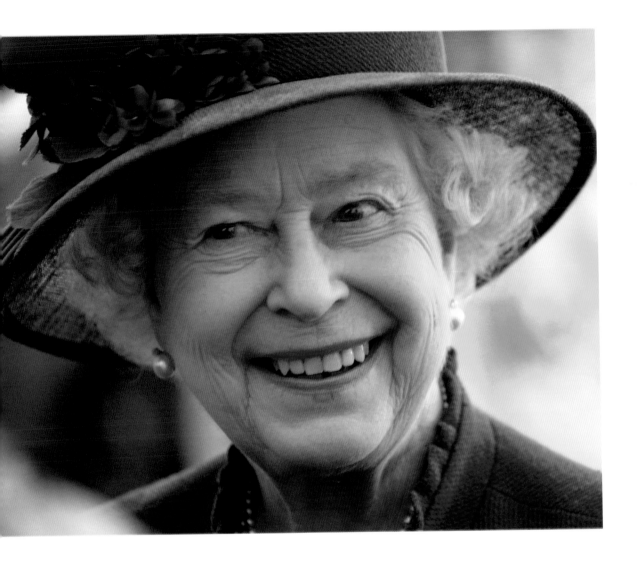

The Queen on a visit to the Defence College of
Policing and Guarding in Hampshire. She toured
the facilities and visited the chapel and new museum
before attending a garden party. 7 June, 2007 ♛

The Queen shelters from the rain at the opening
of the Lawn Tennis Association's new headquarters
in Roehampton. 29 March, 2007 ♛

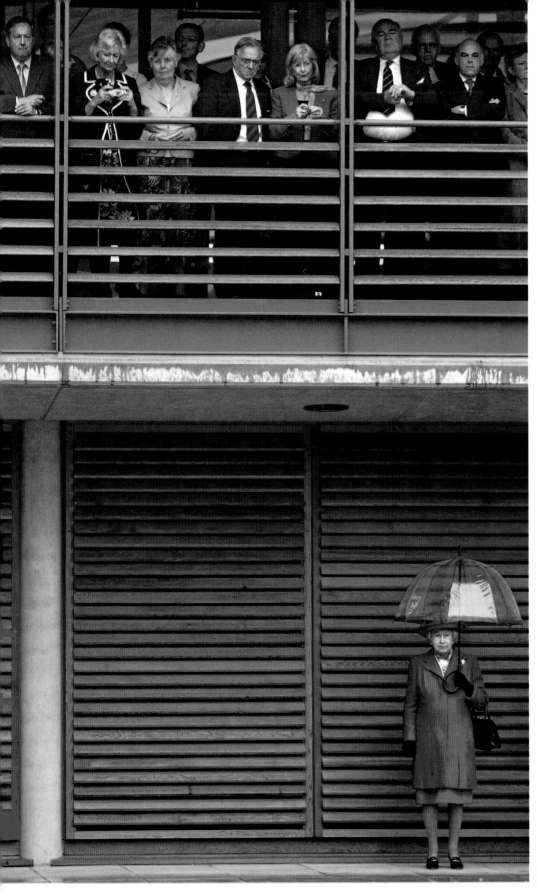

The Queen and other members of the Royal family
watch a flypast from the balcony of Buckingham
Palace during the annual Trooping the Colour ceremony
to celebrate her official birthday. *From left to right*:
Princess Beatrice, the Duke of York, Princess Eugenie,
Prince William, the Queen, the Duchess of Cornwall, the
Duke of Edinburgh, the Prince of Wales, Viscount Linley,
the Princess Royal. 16 June, 2007

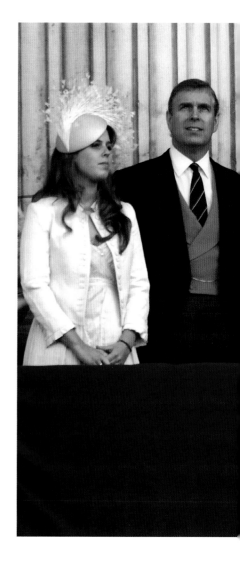

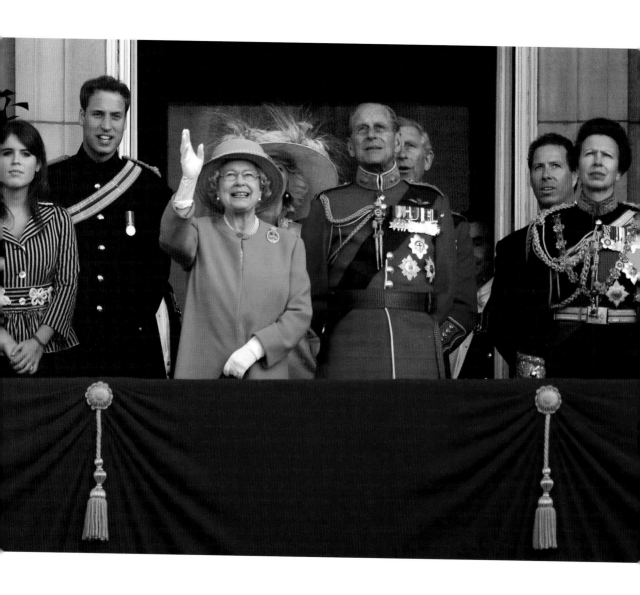

The Queen chats to members of the Yeomen of the Guard during an inspection of the guard at Buckingham Palace.

11 July, 2007

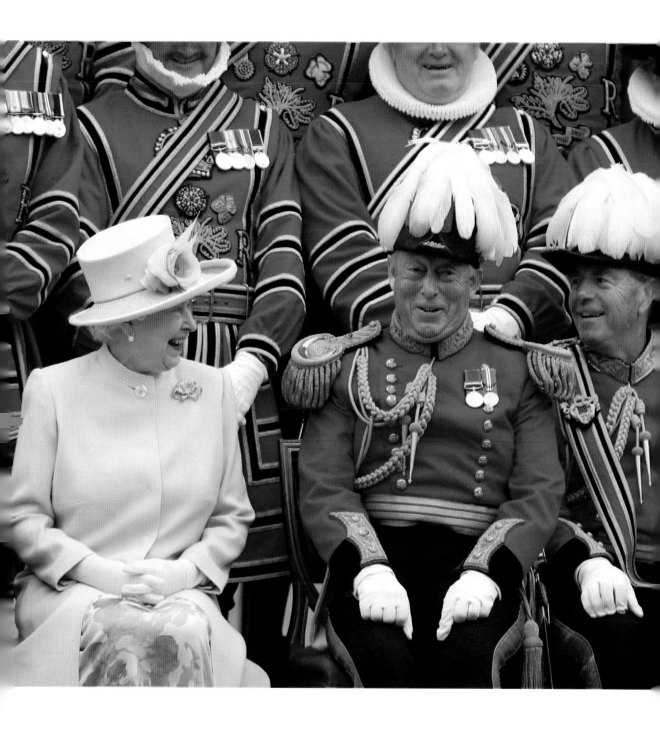

The Queen talks to Tate & Lyle Packing Area
Supervisor Teresa Croxford during a visit with
the Duke of Edinburgh to the east London
sugar refinery, which is celebrating 130 years
of production. 13 March, 2008

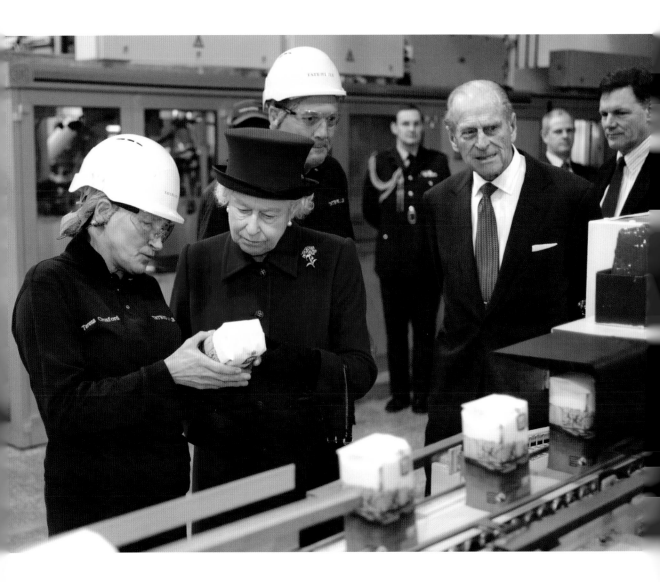

The Queen accepts
a bunch of flowers
during her visit to
Tate & Lyle.

OVERLEAF

The Queen surrounded
by her family. 2008

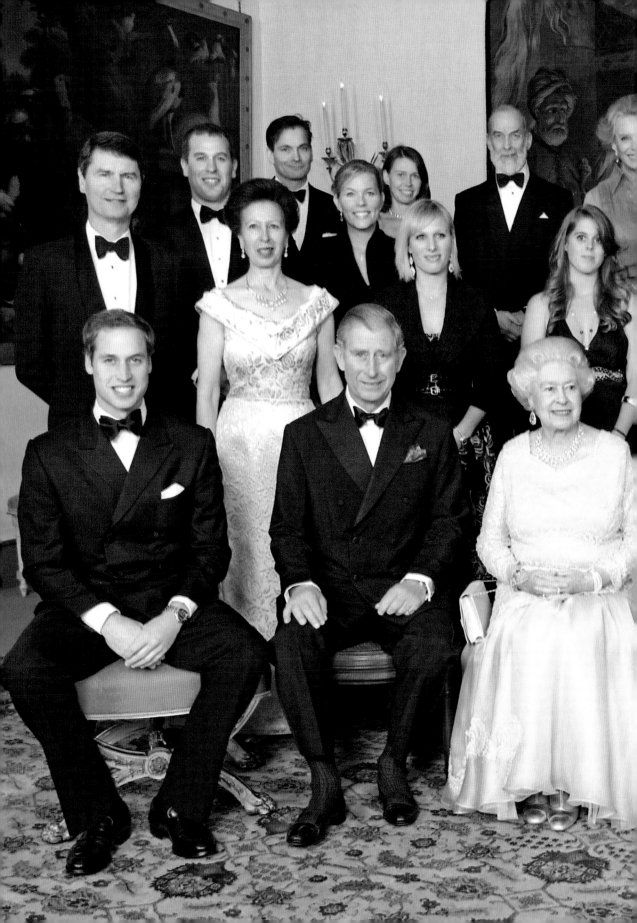

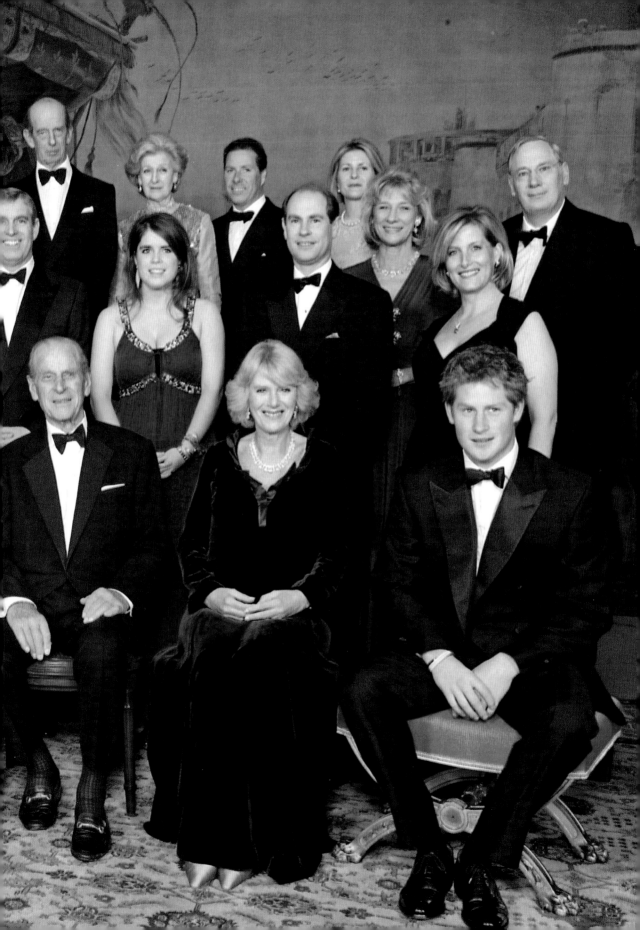

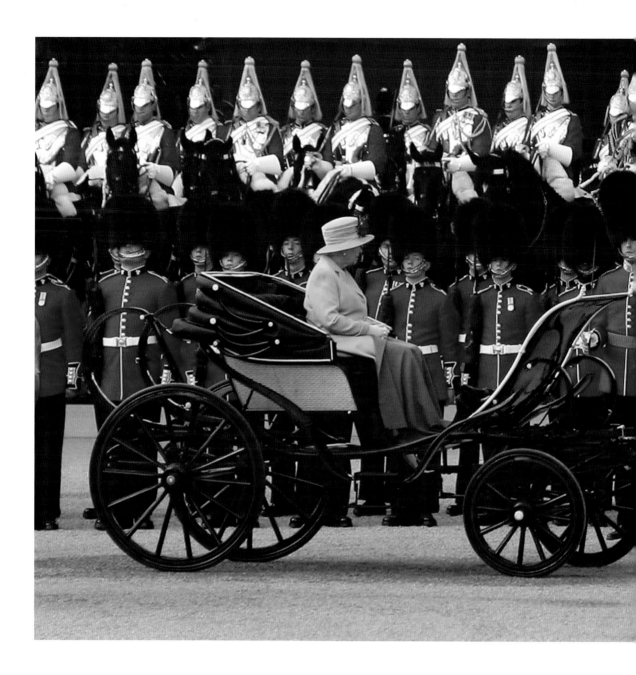

Riding in an open carriage, the Queen inspects her troops
on Horse Guards Parade during the annual Trooping the
Colour ceremony. 13 June, 2009

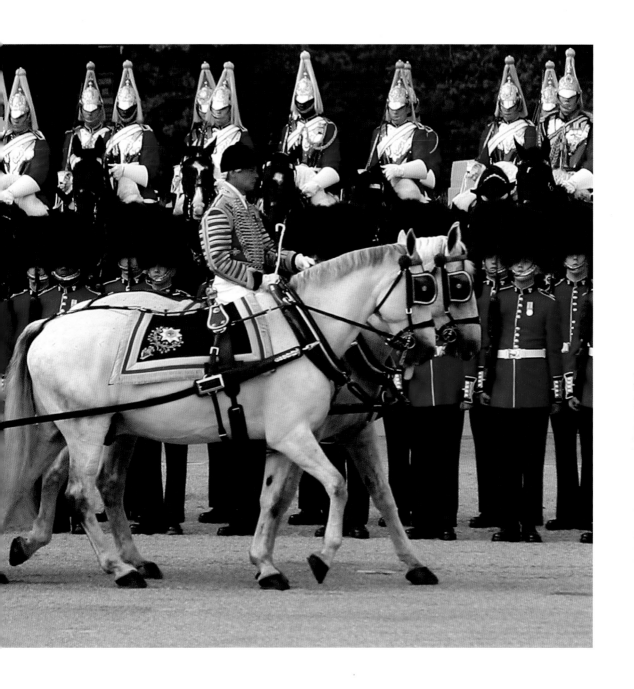

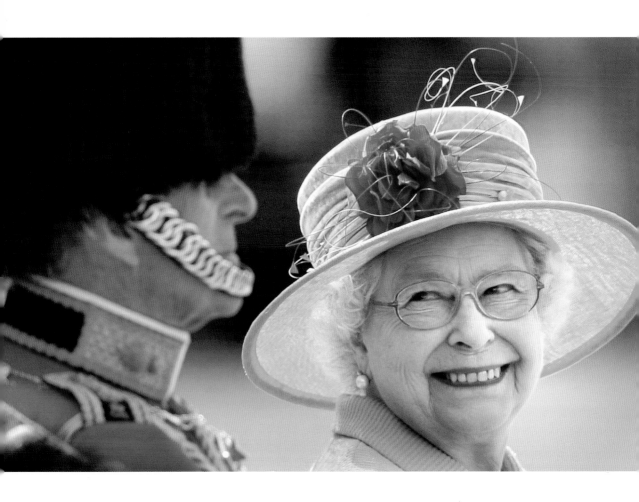

The Queen smiles at the Duke of Edinburgh during the
annual Trooping the Colour ceremony on Horse Guards
Parade in London. 13 June, 2009 ♔

Dressed in her ceremonial robes, Queen Elizabeth
takes part in the procession prior to the Order of
the Garter Service in Windsor. 15 June, 2009 ♛

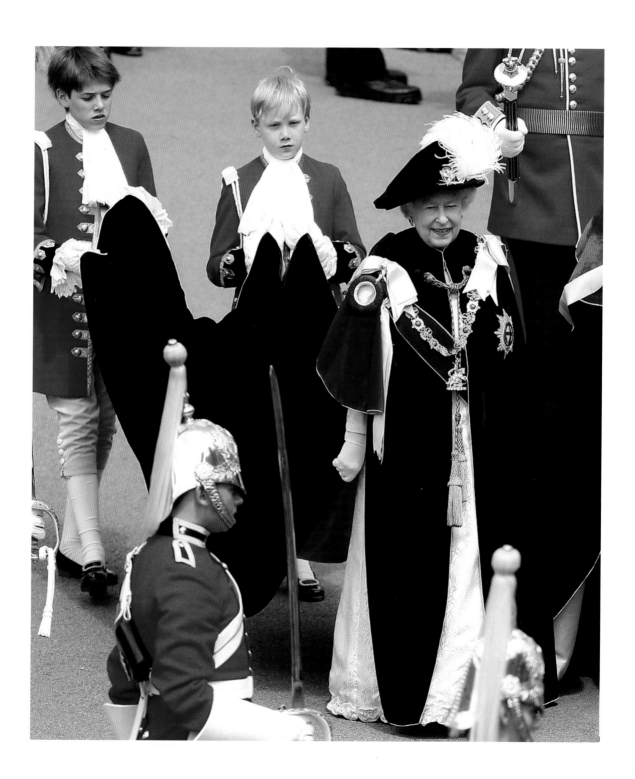

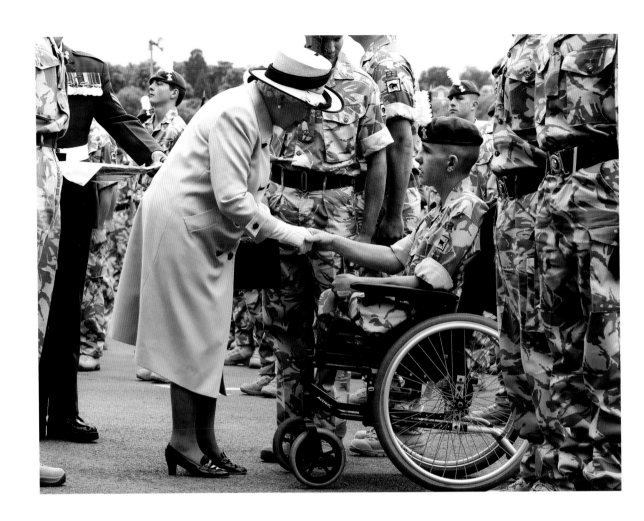

Queen Elizabeth presents a campaign medal to Shaun
Stocker, 19, from Wrexham, during a Drumhead Service
of Thanksgiving to mark the return of 1st Battalion
Royal Welsh from operations in Afghanistan, at Chester
racecourse. 10 June, 2010 ♛

Queen Elizabeth and the Duke of Edinburgh officially
open the Magistrates' Court at the Warwickshire Justice
Centre in Leamington Spa. 4 March, 2011 ♔

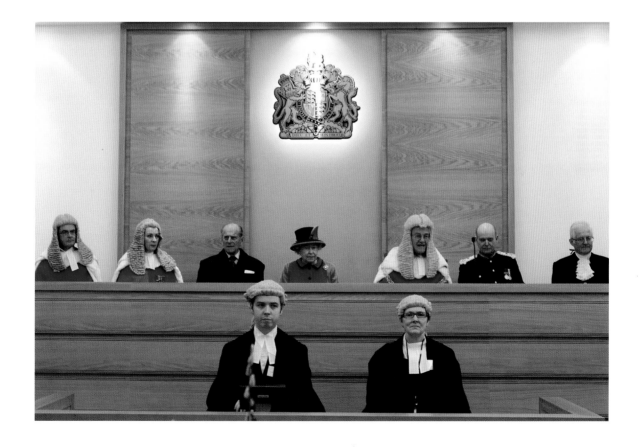

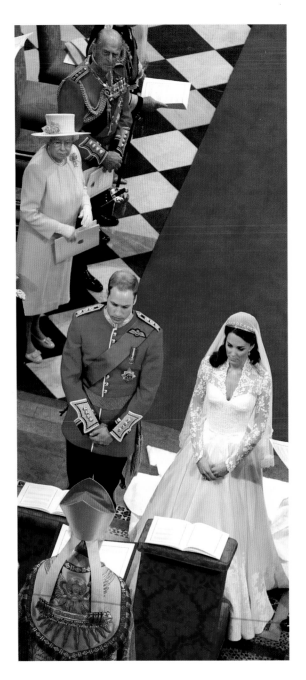

The Queen looks on with interest during the
wedding service of her first grandson,
Prince William, and Kate Middleton at
Westminster Abbey. 29 April, 2011 👑

Queen Elizabeth and the Duke of Edinburgh
are clearly enjoying the wedding of
Prince William and Kate Middleton. 👑

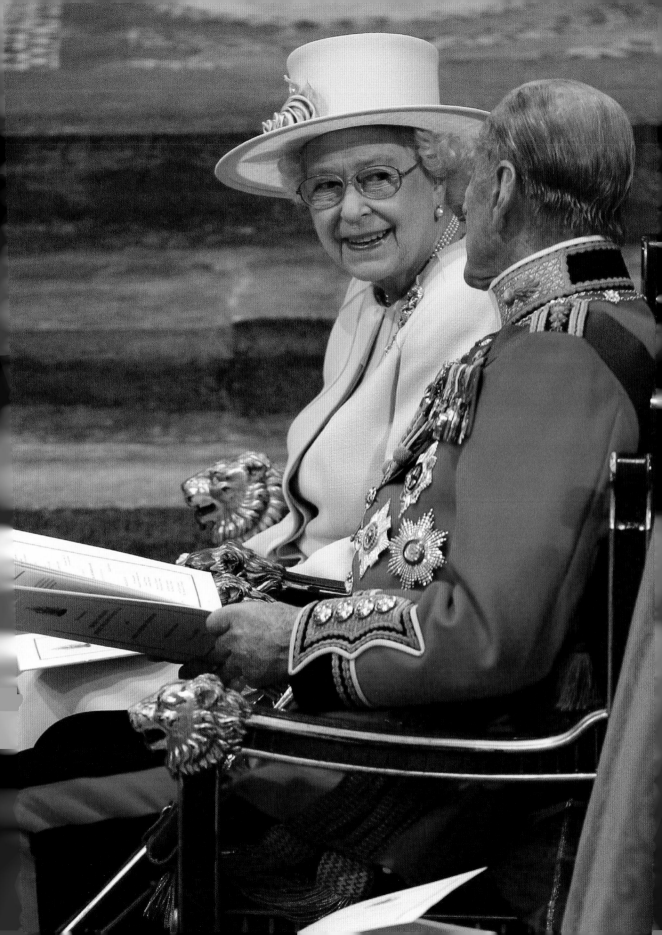

page 19

page 20

page 21

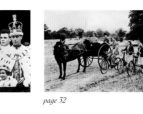

page 22

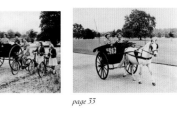

page 22

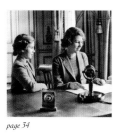

page 23

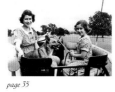

page 24

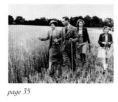

page 25

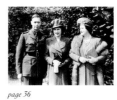

page 26

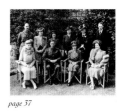

page 26

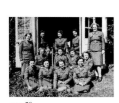

page 27

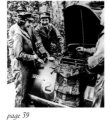

page 28

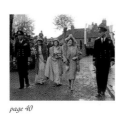

page 30

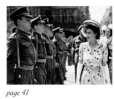

page 32

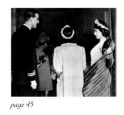

page 33

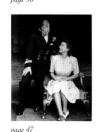

page 34

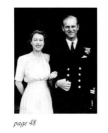

page 35

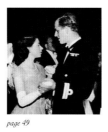

page 35

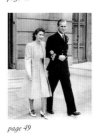

page 36

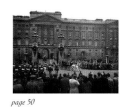

page 37

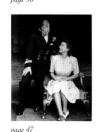

page 38

page 39

page 40

page 41

page 45

page 47

page 48

page 49

page 49

page 50

page 51

page 52

page 53

page 55

page 56

page 56

page 57

page 59

page 63

page 64

page 65

page 66

page 67

page 69

page 70

page 70

page 71

page 73

page 74

page 75

page 76

page 77

page 77

page 79

page 81

page 84

page 87

page 89

page 90

page 91

page 92

page 93

page 94

page 95

page 96

page 98

page 99

page 103

page 105

page 106

page 106

page 107

page 108

page 109

page 110

page 111

page 112

page 113

page 115

page 116

page 117

page 117

page 118

page 120

page 121

page 122

page 123

page 125

page 129

page 130

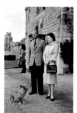

page 131

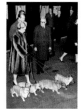

page 133

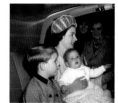

page 134

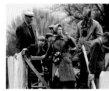

page 135

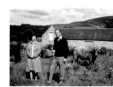

page 136

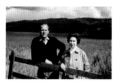

page 137

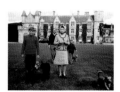

page 138

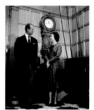

page 139

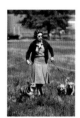

page 141

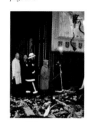

page 142

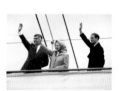

page 143

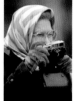

page 144

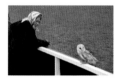

page 145

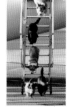

page 146

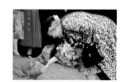

page 147

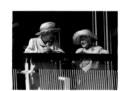

page 149

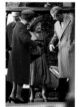

page 150

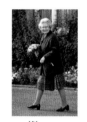

page 151

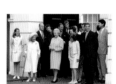

page 153

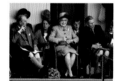

page 154

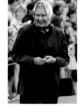

page 155

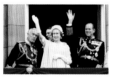

page 159

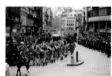

page 160

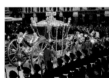

page 161

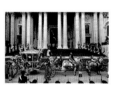

page 163

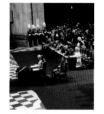

page 165

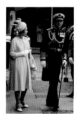

page 166

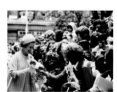

page 167

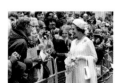

page 168

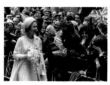

page 168

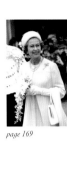

page 169

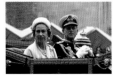

page 170

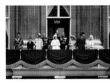

page 171

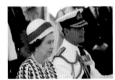

page 173

page 174

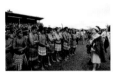

page 175

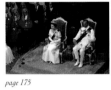

page 175

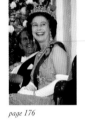

page 176

page 177

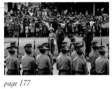

page 177

page 178

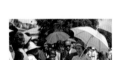

page 179

page 180

page 181

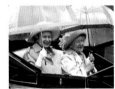

page 185

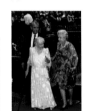

page 186

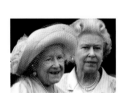

page 187

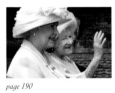

page 189

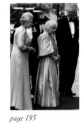

page 190

page 193

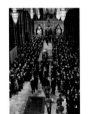

page 194

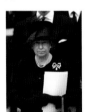

page 195

page 199

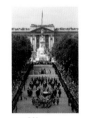

page 201

page 202

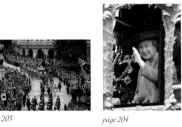

page 203

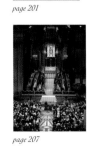

page 204

page 205

page 207

page 208

page 209

page 210

page 212

page 213

page 215

page 216

page 217

page 218

page 219

page 220

page 221

page 222

page 223

page 224

page 225

page 229

page 230

page 230

page 231

page 232

page 233

page 234

page 236

page 237

page 239

page 240

page 241

page 242

page 243

page 245

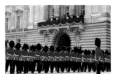

page 247

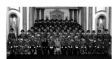

page 250

page 252

page 253

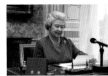

page 254

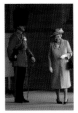

page 255

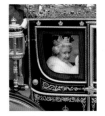

page 256

page 258

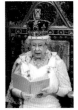

page 259

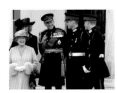

page 260

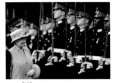

page 261

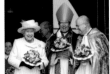

page 263

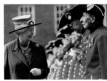

page 264

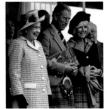

page 266

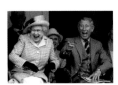

page 267

page 269

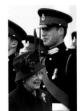

page 270

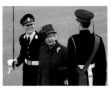

page 271

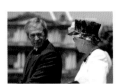

page 272

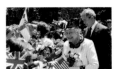

page 273

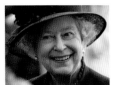

page 274

page 275

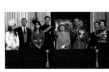

page 277

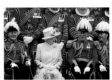

page 279

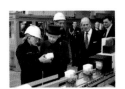

page 280

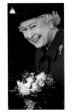

page 281

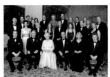

page 282

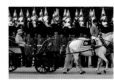

page 284

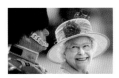

page 286

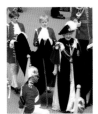

page 287

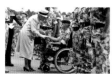

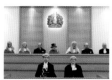

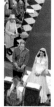

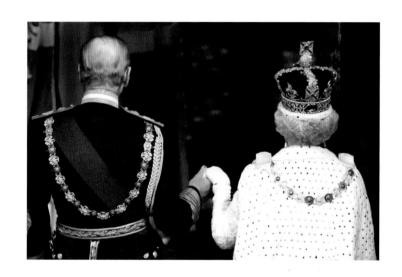

The Publishers gratefully acknowledge Press Association Images, from whose extensive archives the photographs in this book have been selected. Personal copies of the photographs in this book, and many others, may be ordered online at www.prints.paphotos.com

For more information, please contact:
Ammonite Press
AE Publications Ltd, 166 High Street, Lewes, East Sussex, BN7 1XU, United Kingdom
Tel: +44(0)1273 488006 Fax: +44 (0)1273 472418
www.ammonitepress.com